VISION ON

PEOPLE YOU'D LIKE TO KNOW

Legendary Musicians Photographed by Herb Wise

VISION ON

OMNIBUS PRESS

London / New York / Paris / Sydney / Copenhagen / Berlin / Madrid / Tokyo

Key to image location

A Mariposa Festival, Toronto

B Philadelphia Folk Festival, Philadelphia

C New York

D Philadelphia

E Big Sur Festival

F The Dick Cavett Show, New York

G Madison Square Garden, New York

H ABC-TV In Concert, New York

I Ann Arbor Blues Festival, Detroit

J Washington, Massachusetts

K Lincoln Center, New York

L Central Park, New York

M Mar Y Sol Festival, San Juan, Puerto Rico

N Madison Square Garden, New York

O New Orleans Jazz & Heritage Festival, New Orleans

P American Folk Life Festival, Washington

Q Hudson River Revival, Croton-on-Hudson, New York

R Beverly Hills

S National Folk Festival, Vienna, Virginia

T Fox Hollow Festival, Petersburgh, New York

U Hilton Hotel, New York

V Gramercy Park, New York

W Broadway, New York

X New Orleans

Y Baton Rouge

The photographs in this book were taken using a Nikon F2 camera, Kodak Tri X film with the results digitally scanned.

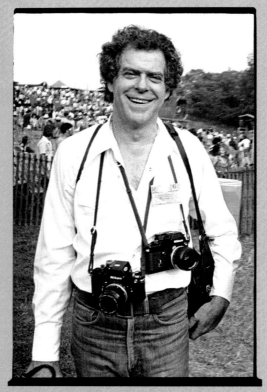

HERB WISE

DAWG

PEOPLE YOU'D LIKE TO KNOW

You'd like many of these people. They are good friends, even to know them through a brief glance along the way. The time was the ebullient 60s and 70s; their high spirit, their concern, their involvement were apparent.

During this swing period of American culture these bluesmen influenced the music of generations with their tales of yearnings. The bluegrass, country and folk artists celebrated other times.

What fascinating history lessons, taught on a grassy field in Washington, the hills of Vermont, the clubs of New Orleans or alongside the cool waters of the St Lawrence, where classicists of music and dance revealed the gold of their thoughts.

Today a near-deluge of talent appears every summer at hundreds of festivals in America. So if you don't recognize some of the names or faces shown here, trust that they are friends whose music, tall tales and humor you would surely treasure and enjoy.

Herb Wise

ISBN 978.1.84938.230.4
Order Number VO10483

Exclusive Distributors

Music Sales Limited
14/15 Berners Street, London W1T 3LJ
United Kingdom.

Music Sales Corporation
257 Park Avenue South, New York NY 10010
United States of America.

Macmillan Distribution Services
56 Parkwest Drive, Derrimut, Vic 3030
Australia.

Printed in China.

A catalogue record for this book is
available from the British Library.

The photographer can be contacted at
photoeditor@musicfotos.com

Visit Omnibus Press at www.omnibuspress.com

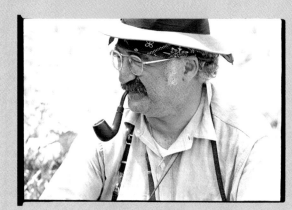

DAVID GAHR

FOREWORD

Herb Wise's photography grew out of his role as an editor at Oak Publications, the legendary
New York music publisher specializing in folk, blues, country, and jazz. A musicology background
and a personal love for musical diversity made him a vital force in that company.

This was back in the 1960s and Herb Wise now recalls that he was inspired and encouraged by
one of Oak's regular suppliers of photographs, David Gahr, America's pre-eminent photographer of
folk, blues, jazz, and rock musicians.

'I was sitting at my desk one day when Dave burst into my office with two cameras, one for him,
the other for me. He loaded them with film and got me onto the street. "Take some pictures" he said.
'We walked down 57th street in Manhattan and he got me to shoot anything – signs, bums, taxis
and interesting buildings. When he brought the results back the next day we both acknowledged that
it had been a well-intentioned experiment, although there was but one scant usable image on my
negatives'.

When Herb learned that a friend was visiting Japan he placed a shopping list request for two
Nikons and a selection of lenses and accessories.

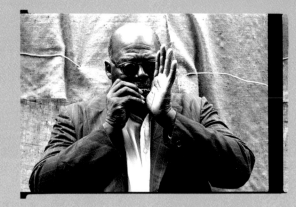 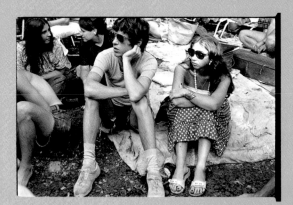 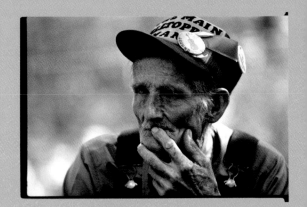

These were the days when the recently launched Nikon F single-lens reflex line of cameras was already becoming the professional photographer's natural choice. Duly equipped, he started to visit some of the leading North American music festivals: The Philadelphia Folk Festival, Wolf Trap Farm in Virginia, Mariposa on the St Lawrence, New Orleans Jazz & Heritage Festival and many more.

He learned a lot from his mentor and friend Gahr although, at one particular gig, he also got free advice from a fellow photographer who saw him struggling with the wrong sort of camera and a dwindling supply of film at the dimming of the day.

As he walked past, the young man said, 'f8 at a thirtieth of a second and push it two stops'. 'This high school amateur with a beat-up camera knew more than the fledgling, and he was right', Herb recalls.

As his technique improved Wise became a prolific photographer of music festivals which, in the 1960s and 1970s, were often laid-back, amiable and quite manageable affairs even if the famous historical examples of Woodstock and Altamont may suggest otherwise. Many were simply a field with an informal arrangement of tents that made the term 'backstage pass' a conceptual rather than a literal one.

Such festivals offered many opportunities for a sympathetic photographer to take informal portraits and intimate performance shots as well as to catch some genuinely spontaneous off-guard moments.

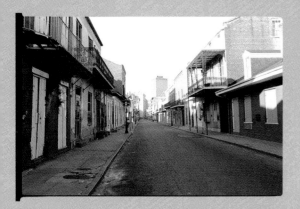 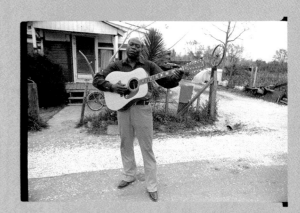

To a modern generation that may equate photographs of pop stars with warts-and-all paparazzi shots or pre-sold wedding pictures taken in locations bristling with military levels of security, it must be refreshing to see these famous musicians of the day relaxing, goofing off or just singing and playing without vast video screens and sound systems. Of course many of the artists pictured here are no longer with us. For every durable Kris Kristofferson, Joan Baez, and Bob Dylan there was a Steve Goodman, a Mimi Fariña, or a Frank Zappa who proved less lucky.

Some who survived have seen their fame dim, others became the elder statesmen and women of the counter culture they once personified, while a handful continued to reinvent themselves through the decades, reworking their celebrity for each new generation.

After criss-crossing the continent from Philadelphia to Big Sur, the final section of this book focuses on a single location: New Orleans. A place steeped in a rich stew of music like no other, The Crescent City became a favorite destination for Herb, particularly after he got to know Allison Miner, a woman who had helped organize the first New Orleans Jazz & Heritage Festival in 1970.

(Herb's life seems to have been punctuated with happy accidents like this, casual meetings with people who would help him, guide him and introduce him to new possibilities and achievements.)

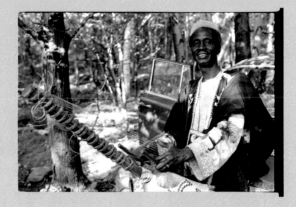 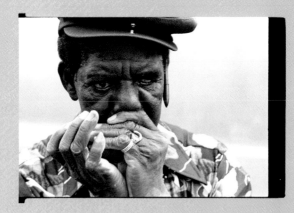

In this case Allison arranged a series of trips to visit New Orleans blues players in their own home where her interests (she had worked as an archivist at Tulane University's Hogan Jazz Archives) coincided with Herb's unforced style of making pictures in sympathetic surroundings.

Accordingly his New Orleans pictures featured here are a mix of these 'at home' shots, a variety of famous performers and unknown street musicians, scenes of New Orleans funeral processions, and smoky beer parlor jazz bands. But the real star of the show is the city itself, the home of jazz, cajun, zydeco, its own distinctive style of blues, and numerous cross-bred musical genres.

Some of the images in this section call to mind the work of August Sander who, early in the 20th century, published a series of unpretentious photographs of German tradesmen, each in his work clothes and each holding the tools of his trade. Similarly, here we have performers shown in their natural setting with the tools of *their* trade in unassuming poses and with the beauty of the moment captured by a skilful photographer.

In his title and introduction, Herb Wise stresses the generally good-natured spirit of his encounters with a generation of famous musicians. The pictures bear out this impression and his quiet style of photo reportage should not be undervalued since it surely contributed to that spirit.

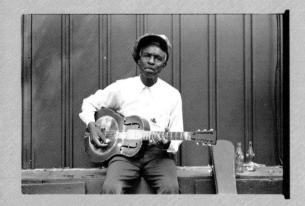 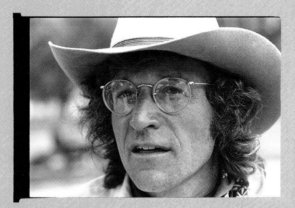

Herb claims only to have acquired a talent for identifying the moment when a performing artist would naturally turn this way or that, strum downward on his guitar or blow his horn on a high note, so allowing him – the photographer – to get the 'shot' without intruding upon the scene. He deplores the in-your-face approach of those photographers who would leap on stage and try to attract their subject's attention.

Herb, in contrast, is the archetypical observer... but some of his observations are extraordinary and certain pictures in this collection stand out as exceptionally potent images in their own right. Others bear simpler testimony to the comparative innocence of the time: a chilly-looking Henry Saint Clair Fredericks aka Taj Mahal, huddled in a blanket that contrasts strangely with his African headgear; a fourteen-year-old Rosanna Arquette who already looks like no stranger to the camera; the communal showers at an otherwise facilities-free festival in Puerto Rico. It's all a long way from 57th street and an aspirant photographer in search of a subject.

Considering his early failed experiment produced no artful or even 'usable' images it didn't stop him from eventually succeeding in producing a significant, maybe historic body of work.

Graham Vickers

PORTRAITS

Photographic portraits of musical figures can
range from the stiff formal poses of 19th century
composers to the equally contrived studies of
contemporary rock musicians, organized à la Leibovitz
into attitudes of mock informality for a knowing
magazine readership.

By contrast, the portraits of musicians in this
section are studies of a very different kind. Like most
of Herb Wise's photographs from the 1960s and
1970s, they were taken in an atmosphere of informal
al fresco reportage rather than within the confines
of a lit studio.

Musicians who were sometimes already stars
usually seemed happy enough to cooperate with
Wise's unobtrusive approach and as a result we get
intimate shots of singers and musicians, both
famous and unknown, working in a variety of genres,
as often as not captured in the downtime between
performances.

Some, like Thelonius Monk, remained enigmatic.
This instantly recognizable and highly influential
jazz pianist worked relatively little during the 1970s.
As his health deteriorated, he gradually withdrew
from being the once verbose champion of music to a
monosyllabic introvert.

Those who saw him play live at festivals and concerts

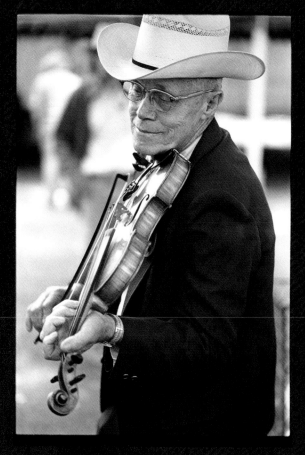

VAN KIDWELL 1974 Ⓐ

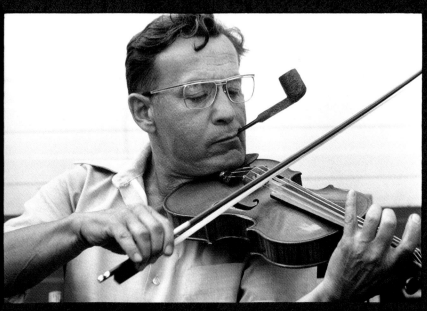

JEAN CARIGNAN 1974 Ⓑ

Fiddlin' Van Kidwell was a traditional fiddler and member of The Hot Mud Family band. Jean Carignan, another traditional player and a much feted Québecois, was friends with classical violinist Yehudi Menuhin.

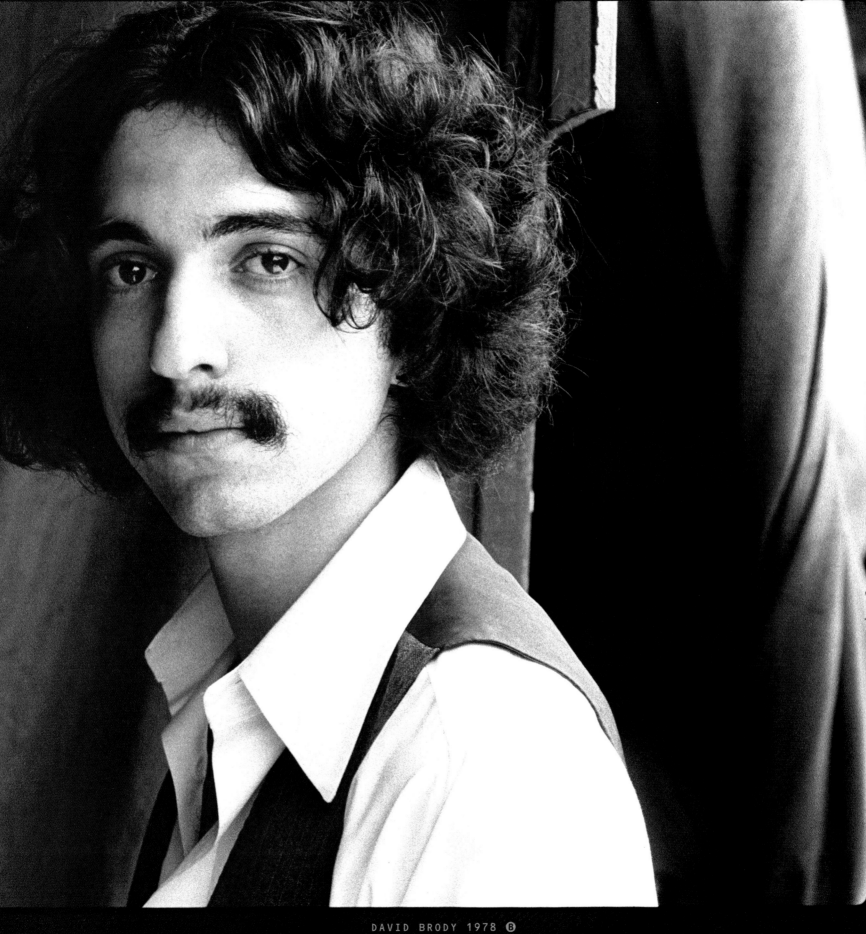

DAVID BRODY 1978 Ⓑ

A much-admired musician was David Brody, just one of many fiddle players ranging from old timers to neophytes who flocked
to festivals all over North America during sporadic folk and country revivals. The fiddle traditions which had survived intermittent
periods of unfashionability had been sustained through countless regional fiddle contests from Canada and New England to Idaho
and points west. The festivals were just bigger events with different audiences.

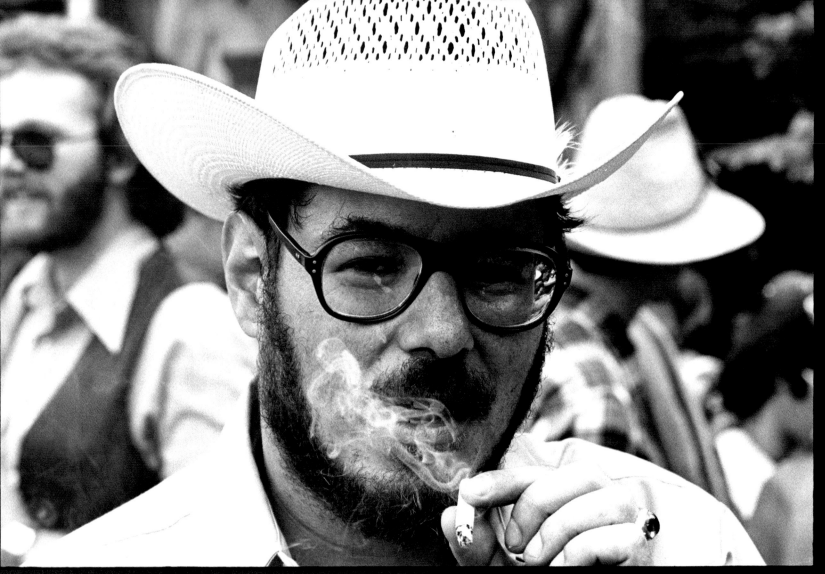

SAUL BROUDY 1977 Ⓑ

Saul Broudy, a folk singer and folklorist from Philadelphia, made a study of the role of folk music in the Vietnam conflict in which he served. A regular festival performer and lecturer he was as likely to turn up in a field and sing a Townes Van Zandt song as he was to give a more formal lecture theatre talk entitled *Oh, You Saigon Girls, Can't You Dance The Polka!*

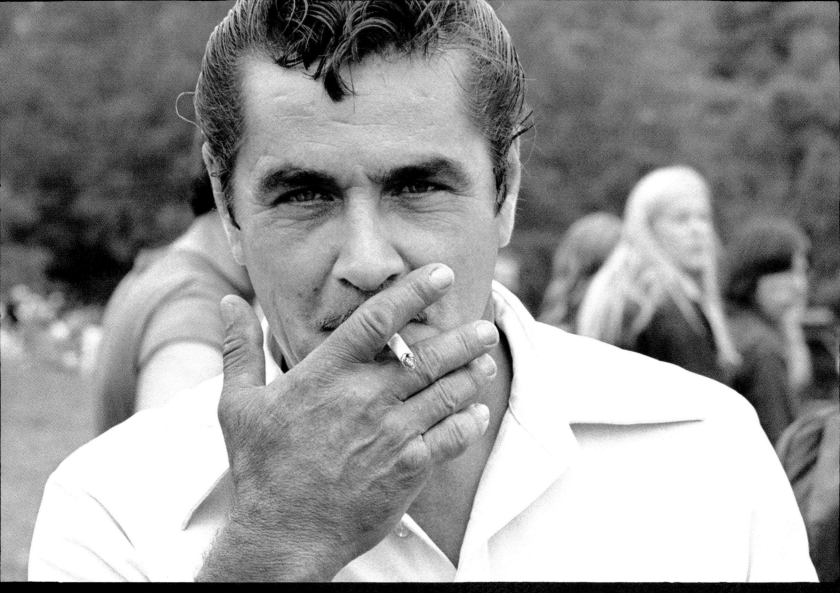

SIMON ST PIERRE 1978 Ⓑ

Simon St Pierre, a Quebec-born fiddler, relocated to Maine in the late 1950s, became something of a star on the festival circuit and was eventually awarded a National Heritage Fellowship by the NEA in 1983.

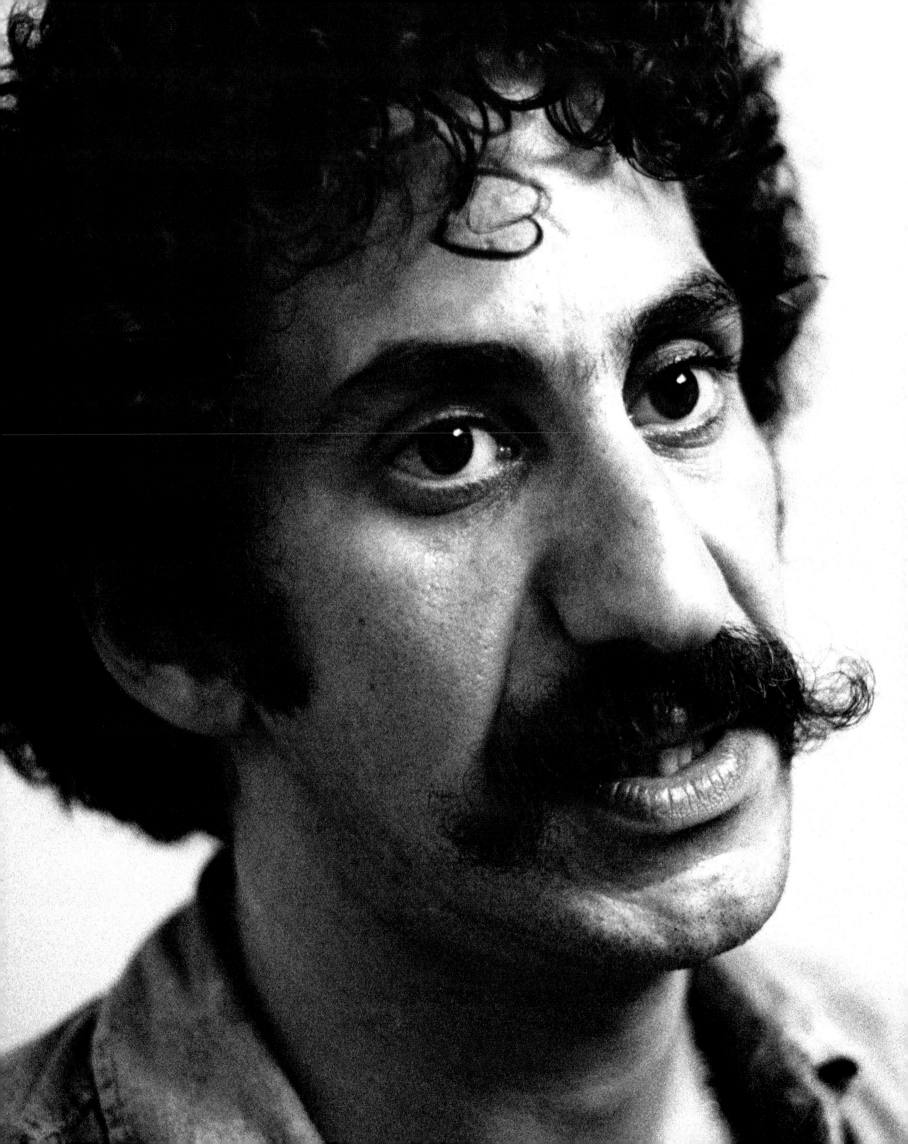

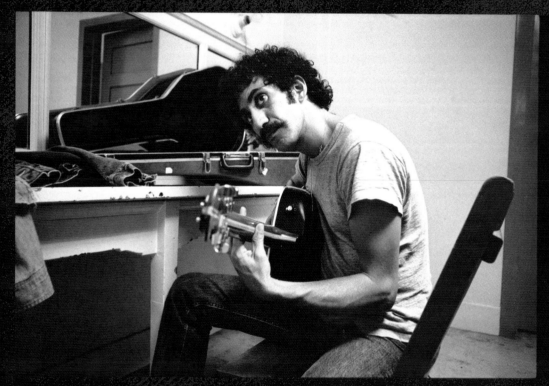

JIM CROCE 1973 ©

Fame came early to Philadelphia-born Jim Croce, and so, sadly, did death.
He released six albums and had two No1 hits on the *Billboard* chart before being
killed in a plane crash in 1973 flying between concerts in Louisiana and Texas.
He was thirty years old and had won a huge following with his warm and
amiable songs and performances that had taken his folk sensibilities into the
pop charts.

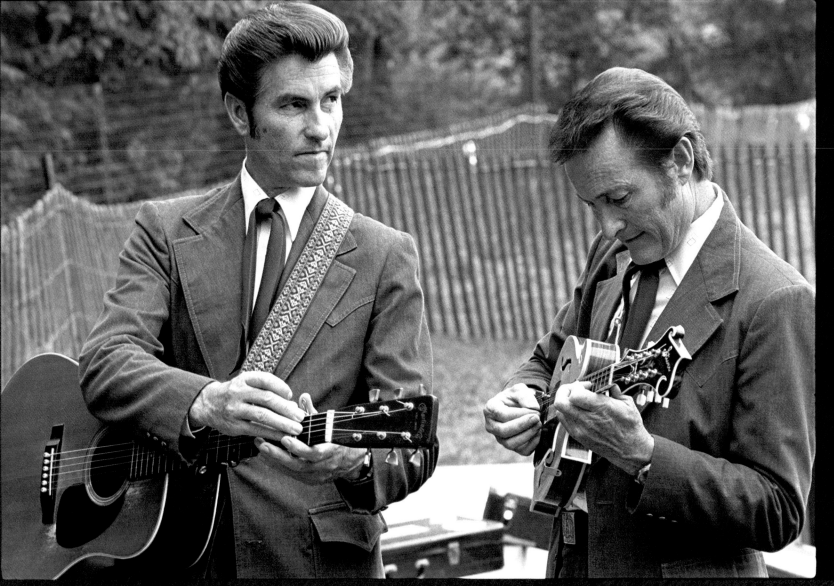

JIM & JESSE McREYNOLDS 1979 Ⓑ

Bluegrass music has its revivals and its doldrums, but for hardcore fans of the genre there are a few names that define the music form. If Bill Monroe and his Bluegrass Boys gave the Kentucky-born music its name and Earl Scruggs bestowed truly dazzling banjo playing, Jesse McReynolds gave it a unique and highly distinctive 'cross-picking' mandolin sound. With his brother Jim he formed a duo, Jim & Jesse, and they fronted one of bluegrass's most durable bands from the early 1950s until Jim's death in 2002. It was a band instantly recognizable by those rapid flat-picking mandolin solos and the brothers' high, keening harmonies.

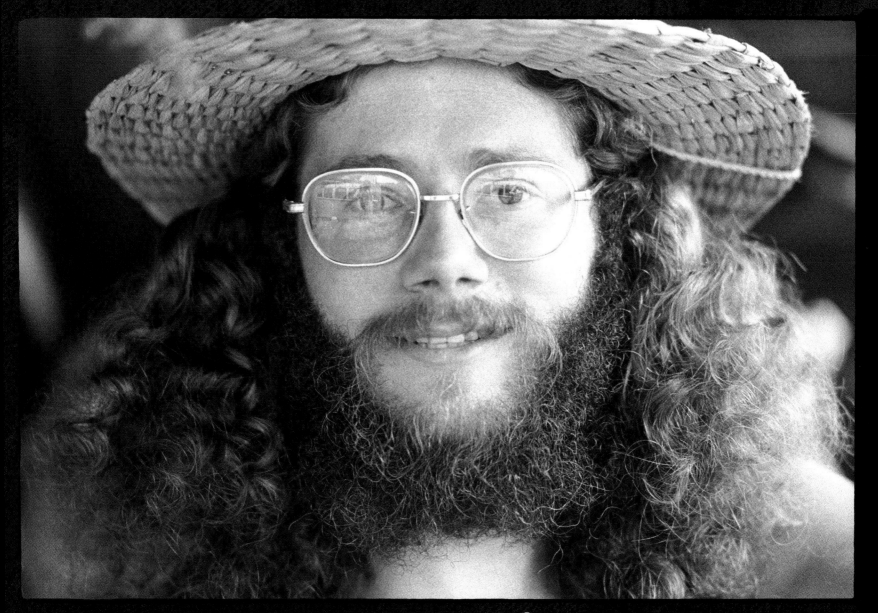

THE SPICE MAN 1974 Ⓑ

The anonymous Spice Man was a familiar face at many festivals, selling herbs, spices and perhaps even other related merchandise.

Todd Rundgren was a native of Pennsylvania, a chameleonic musician
and producer who in the 1970s emerged from his alter ego, Runt,
and started to move from pop into progressive rock under his own name.

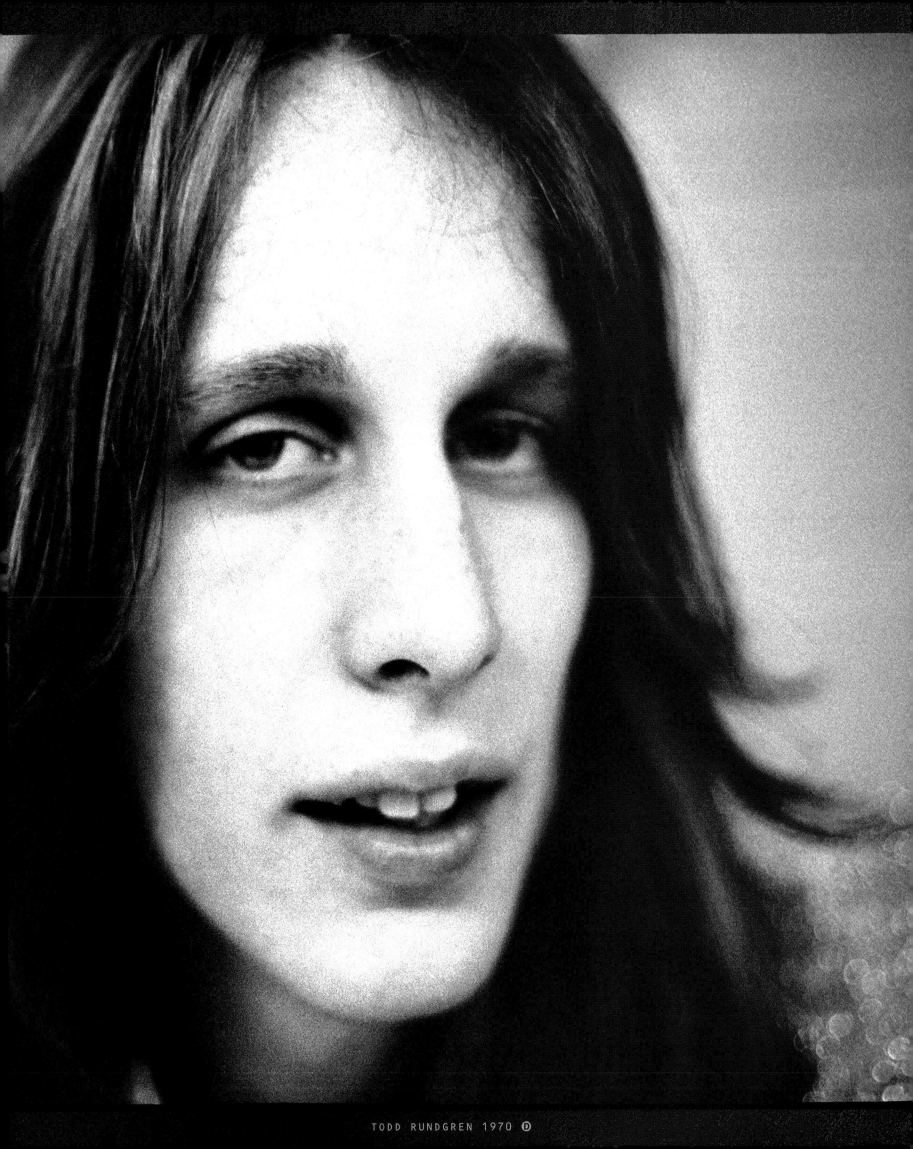

TODD RUNDGREN 1970 Ⓓ

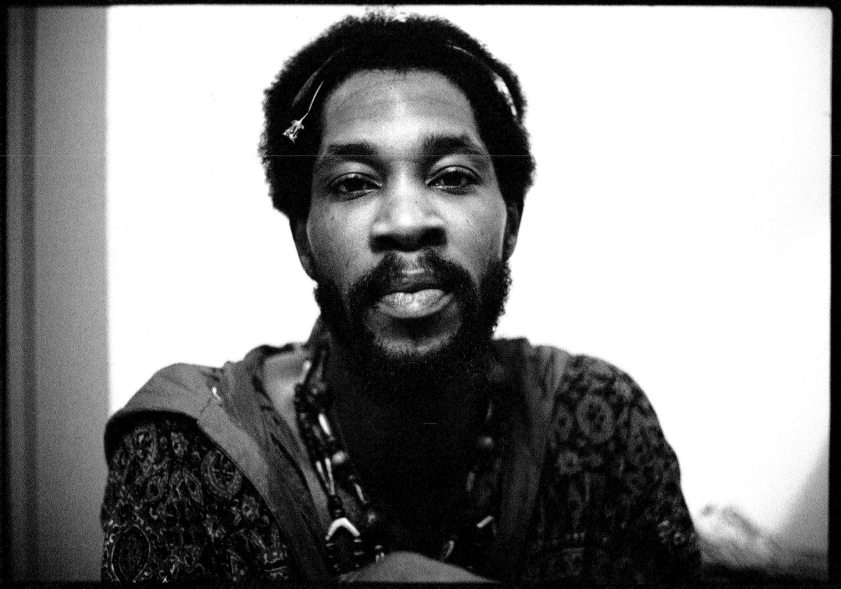

MANNU DIBANGO BAND MEMBER 1972 ©

Emmanuel N'Djoké Dibango, known as Manu Dibango (lower picture, facing page), introduced an early taste of World Music to New York's *In Concert* TV show back in 1972. That same year he became famous for what is often considered to be the first disco record, 'Soul Makossa'. Dibango was a Cameroonian saxophonist and vibraphone player who fused the traditional music of his homeland with jazz and funk. The accompanying portraits are of two of his band members from the *In Concert* broadcast.

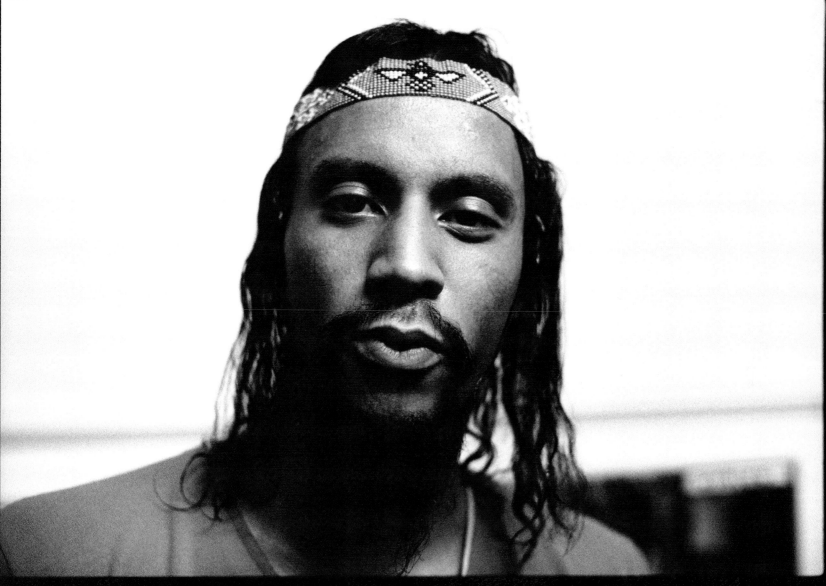

MANNU DIBANGO BAND MEMBER 1972 ©

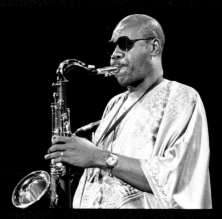

MANNU DIBANGO 1972 ©

Richie Havens, a festival luminary, was the man from Brooklyn who had opened the Woodstock Festival in 1969 with the legendary three-hour set that kick-started his career. The movie of the event increased his fame and Havens went on to be a virtuous and much honoured champion of America's musical heritage.

Notable at Woodstock for his conspicuous lack of teeth, he had managed to acquire and display some rather good ones by the time Wise took this

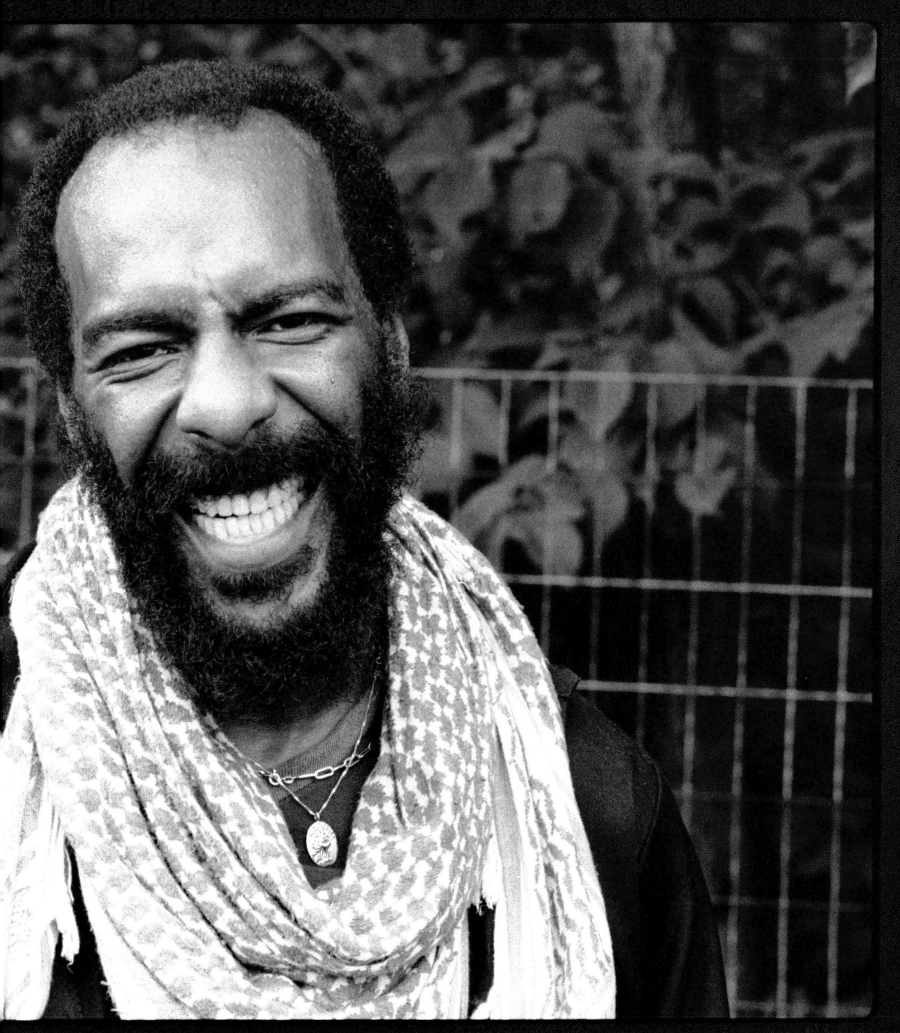

RICHIE HAVENS 1971 Ⓔ

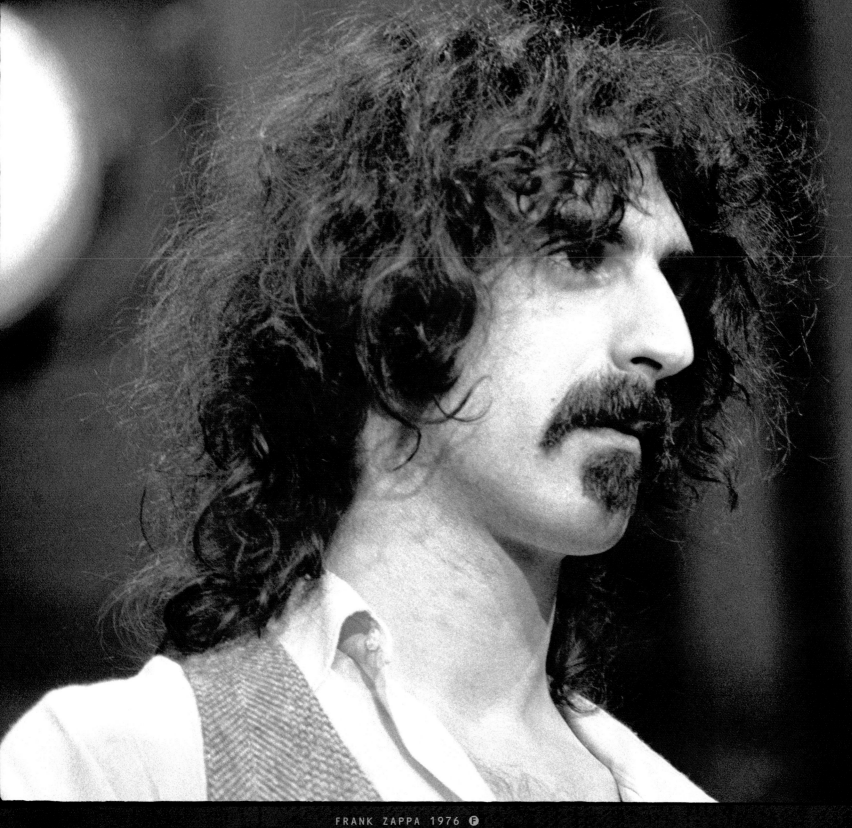

FRANK ZAPPA 1976 F

Frank Zappa, from Baltimore, was a musical force of nature who progressed from a fondness for percussion-driven *avant-garde* music to a bewildering variety of eclectic musical experiments that found early expression in the 1966 Zappa-led Mothers Of Invention album, *Freak Out!* Accordingly, festival-goers were never sure quite which Frank Zappa they were going to get: the rocker, the jazz musician, the classical performer, or the prodigious guitarist.

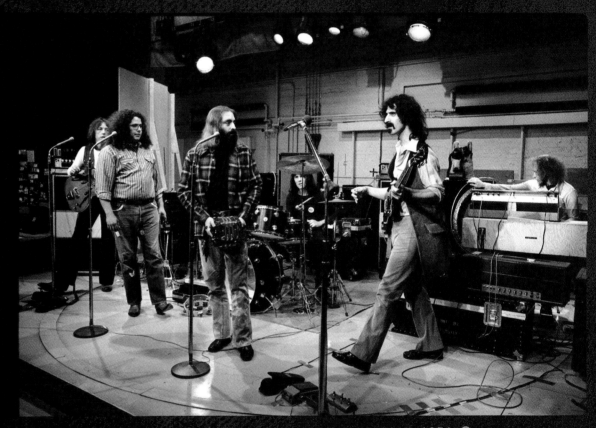

FRANK ZAPPA & THE MOTHERS OF INVENTION 1976 Ⓕ

JAMES TAYLOR 1971 Ⓖ

Two representatives of the quieter side of folk/rock were
James Taylor and Jackson Browne, their respective personalities
well represented in these portraits. Taylor was the quiet,
introspective and romantic singer/songwriter and Browne was
the heart-on-sleeve face of pacifism and political awareness.
Browne attended this 1972 Mariposa Festival not as a performer
but as a guest of his friend Joni Mitchell.

Both Taylor and Browne went on to enjoy long careers with

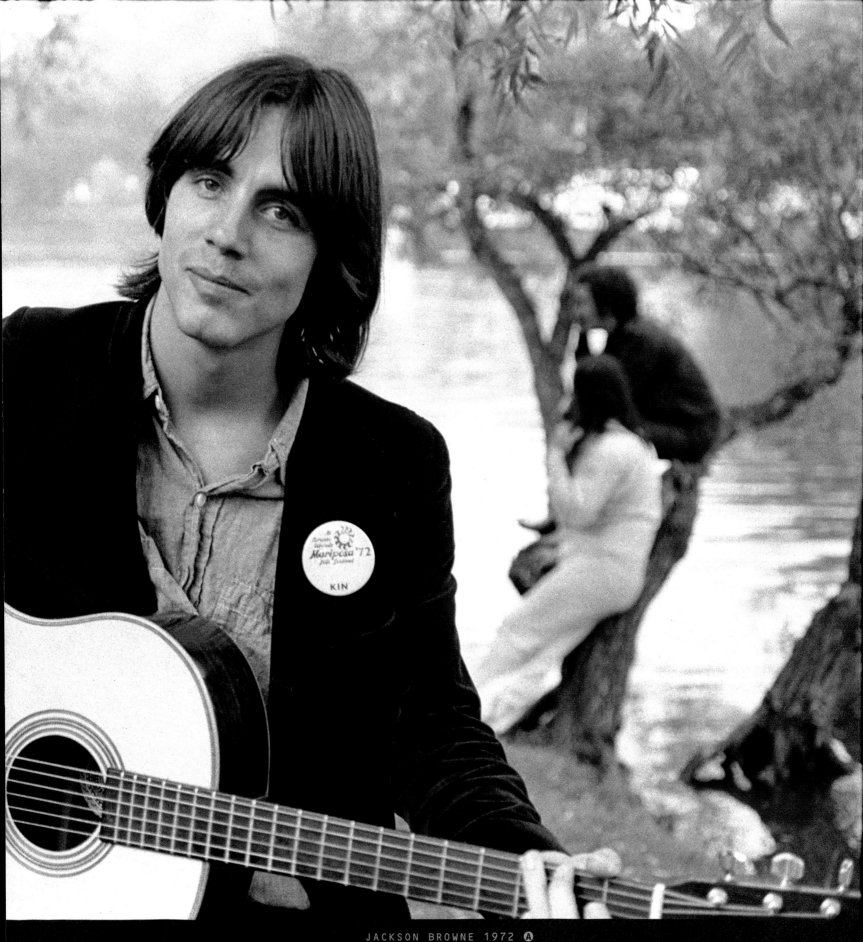

JACKSON BROWNE 1972 Ⓐ

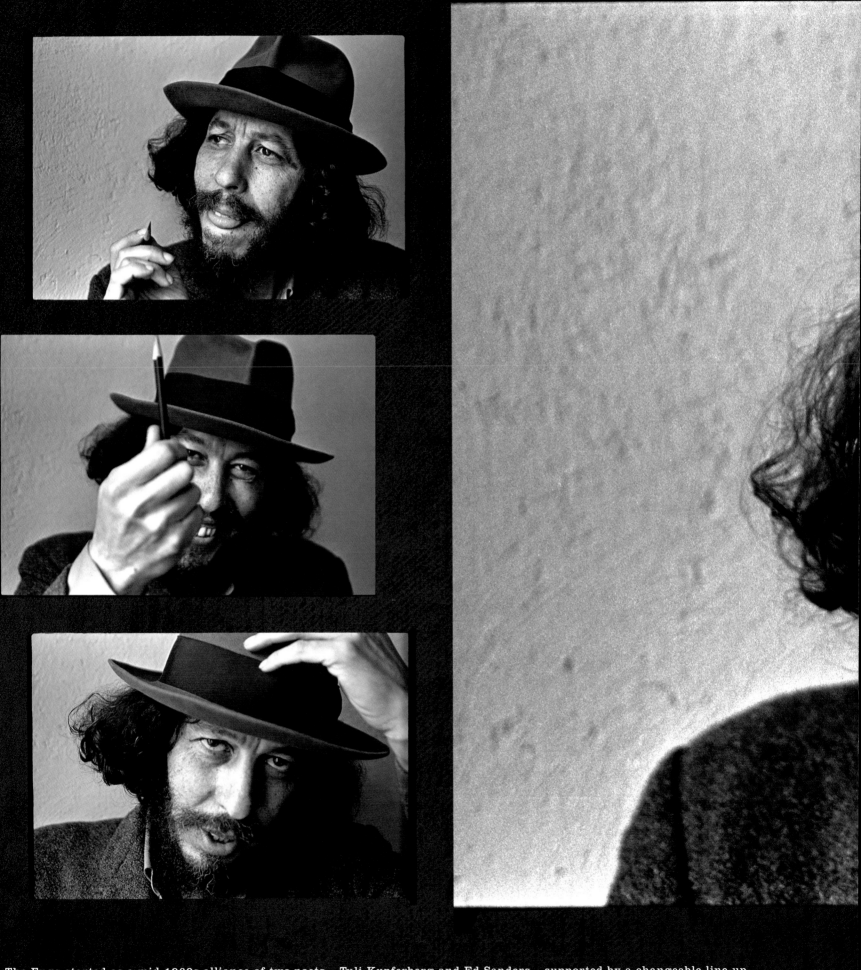

The Fugs started as a mid-1960s alliance of two poets – Tuli Kupferberg and Ed Sanders – supported by a changeable line-up of session and other musicians. Kupferberg became the most recognizable face of a band that was brazen about sex and drugs, and always took an iconoclastic approach to politics (their track 'CIA Man' was featured in The Coen Brothers' 2008 Washington DC - set black comedy *Burn After Reading*).

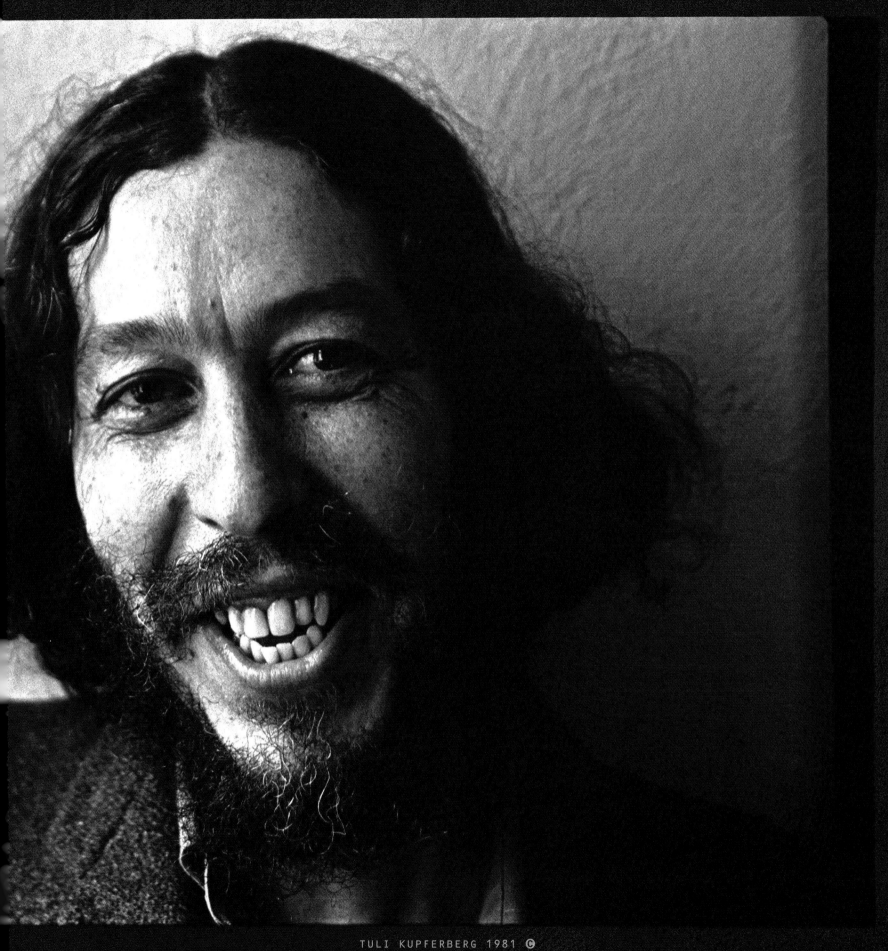

TULI KUPFERBERG 1981 Ⓒ

Having affinities with the spirit of the earlier Beat Generation they occasionally worked with Allen Ginsberg and maintained a counter-culture stance to the last, even decrying a 1984 re-staging of Woodstock as being 'too commercial'. They put on their own alternative event.

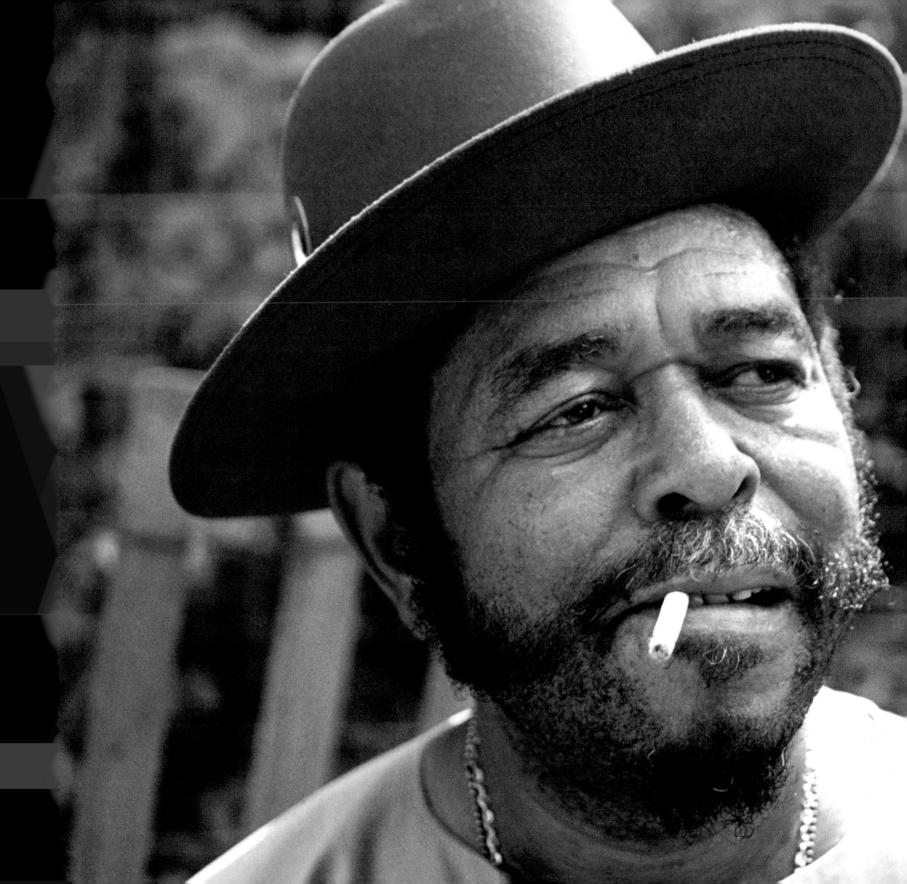

Juxtapositions of the old and the new were always part of the appeal of festivals, and quite often legendary bluesmen could suddenly be seen playing live by a generation that had believed them to be dead or at least consigned to music's remote past. The duo Sonny Terry and Brownie McGhee were a case in point. Brownie McGhee (left) from Knoxville, Tennessee, had started out with a homemade guitar made from a tin marshmallow box and a piece of board.

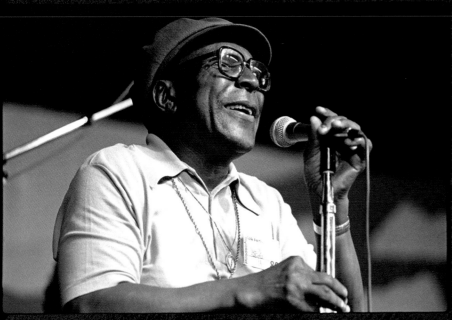

SONNY TERRY 1980 ⓑ

Blind harmonica player Sonny Terry (above and right) from
Greensboro, North Carolina, first worked with Brownie McGhee in
1939 when both played with Blind Boy Fuller. Reunited with McGhee
in New York Terry brought his distinctive staccato harmonica
accompaniment (plus whoops and hollers) to what would be a
long-standing musical act that eventually saw them playing as part
of the folk revival of the 1960s.

Fans unborn in 1942 were therefore able to witness the legends
playing together, McGhee stomping his foot and Terry playing a harp

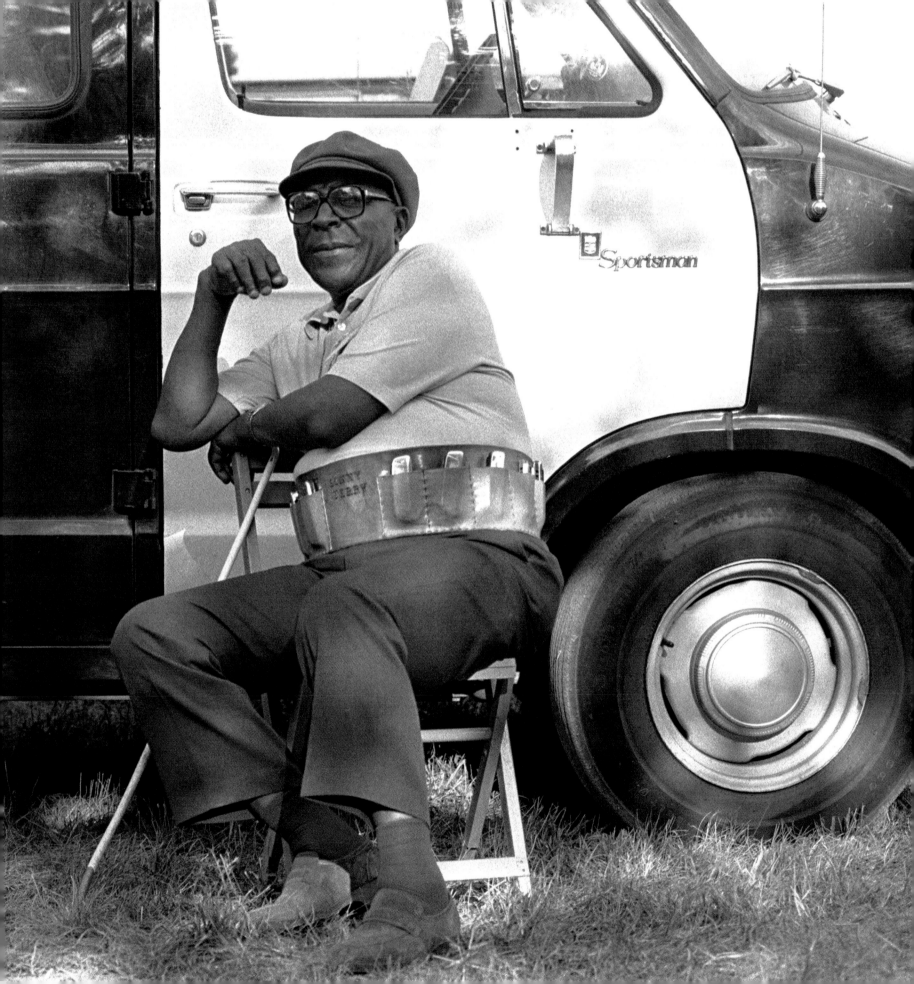

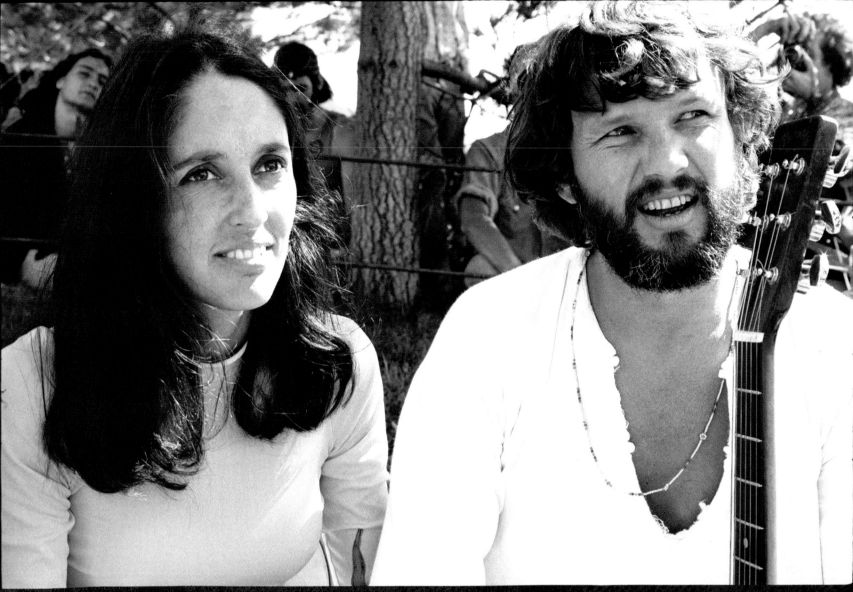

JOAN BAEZ & KRIS KRISTOFFERSON 1971 Ⓔ

Joan Baez and Kris Kristofferson make for a fascinating double portrait that reminds us that the counter-culture recruited from all kinds of people. The patrician Baez, of Scottish-Mexican parentage, possessed a penetratingly true soprano voice that she used to sing other people's folk songs about social injustice. Kristofferson possessed virtually no voice at all but wrote powerfully honest and sometimes ironic country songs about personal relationships; he had come out of a military career (in which he had excelled) before moving to Nashville to try to make it as a songwriter.

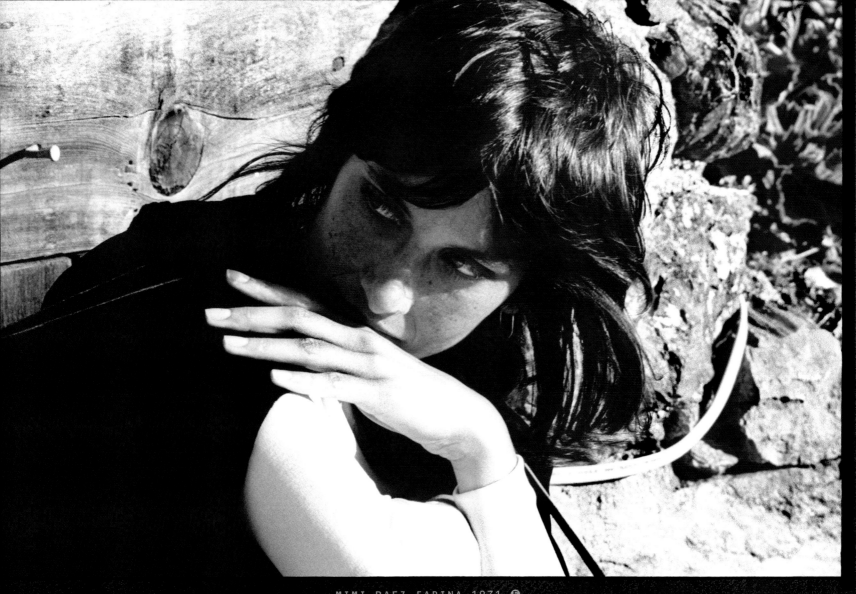

MIMI BAEZ FARINA 1971 Ⓔ

Joan Baez's sister Mimi married intellectual and Greenwich Village activist Richard Fariña in 1962 when she was still a teenager.

He was to die in a motorcycle accident just four years later – on Mimi's 21st birthday. In their short time together they often performed

as Richard and Mimi Fariña.

DAVID AMRAM 1974 Ⓑ

David Amram's multi-stranded musical career drew on folk and jazz influences and took him into everything from composing movie

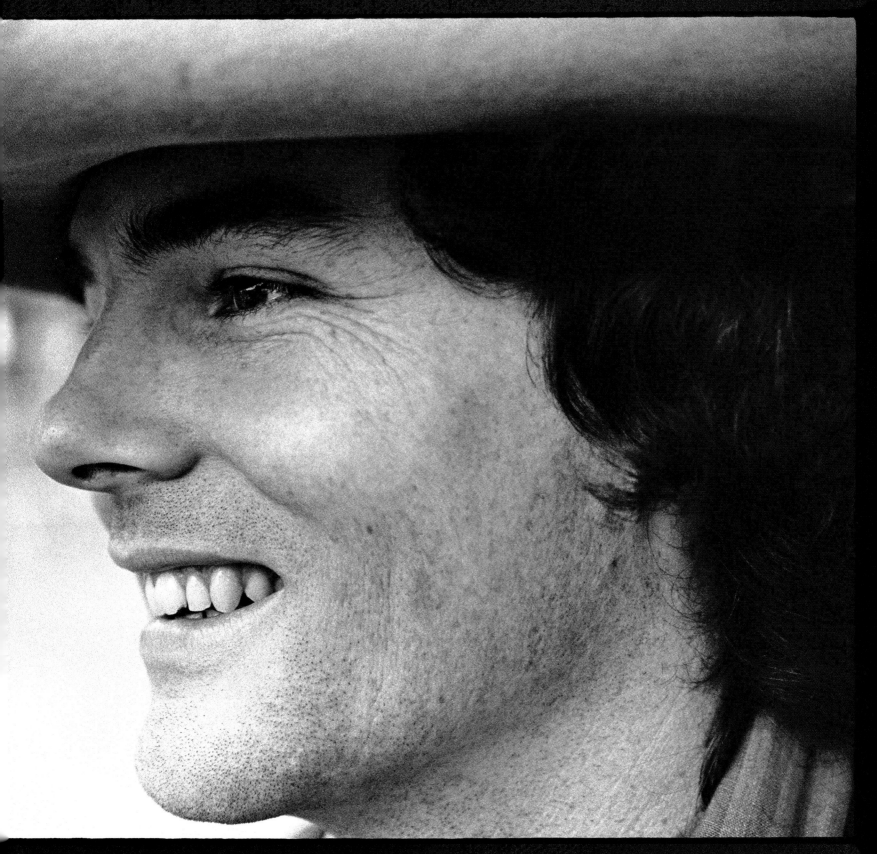

MICHAEL COONEY 1972 Ⓐ

The hot question among many folk artists in the 1960s and 1970s had to do with selling out. In the 1970s Michael Cooney,

a staple of many festivals, wrote a heartfelt piece about the dangers of fame and seemed happy enough to avoid those dangers himself.

He travelled widely through North America and Europe as a working folksinger and raconteur, before finally settling in Maine

and continues to sing for the fans while displaying his legendary good humor and a wealth of knowledge about the traditional music

he loved. *The New York Post* called him 'a one-man folk festival'.

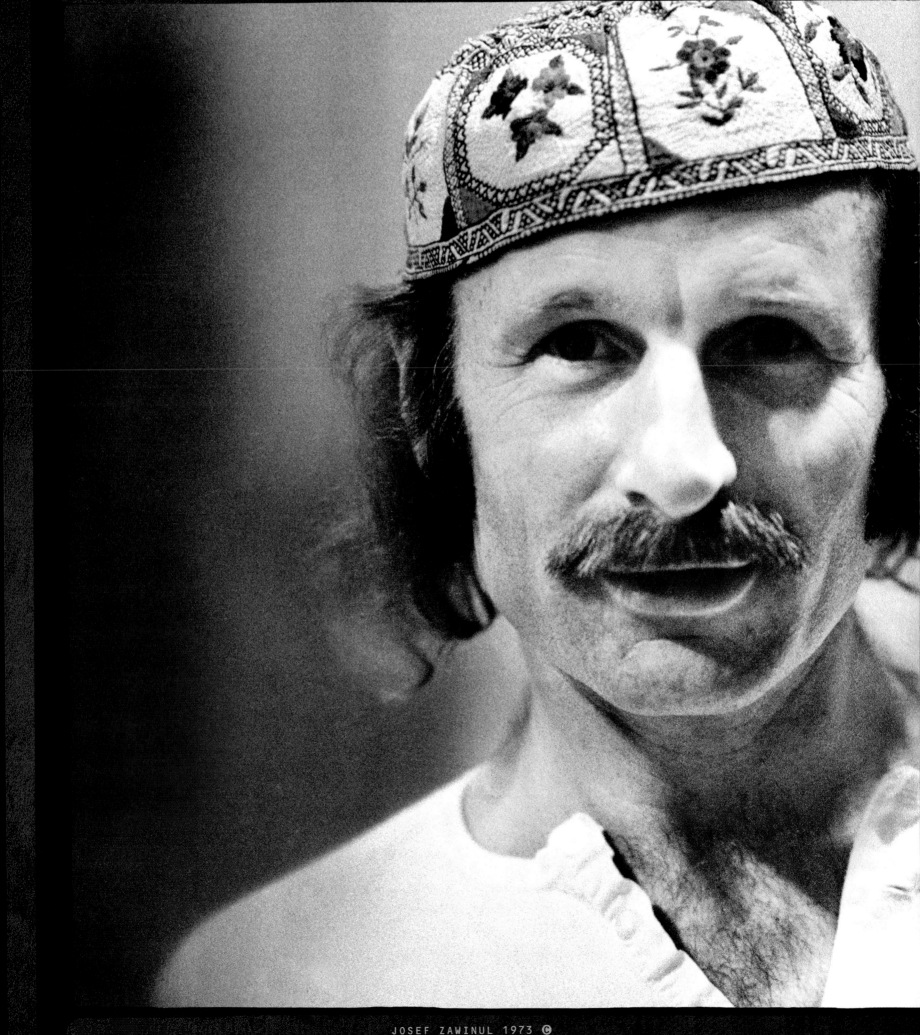

Austrian Josef Zawinul was a co-founder
of Weather Report, an influential jazz fusion
band of the 1970s and early 1980s that
combined jazz and Latin sounds with ethnic
music, R&B, funk and rock.

Known as Zolie, Zawinul was an innovative
keyboard player and a driving force in
the band. It was largely him who drove
Weather Report to experiment and produce
what was widely hailed as a classic fourth
album, *Mysterious Traveller*.

Many luminaries passed through the
band before Weather Report's dissolution
in the mid-1980s, one notable being

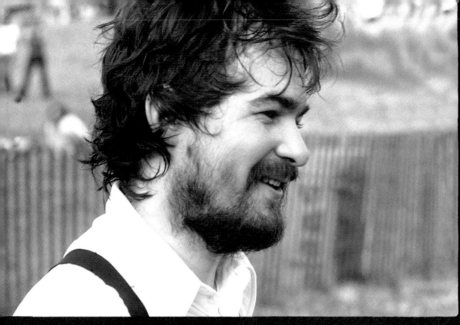

JOHN PRINE 1974 Ⓑ

John Prine, once optimistically cast as 'the new Dylan' by his record company, soon subverted that idea with his self-deprecating style and irrepressible goofy humor. Despite this he wrote and sang some haunting songs. His 'Paradise' virtually became a theme for the outrage that greeted the obliteration of whole Kentucky communities in the name of mining.

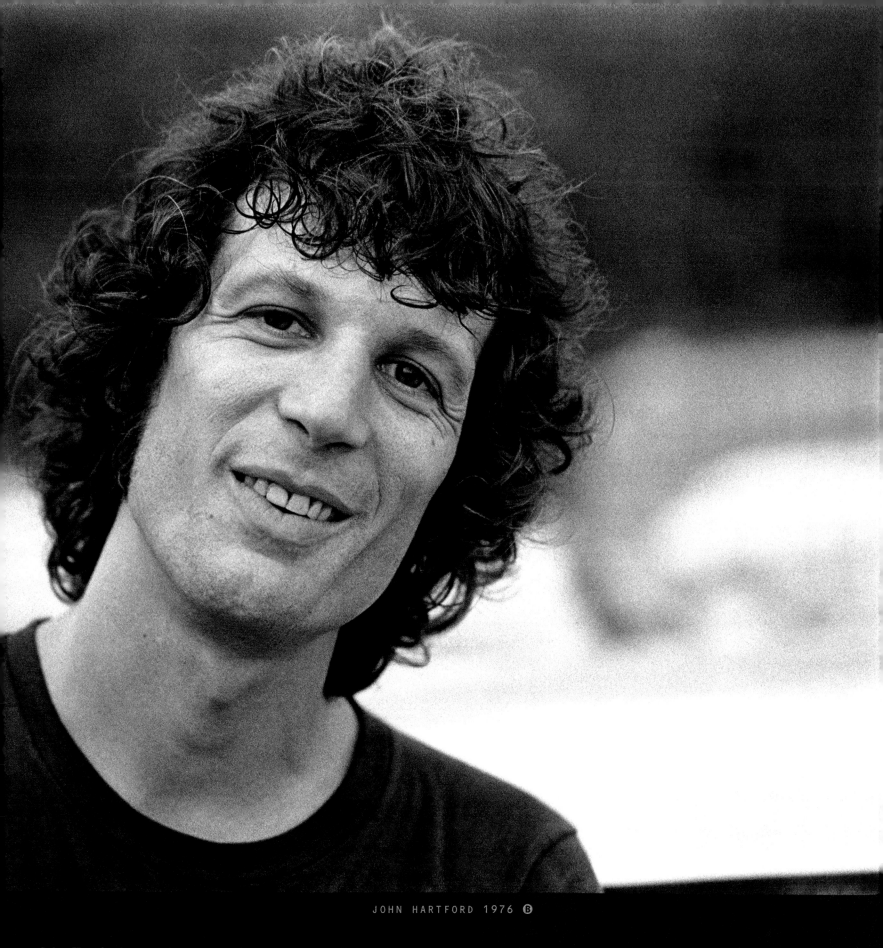

JOHN HARTFORD 1976 Ⓑ

John Hartford, musician, songwriter, steamboat pilot, author, artist, disc jockey, dancer and a dedicated folklorist, was a complex character. The writer of the hit 'Gentle On My Mind' Hartford happily flirted with show business but always retained a seriousness of purpose until the end of his life. One of his final appearances was as emcee at Nashville's Ryman Auditorium for the 'Down From The Mountain' concert organized by Joel and Ethan Coen to complement their movie *Brother Where Art Thou?*

This informal New York rooftop party portrait of a very young-looking Steve Winwood dates from 1970 at about the time he was playing with Blind Faith, soon to become the short-lived Ginger Baker's Airforce.

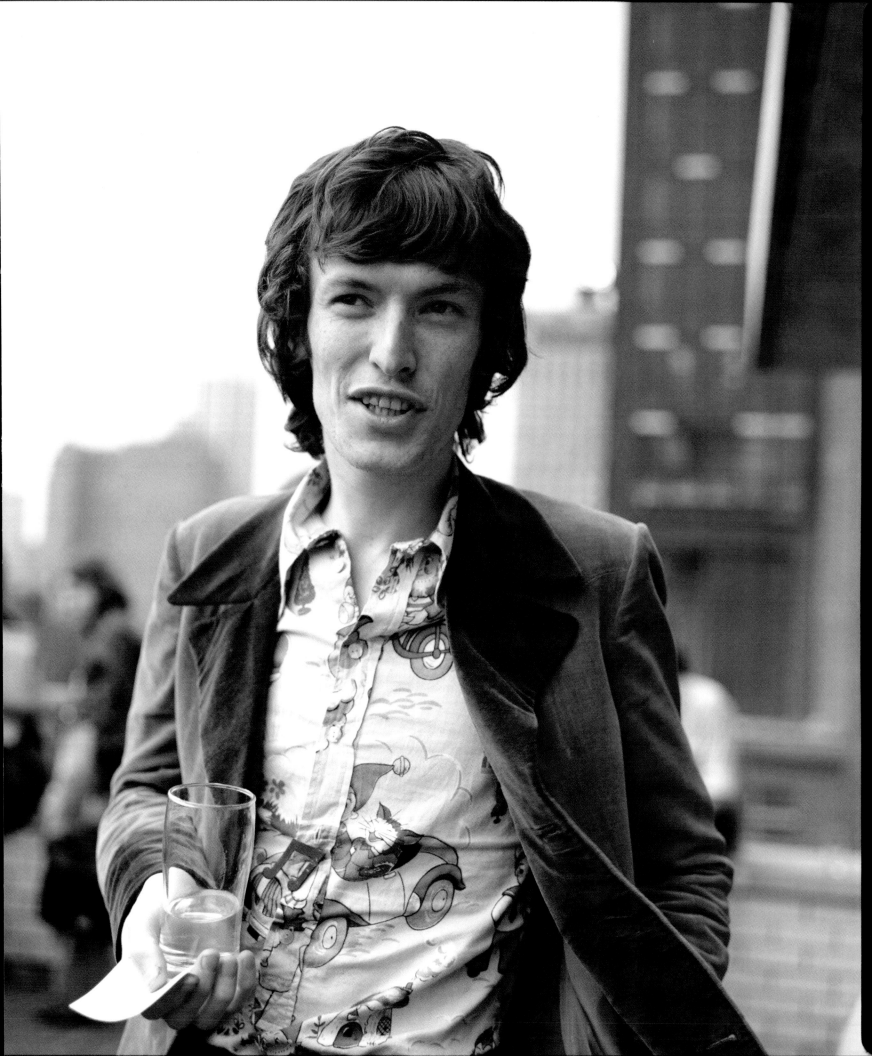

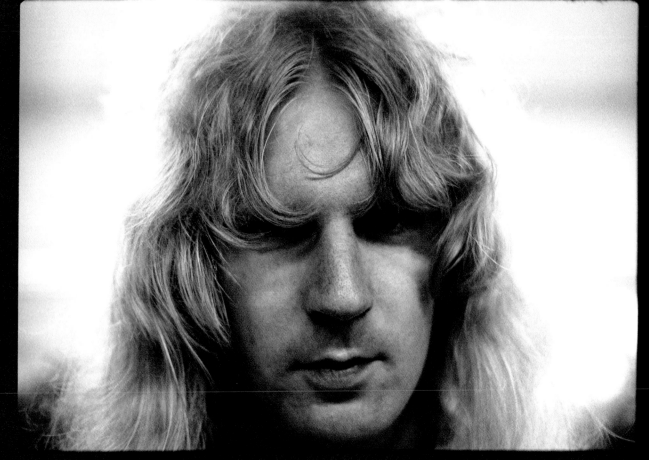

ARTHUR 'KILLER' KANE 1973 ©

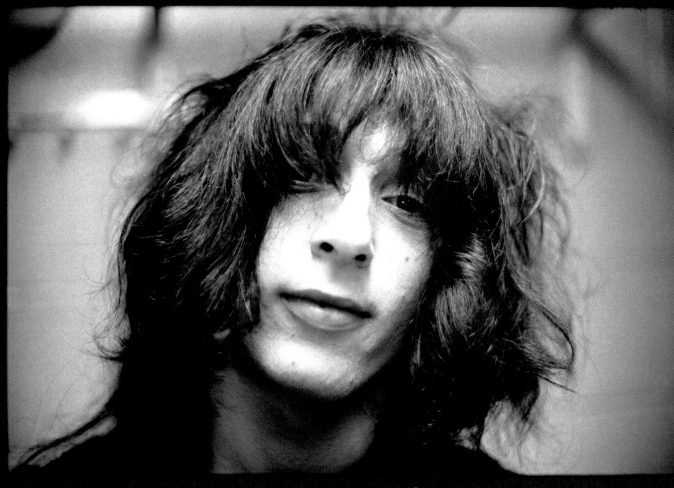

JOHNNY THUNDERS 1973 ©

Four particularly successful portraits show the individual members of the original New York Dolls, each here given his due rather than being featured as part of a Dolls tableau. They were the proto-punks who paved the way for bands like Ramones, Blondie, Television and Talking Heads. Singer David Johansen also achieved solo fame under the name Buster Poindexter.

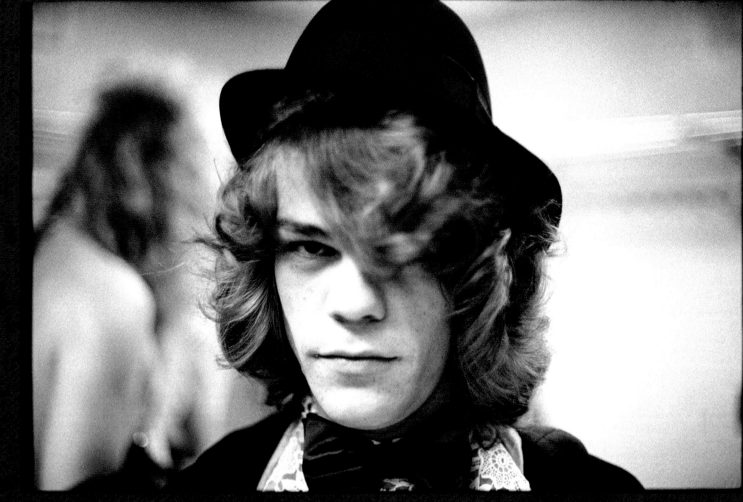

DAVID JOHANSEN 1973 ©

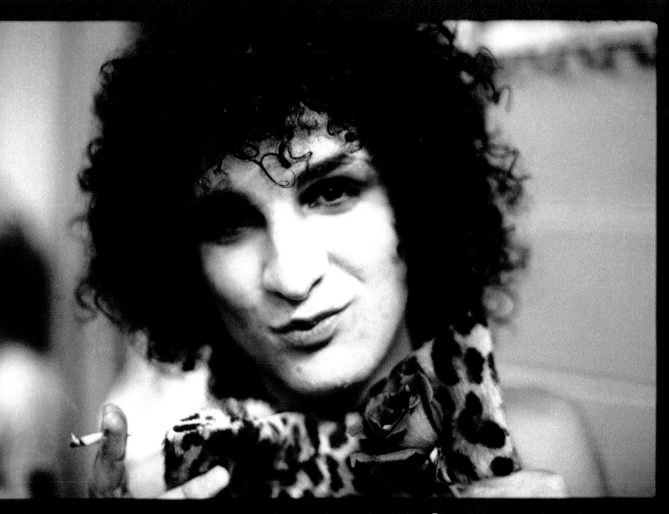

SILVAIN SILVAIN 1973 ©

Mississippi-born John Lee Hooker was a true blues innovator, developing his own idiosyncratic style of talking blues and a rolling guitar style reminiscent of boogie piano.

He spent the 1930s in Memphis, Tennessee and later gravitated to Detroit, Michigan where he acquired an electric guitar to cut through the noise of the rowdy East Side clubs.

His first record was in 1948, but many of his greatest fans were recruited in the 1960s when, playing solo at festivals and other venues, he extended his appeal to young blues and folk enthusiasts as well as to wider white audiences.

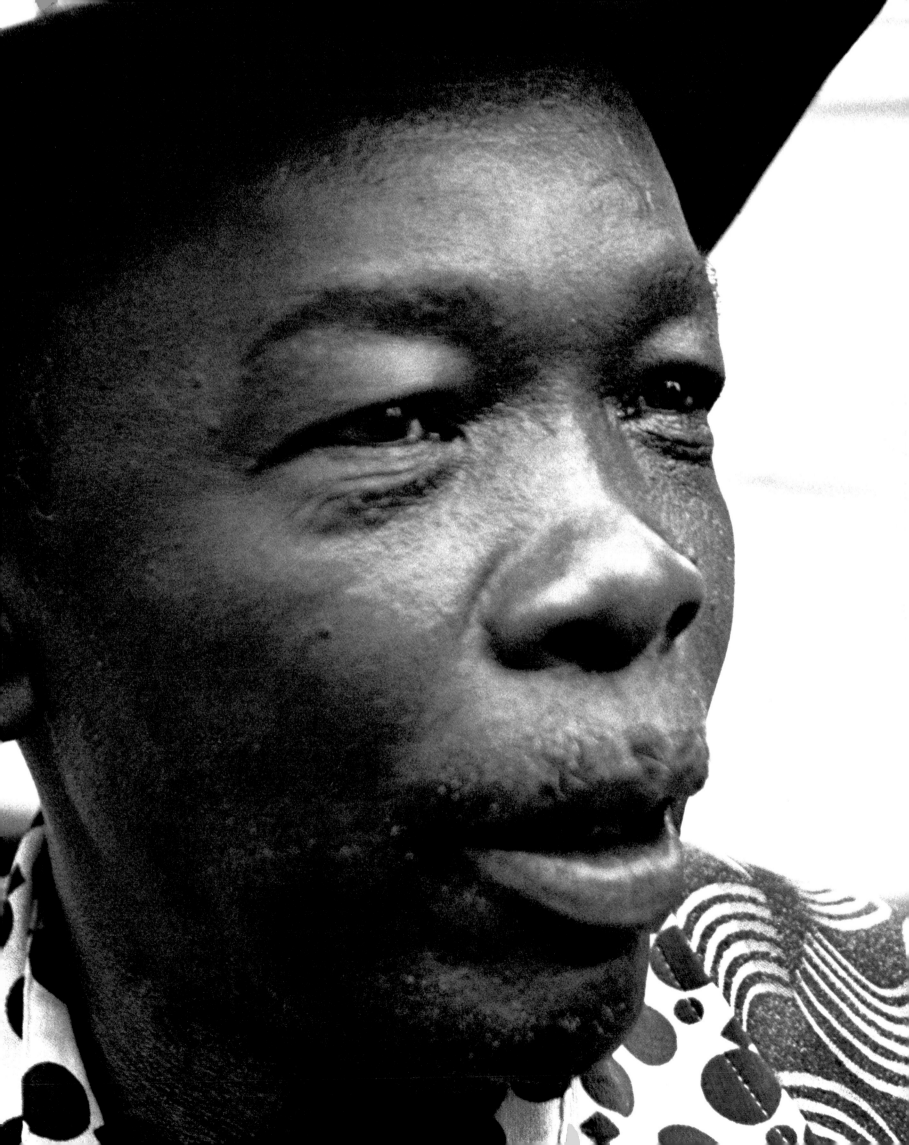

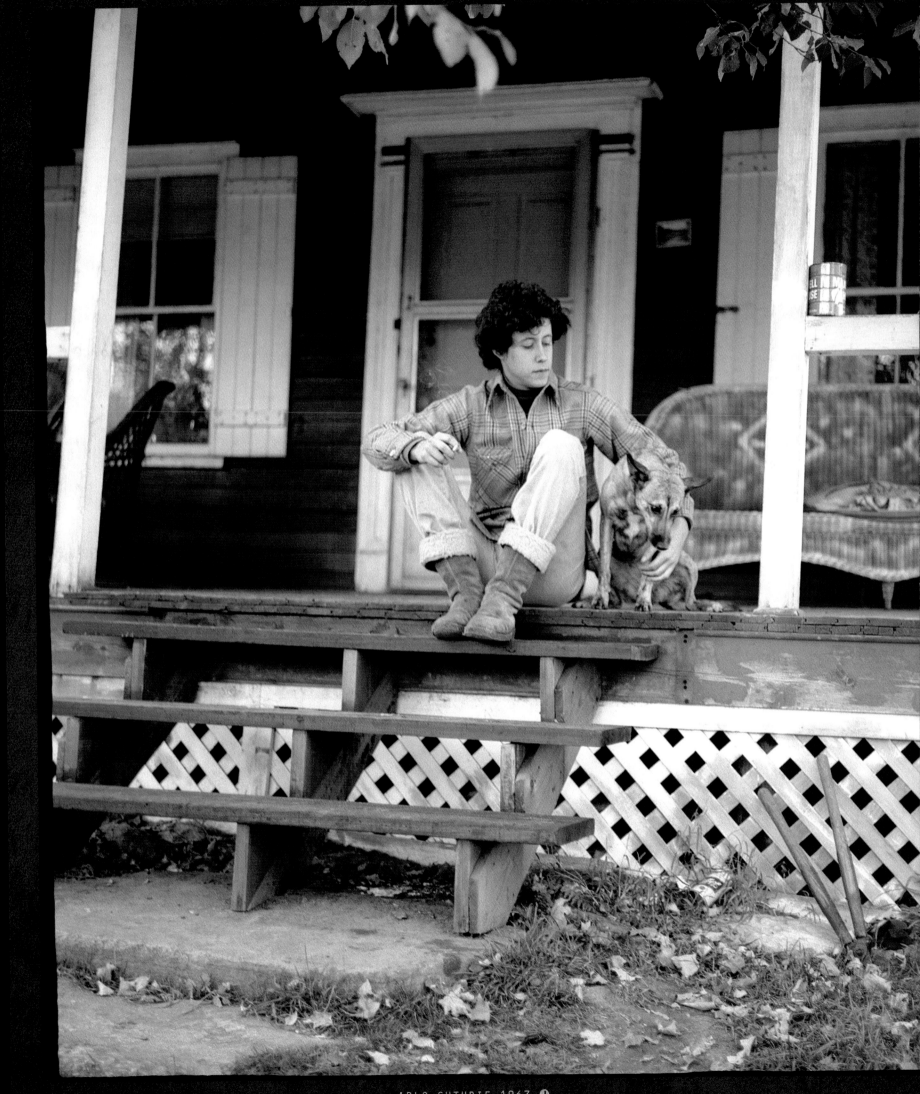

ARLO GUTHRIE 1967 Ⓙ

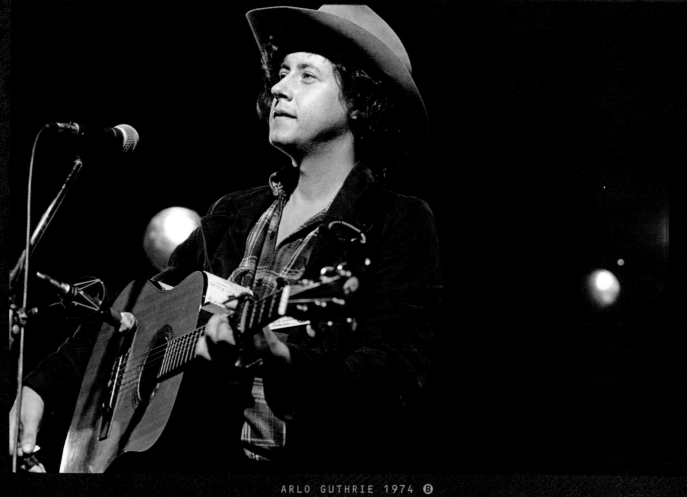

ARLO GUTHRIE 1974 Ⓑ

Arlo Guthrie, son of the legendary Woody, made his name with a discursive 18-minute talking blues,
'Alice's Restaurant Massacree' in 1967. His whimsical account of how, as an eighteen-year-old,
he was convicted of littering (thereby becoming ineligible to be sent to Vietnam when conscription time came)
was later turned into a movie directed by Arthur Penn. In 1972 Guthrie had a hit with Steve Goodman's
train song 'City Of New Orleans' and he has since enjoyed a long career, frequently singing songs of protest
against social injustice.

JOHNNY SHINES 1975 Ⓐ

A blues hero in his own right, Johnny Shines was also a living link with 'the father of the blues', Robert Johnson. Shines was born in Tennessee where he learned to play slide guitar at an early age. Moving to Arkansas in 1932 he undertook agricultural work for three years until a chance meeting with Johnson. Shines was seventeen and Johnson probably a couple of years older.

From 1935 to 1937 Shines and Johnson travelled together, singing and playing, from the American south up to Canada. 'Robert was a very friendly person' Shines attested, 'even though he was sulky at times, you know. And I hung around Robert for quite a while. He was kind of peculiar fellow. Robert'd be standing up playing some place, playing like nobody's business... and money'd be coming from all directions. But Robert'd just pick up and walk off and leave you standing there playing. And you wouldn't see Robert no more maybe in two or three weeks...'

JOHNNY SHINES 1975 Ⓑ

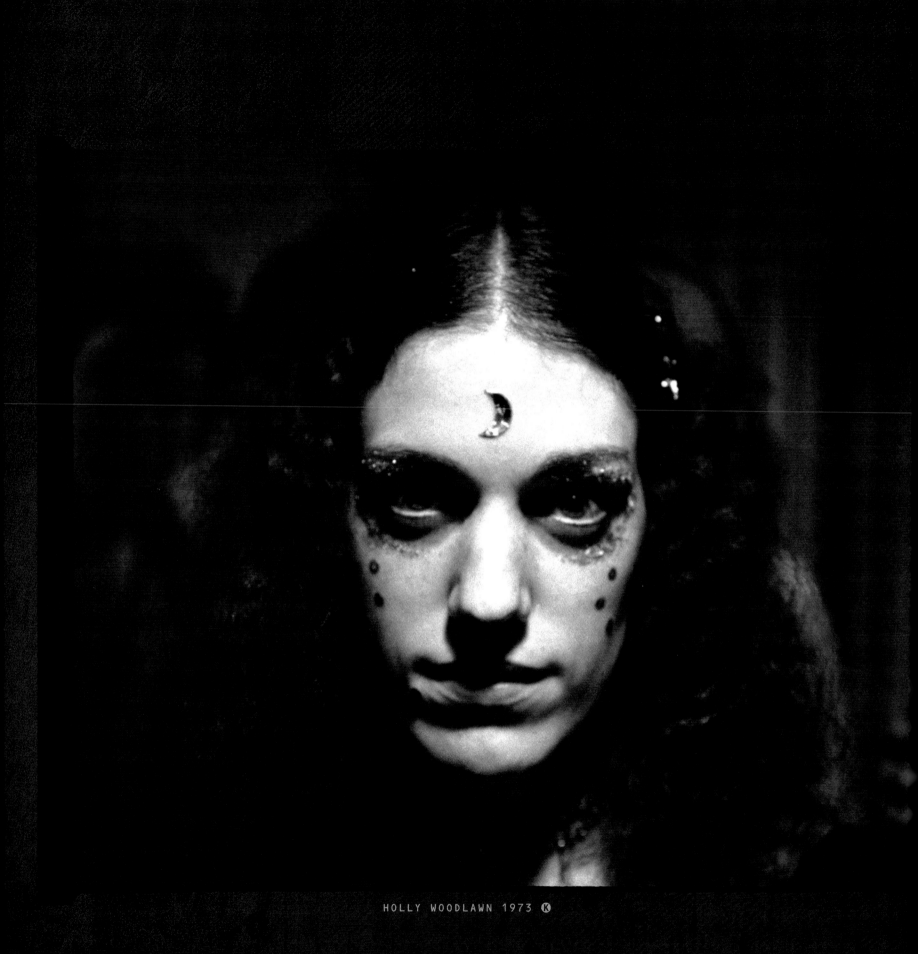

HOLLY WOODLAWN 1973 Ⓚ

Holly Woodlawn, Candy Darling and Divine (aka Haroldo Danhakl, James Slattery and Harris Millstead respectively) were gender-bender friends of Lou Reed. Holly and Candy were transsexuals but Divine was the drag persona of an accomplished singer, performer and mainstay of John Waters films.

Haroldo got a memorable name check in Reed's 'Walk On The Wild Side': 'Holly came from Miami FLA/hitch-hiked her way across the USA/plucked her eyebrows on the way/shaved her legs, and then he was a she...'

CANDY DARLING 1973 K

DIVINE 1973 K

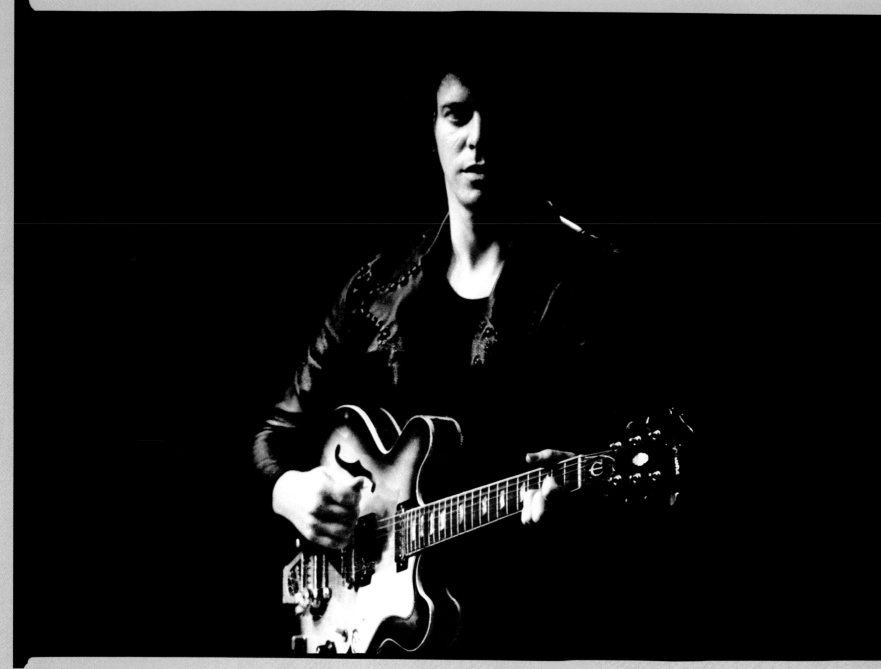

LOU REED 1973 Ⓚ

PERFORMANCE

Stage performances often involve the spotlight isolating an artist against an ink-black background. By contrast, open-air festivals can make performers look more accessible. In both cases a good photograph brings its own point of view to the prevailing look of the performance.

Here a dramatically-lit Lou Reed performs at Lincoln Center, the year after the release of *Transformer*, the famous album that featured 'Walk On The Wild Side'.

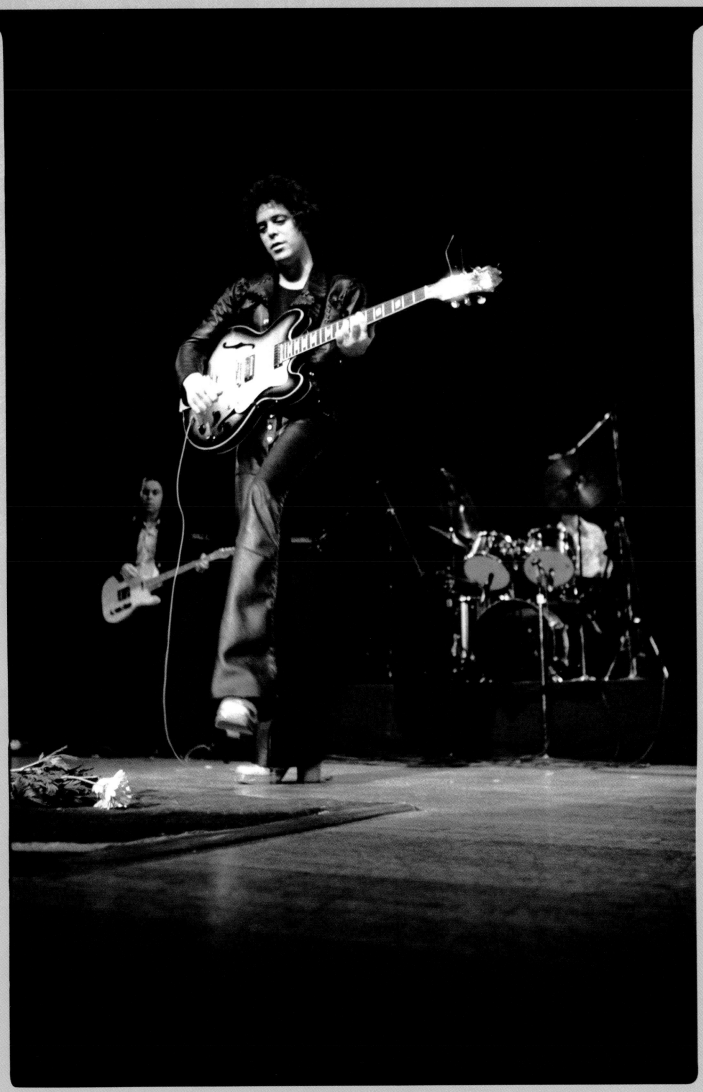

LOU REED 1973

By 1972 Ray Charles was a fully-fledged musical legend. A prolific recording artist, his milestone albums were *The Genius Of Ray Charles* (1959) and *Modern Sounds In Country & Western Music* (1962) that expanded his soul innovations and illustrated his career-long willingness to tackle any popular music form and give it the unmistakeable Ray Charles touch.

At the time of this concert his current albums were reflecting Charles's interest in reworking jazz classics.

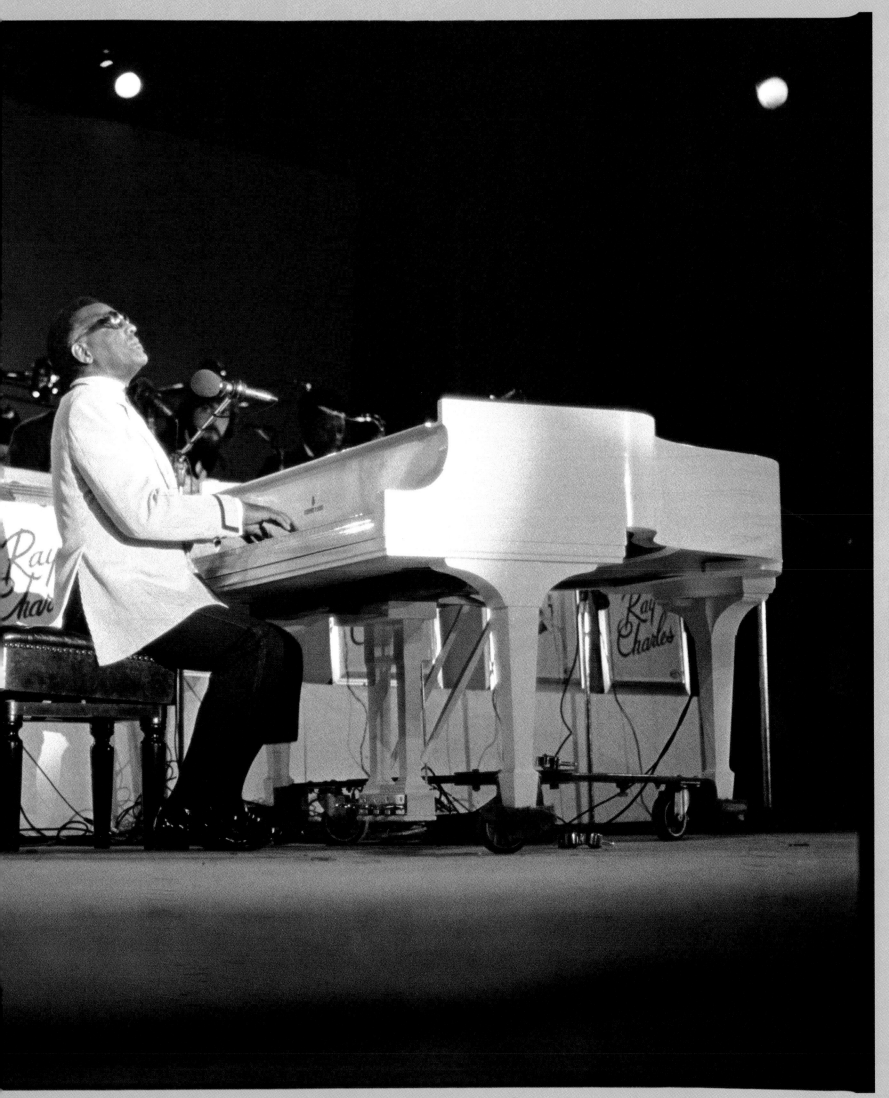

Blondie, a New York band that owed a debt to both The New York Dolls and the girl groups of the 1960s, was formed in 1974 and its punk-with-melody style was embodied by vocalist Deborah Harry. She became the focus of the band, half glamour girl/half punk, an approach reflected in her schizophrenic hairstyle which was Monroe-blonde at the front, brunette at the back. Gradually, in the public's mind, the 'blondie' label attached itself to her rather than the group, making the Florida-born singer a 1970s pop icon, a glamorous figure with attitude and the band's living, breathing logo. After the serious sixties she and they reminded everyone just how exhilarating pure pop could be if you did it right.

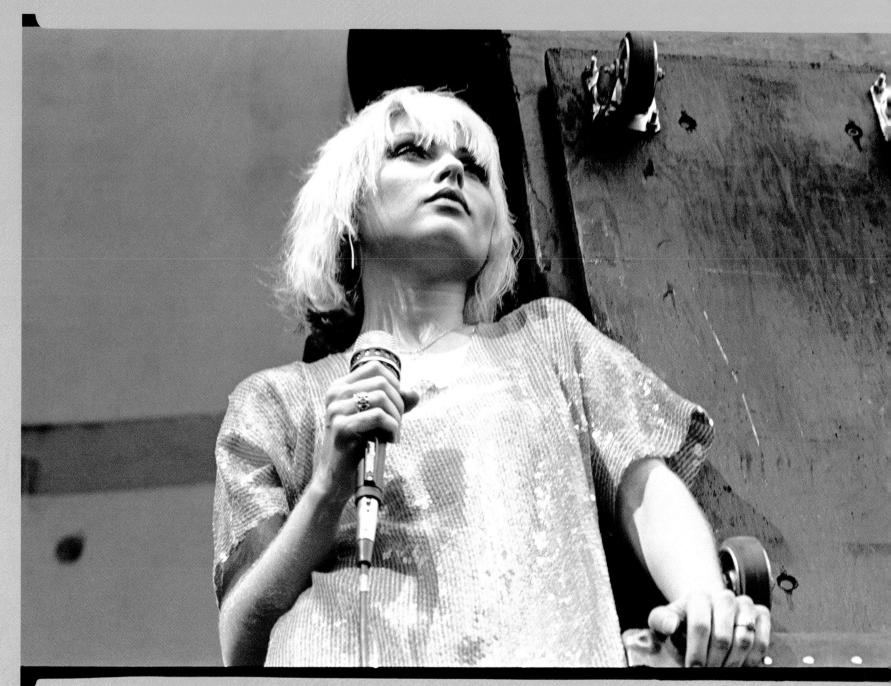

DEBBIE HARRY 1979 Ⓛ

Another champion of pop was the dazzling Welsh guitarist Dave Edmunds, a one-man rock'n'roll champion who followed his 1960s career as the lead guitarist of Love Sculpture with a back-to-basics approach through his band Rockpile and his own recording studio, Rockfield. In recreating some of the 1950s records he loved, Edmunds showed he was a master producer as well as a fine instrumentalist. John Lennon nominated Edmunds' hit version of Smiley Lewis' 'I Hear You Knocking' as a favorite record.

Bassist Nick Lowe formed a creative partnership with Edmunds and was also a co-founder of Rockpile. A quirky talent, Lowe played with and produced many bands and was married for a while to Carlene Carter, the daughter of June Carter and Carl Smith. This gave him a familial relationship with Johnny Cash, and Lowe, along with Elvis Costello, hung out with Cash from time to time in the early 1980s, even writing a song for him, 'The Beast In Me'.

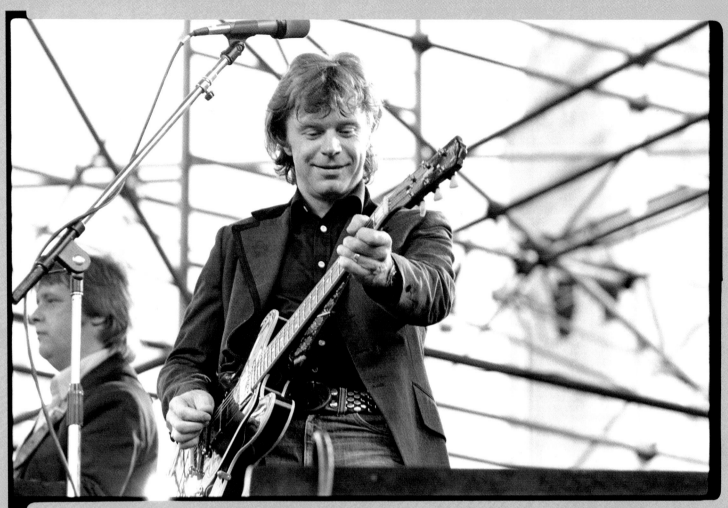

DAVE EDMUNDS 1979 Ⓛ

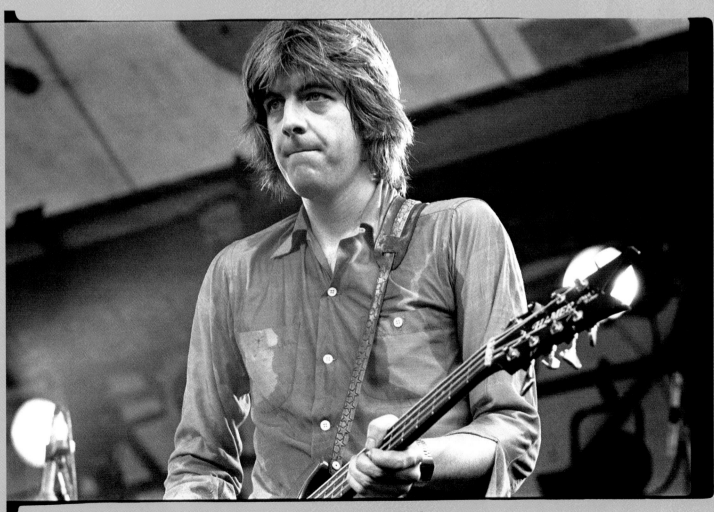

NICK LOWE 1979 Ⓛ

Arizona-born Charlie Mingus was
a supremely gifted musician and
composer whose jazz roots propelled
him into composing complex pieces
that, to begin with, often defied
interpretation by any band that was
not under his direction.

Mingus was a gifted bass player but
his outstanding skill was for finding
other musicians who could interact
with one another in the sort of complex
collective improvisation he loved.

His uncompromising work ultimately
defied categorization and eventually
led to his recognition as a truly great
20th century American musician
who could not be defined in terms of
any pre-existing genre.

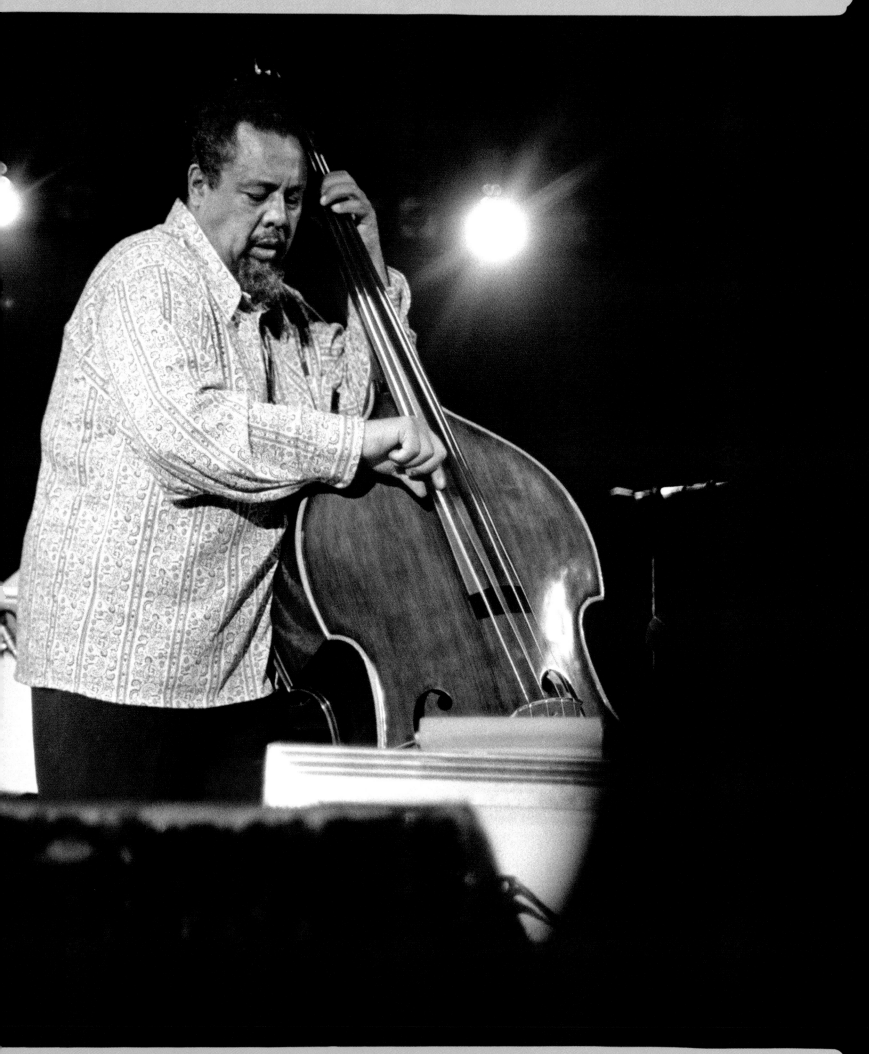

CHARLIE MINGUS 1973 ❶

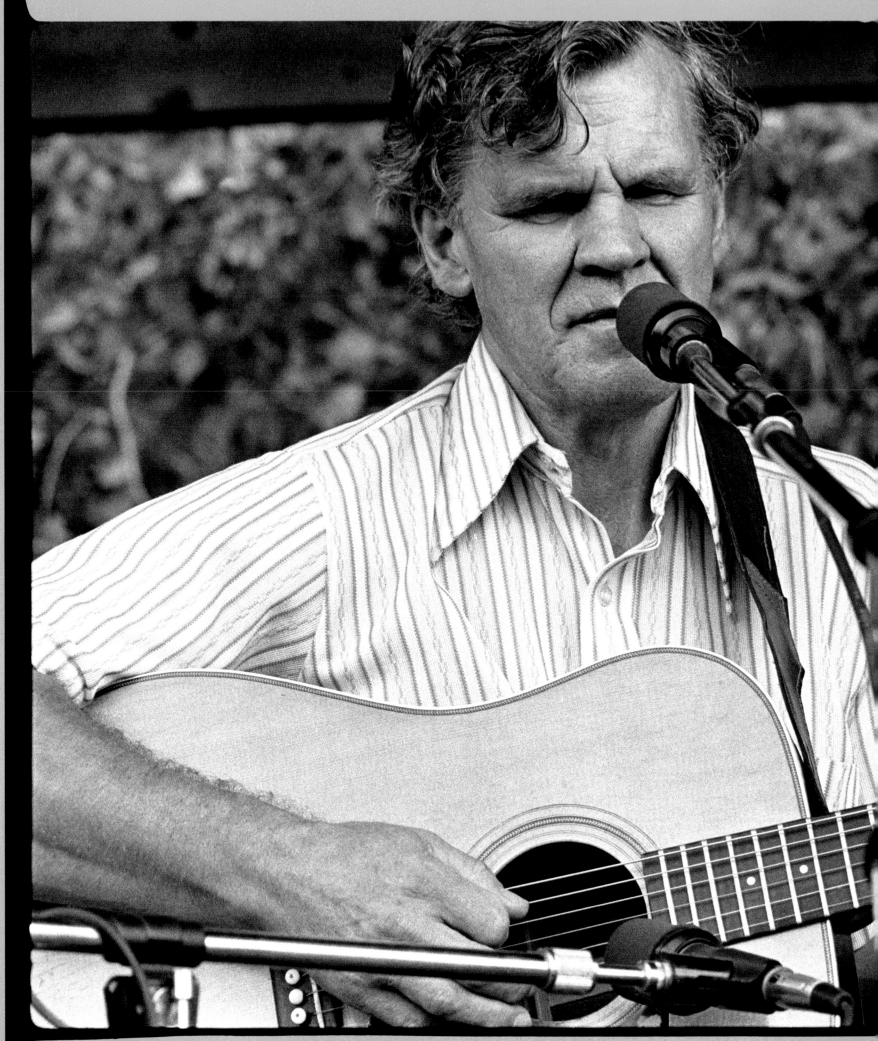

DOC WATSON 1980 Ⓑ

Arthel 'Doc' Watson, born in
North Carolina in 1923, became a highly
accomplished guitarist as a teenager,
often using an electric Les Paul
instrument when he played with various
regional bands.

However his greatest fame came
with the folk revival in the 60s when he
concentrated on acoustic guitar and
banjo and gradually became a repository
for hundreds of old timey North Carolina
songs which he sang in a rich baritone
while accompanying himself.

A tireless performer, he went on to play
with and influence many other guitarists
and bands over the years.

'Doc' Watson impressed as an unfailingly
charming and modest man, a festival
favorite and eventually one of American
folk music's elder statesmen.

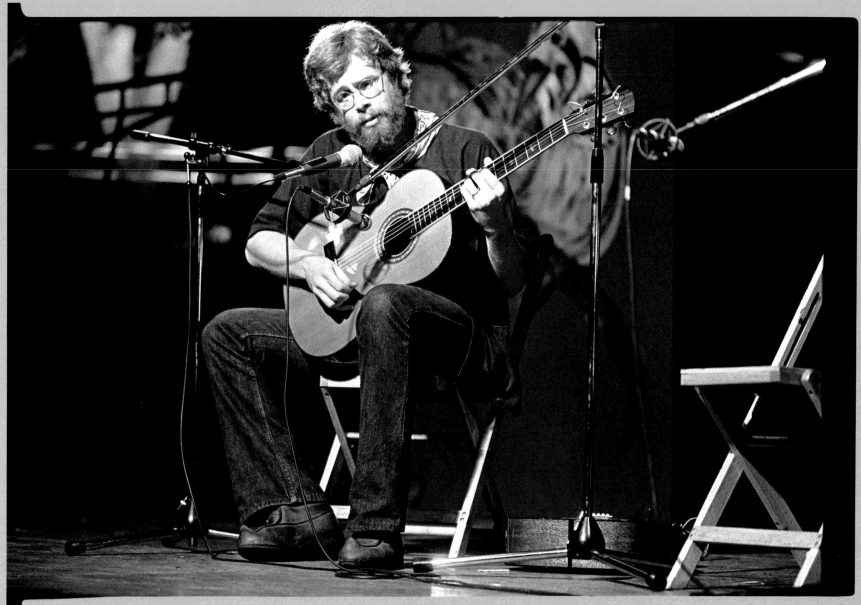

BRUCE COCKBURN 1974 Ⓑ

Canadian folksinger Bruce Cockburn made his first solo appearance at the Mariposa Festival in 1969. From local hero he gradually became well-known in the US and, in the 1980s, globally through his tireless political activism and his love for world music. In 1998, he travelled with filmmaker Robert Lang to Mali where he played with blues musician Ali Farka Toure and kora master Toumani Diabate. The documentary film *River Of Sand* records their trip.

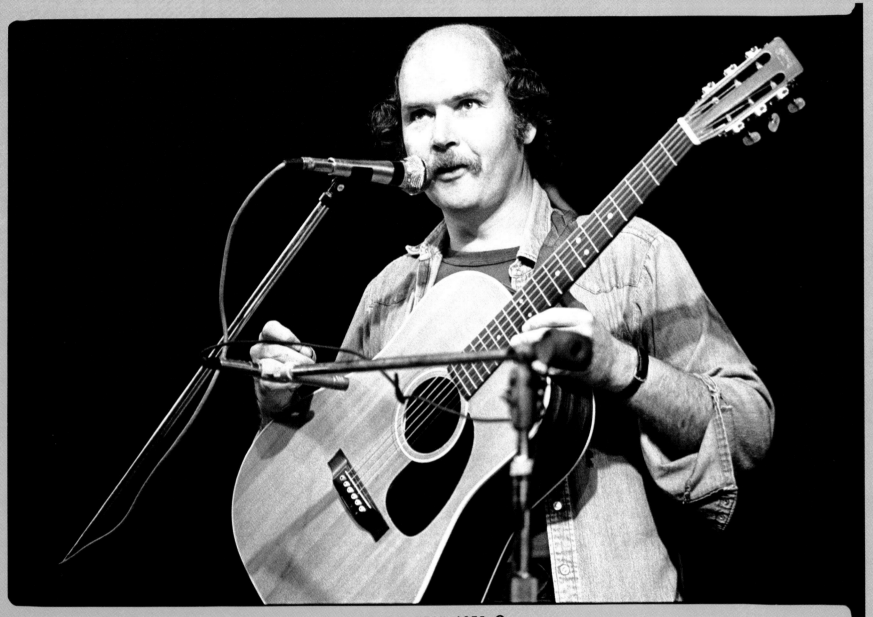

TOM PAXTON 1975 Ⓐ

Folk singer Tom Paxton has always managed to interlace his trenchant political songs with witty comic numbers and the occasional affecting love song. His biggest success, 'The Last Thing On My Mind', was a hit for Dolly Parton and has become a classic, but his festival favourites were usually his short shelf-life satirical topical numbers like 'Lyndon Johnson Told The Nation' as well as his more enduring social broadsides. Dave Van Ronk identifies Paxton, not Dylan, as the performer who actually started the Greenwich Village folk scene with his impressive catalogue of self-penned songs.

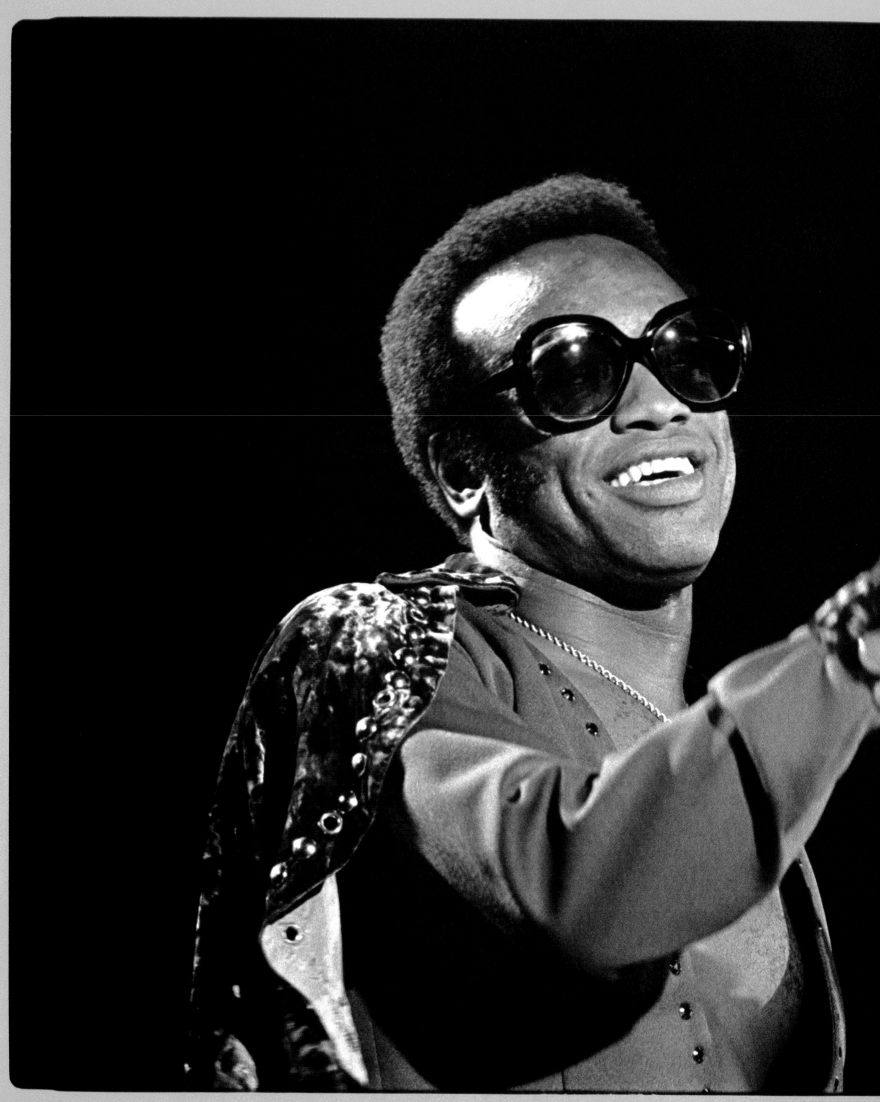

BOBBY WOMACK 1973 ©

Bobby Womack started out
with his four brothers as a
gospel act that was renamed
The Valentinos when they
joined Sam Cooke's SAR label in
the early 1960s with a view to
recording secular material.

Their second single for SAR,
'It's All Over Now' written by
Bobby, proved a big earner when
it was covered by The Rolling
Stones.

When Cooke died Womack
first worked as a sideman and
songwriter but by the time
this picture was taken his solo
career had taken off.

He flourished professionally
until the end of the 1970s and
despite something of a comeback
in Europe, his final hit came
in 1985.

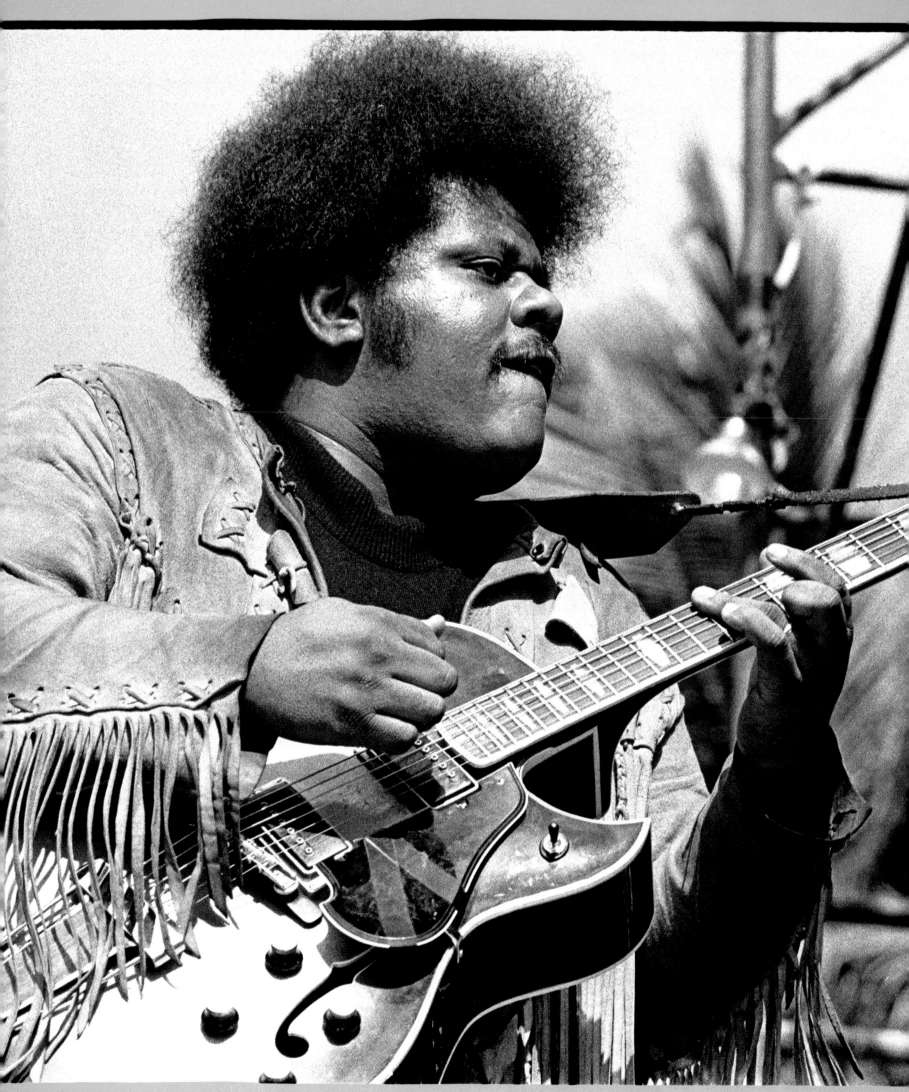

SONNY SHARROCK 1972 Ⓜ

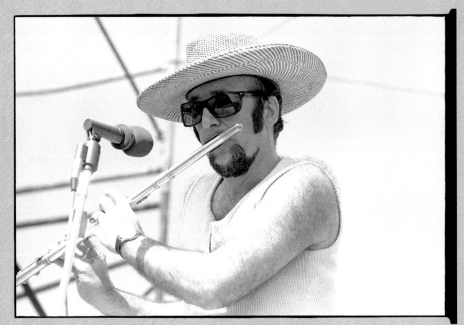

HERBIE MANN 1972 Ⓜ

DUANE ALLMAN 1972 Ⓜ

Sonny Sharrock began his musical career singing doo wop, then became a notable pioneering guitarist in the free jazz movement of the 1960s. He made several appearances with flutist Herbie Mann, as did Duane Allman, co-founder of The Allman Brothers Band.

Felix Pappalardi and Leslie West were the co-founders of Mountain, a Cream-influenced outfit that was named after the title of a solo album Pappalardi had produced for West. Formed in the same year as Woodstock, Mountain played their fourth gig at that festival. They then broke up only to reform in 1973.

The on/off partnership between Pappalardi and West ended when Pappalardi's wife shot her husband dead in 1983.

West and Mountain drummer Corky Laing subsequently formed a duo and continue to tour and record with various other musicians.

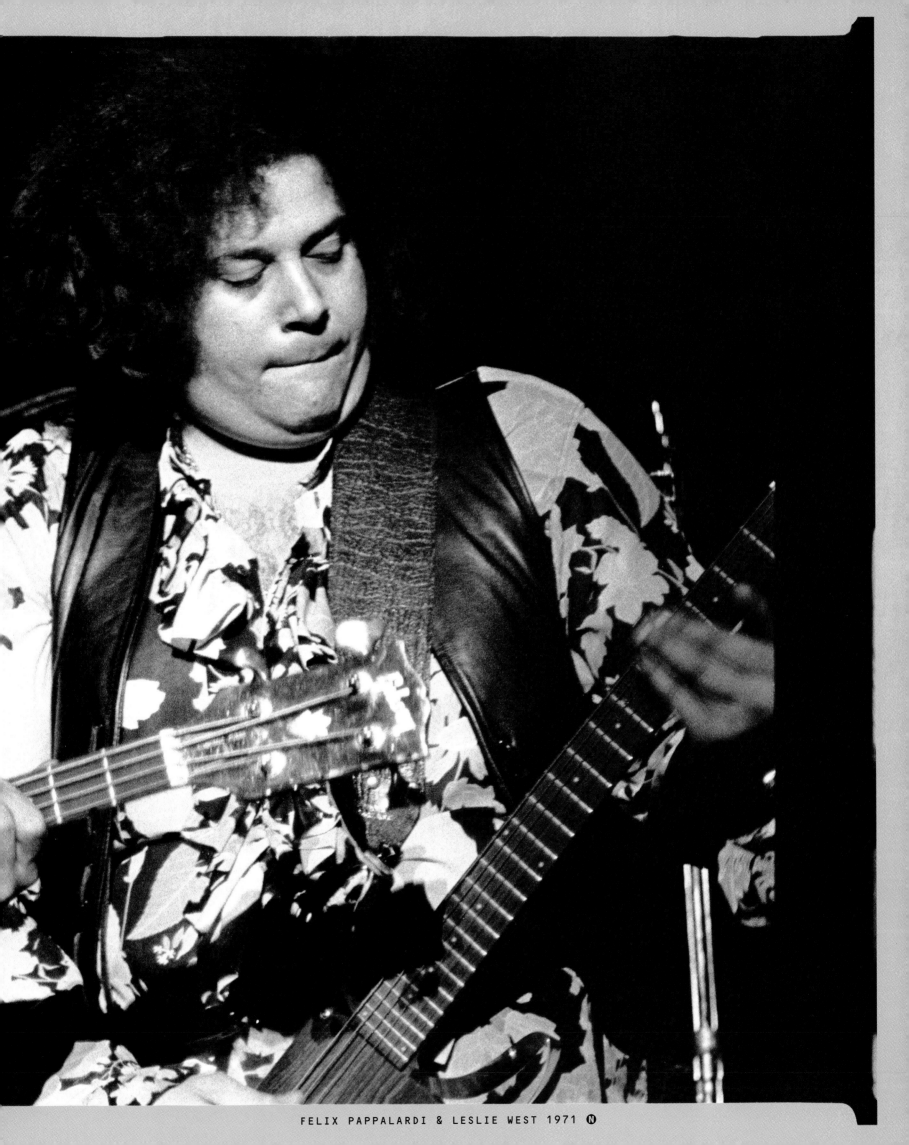

FELIX PAPPALARDI & LESLIE WEST 1971

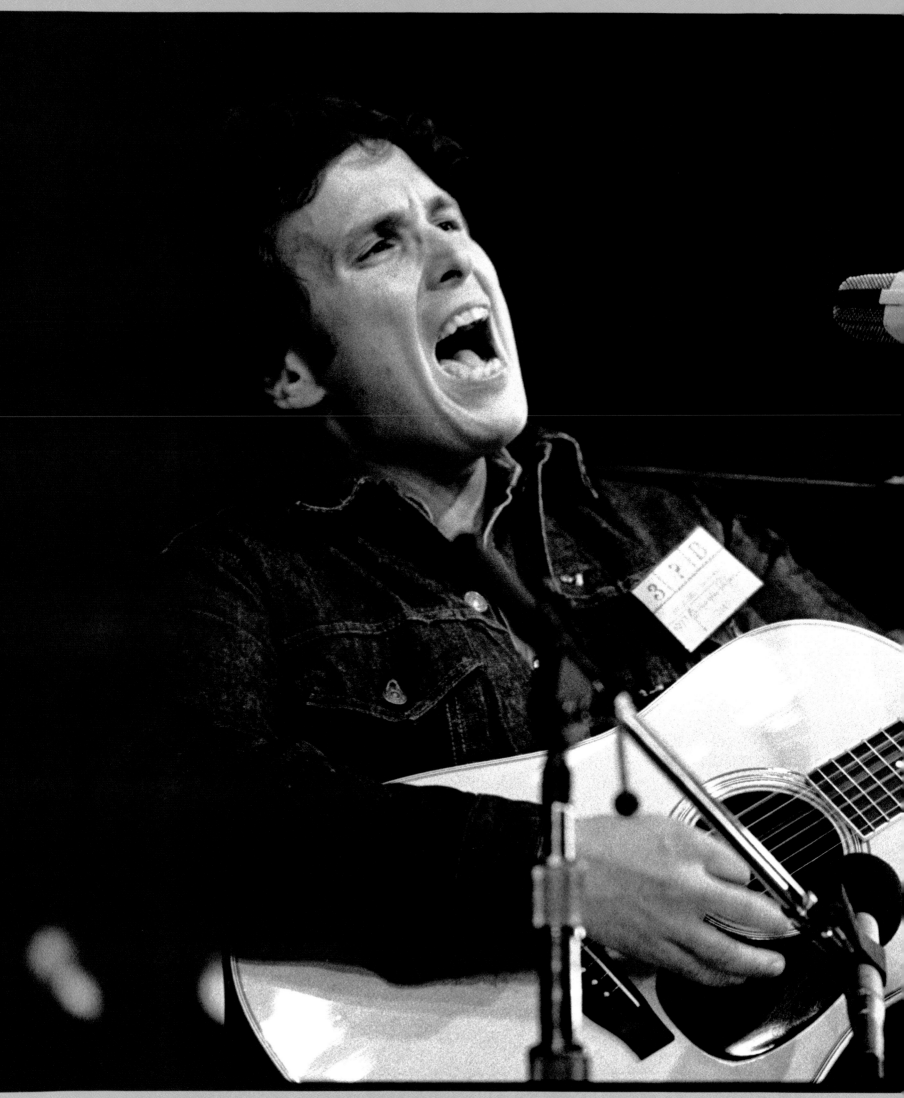

DON McLEAN 1977 Ⓑ

Don McLean's long career has been dominated by his classic hit 'American Pie', recorded for an album six years before this picture was taken. That requiem for Buddy Holly has been much-covered over the years – even Madonna took a shot at it – and its lyric coined the phrase 'The Day The Music Died'. It became more famous than its composer and singer.

The same album also included 'Vincent', McLean's poignant take on the life of Vincent Van Gogh. Later his *tour de force* version of Roy Orbison's hard-to-sing 'Crying' became a hit and McLean himself has the distinction of being the inspiration for the song 'Killing Me Softly'. Through it all he has kept singing, touring and supporting his favorite causes.

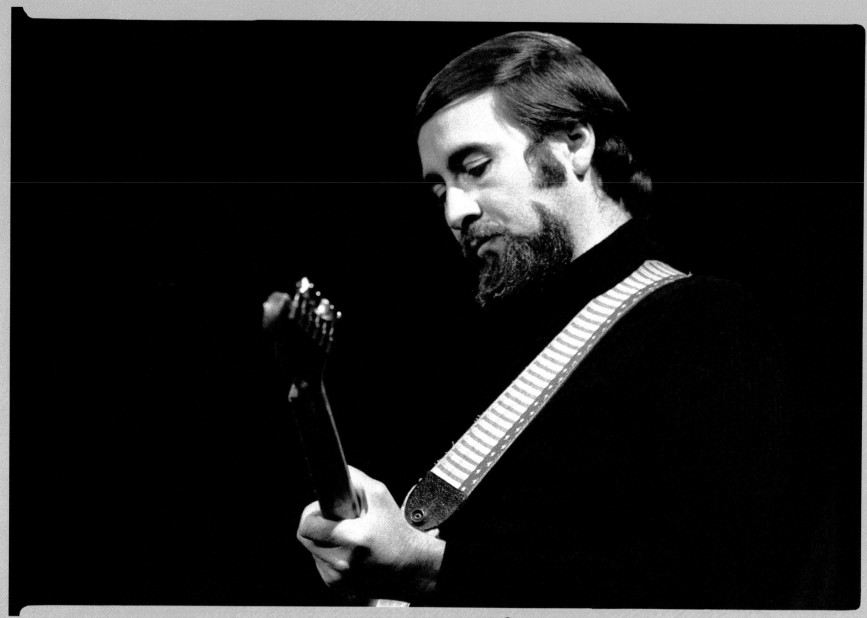

ROY BUCHANAN 1973 Ⓗ

Roy Buchanan was an Arkansas-born guitar virtuoso who started out as a sideman and was eventually offered a solo recording career by Polydor in the early 1970s after encouragement from famous fans including Eric Clapton and Merle Haggard. Leaving Polydor, Buchanan moved to Atlantic but soon gave up recording, dissatisfied with the lack of control he was allowed. Coaxed into the studio once again in the mid-1980s he made two hit albums for the Alligator label, but a long-term drink problem took hold, and in 1988, after being arrested following a domestic argument, he was found hanged in a police cell. His searing instrumental version of Don Gibson's country classic 'Sweet Dreams' was featured over the end titles of Martin Scorsese's 2006 gangster epic *The Departed*.

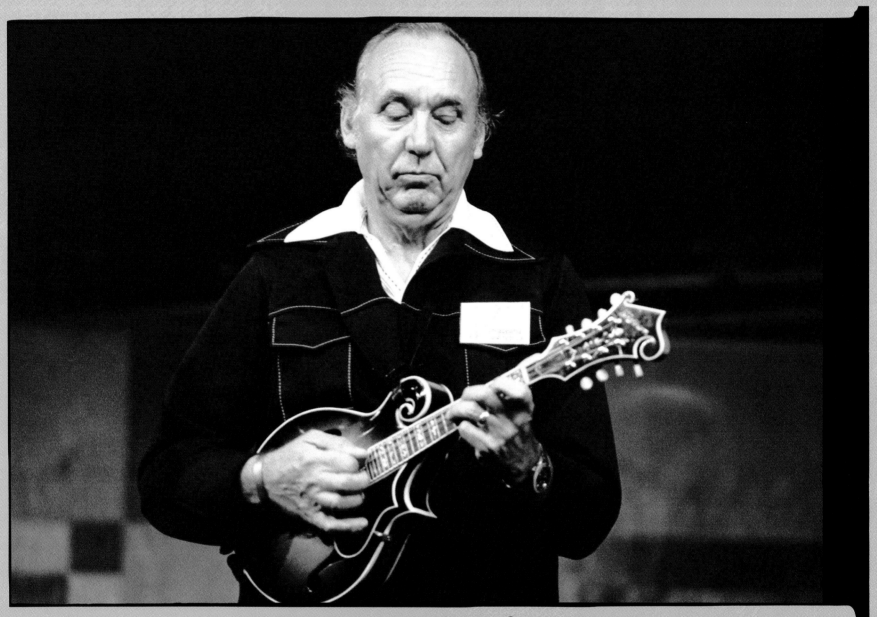

EARL SCRUGGS 1976 **B**

For a couple of years in the mid-1940s Earl Scruggs injected a brilliantly inventive and supremely smooth three-finger banjo style into Bill Monroe's classic bluegrass band. Soon he and guitarist Lester Flatt left Monroe to form Flatt & Scruggs and it was their version of 'Foggy Mountain Breakdown' that would achieve worldwide fame after being featured in Arthur Penn's 1967 gangster classic *Bonnie & Clyde*. By then the duo had already tasted showbiz success with their recording of 'The Ballad Of Jed Clampett' for TV's *The Beverly Hillbillies*. Yet Scruggs remained a serious bluegrass player, forming The Earl Scruggs Review and not averse to playing the mandolin – as in Herb Wise's picture – as well as the banjo.

The veteran blues, cajun and R&B musician Clarence 'Gatemouth' Brown enjoyed a varied career that began in the mid-1940s in Texas where his virtuoso guitar solos and abrasive voice attracted attention that led to a ten-year recording stint with Peacock Records.

Brown relocated to Nashville in the 1960s and pursued a career on the fringe of country music before retiring.

The next decade saw a revival in his musical reputation, mainly due to interest in Europe, and this led to a career renaissance resulting in a busy international touring career that lasted for most of the remainder of his long life. He died in 2005 at the age of 81.

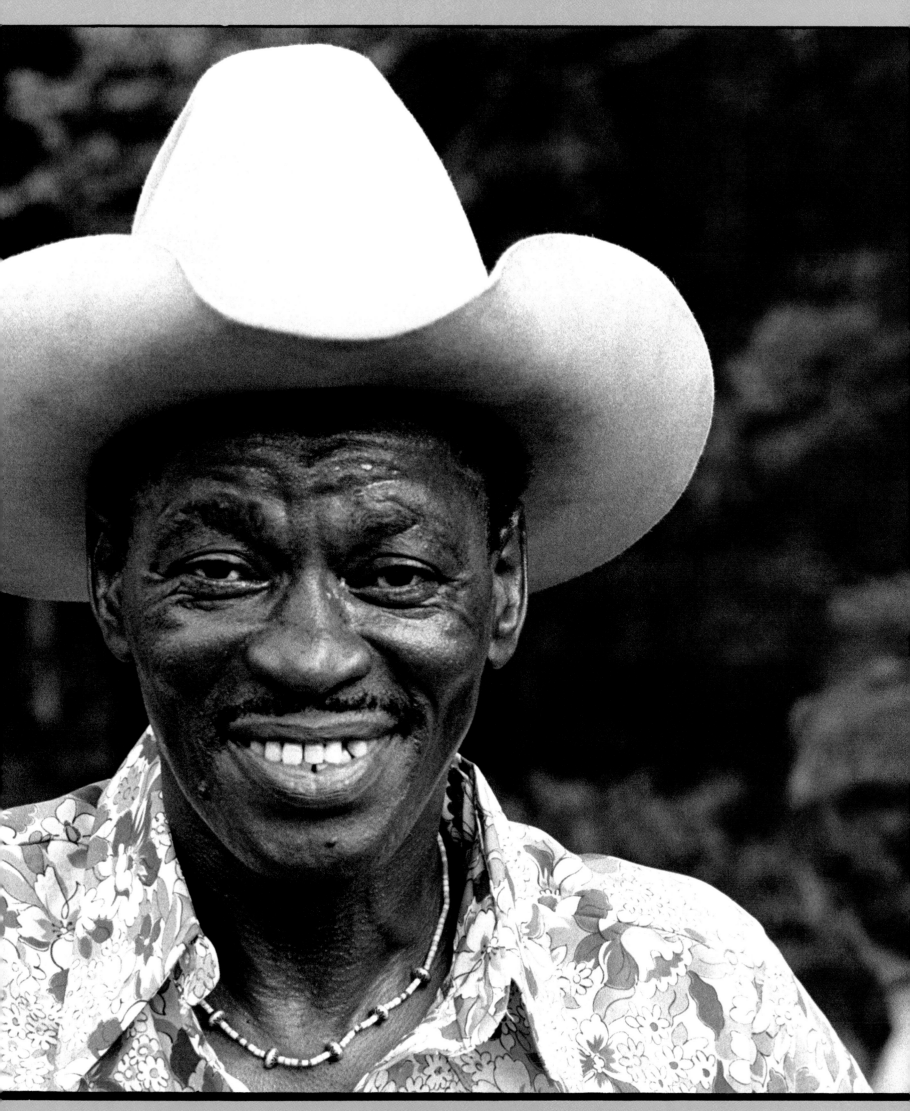

CLARENCE GATEMOUTH BROWN 1976 ®

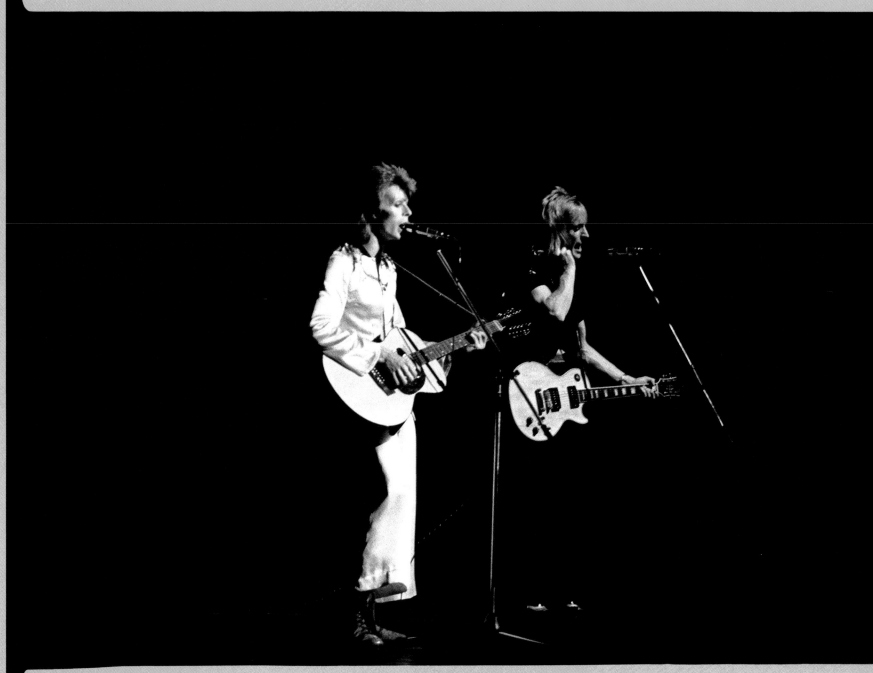

DAVID BOWIE & MICK RONSON 1973

This early 70s concert shot of David Bowie with Mick Ronson captures one of the less exotic incarnations of the man who became Ziggy Stardust. From psychedelia to glam rock and soul, plus a trilogy of distinctive albums influenced by the Berlin music scene, the first half of Bowie's career confirmed him as a musical chameleon, outdoing even Madonna as pop and rock's supreme practitioner of self-reinvention.

When this picture was taken, Carole King's sha-la-la days in the Brill Building were well behind her. With a best-selling 1971 album – *Tapestry* – she had become the singer/songwriter darling of a new audience that adored her more mature songs as well as her occasional reinterpretation of old Goffin-King pop classics like 'Will You Love Me Tomorrow'.

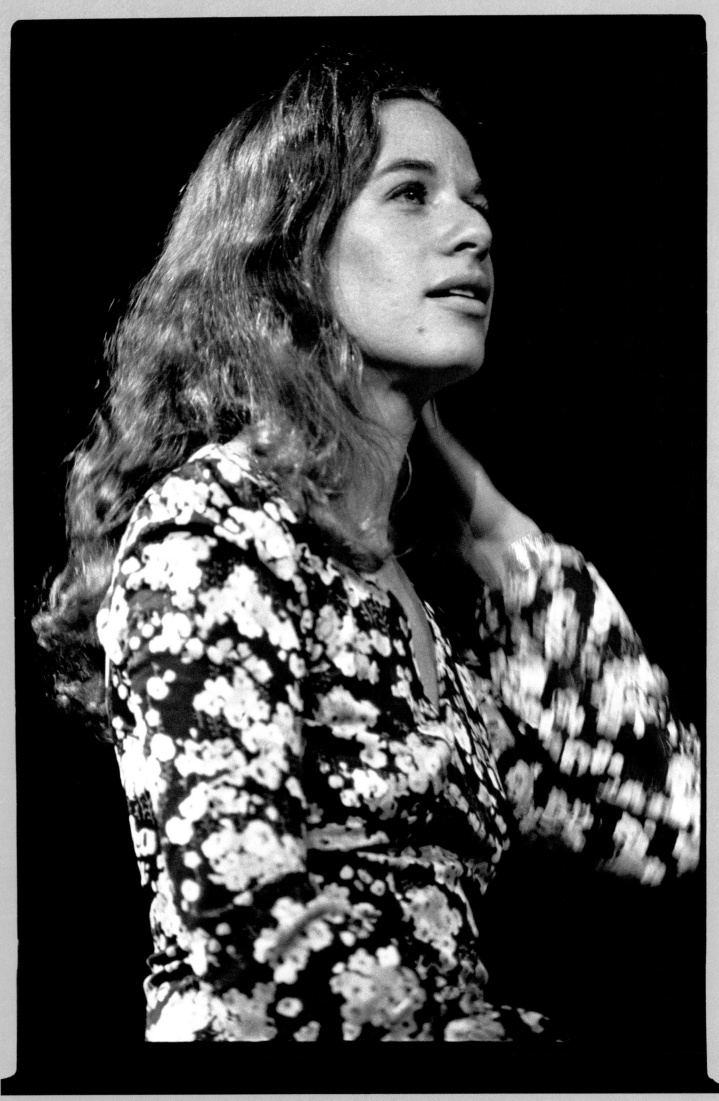

CAROLE KING 1971

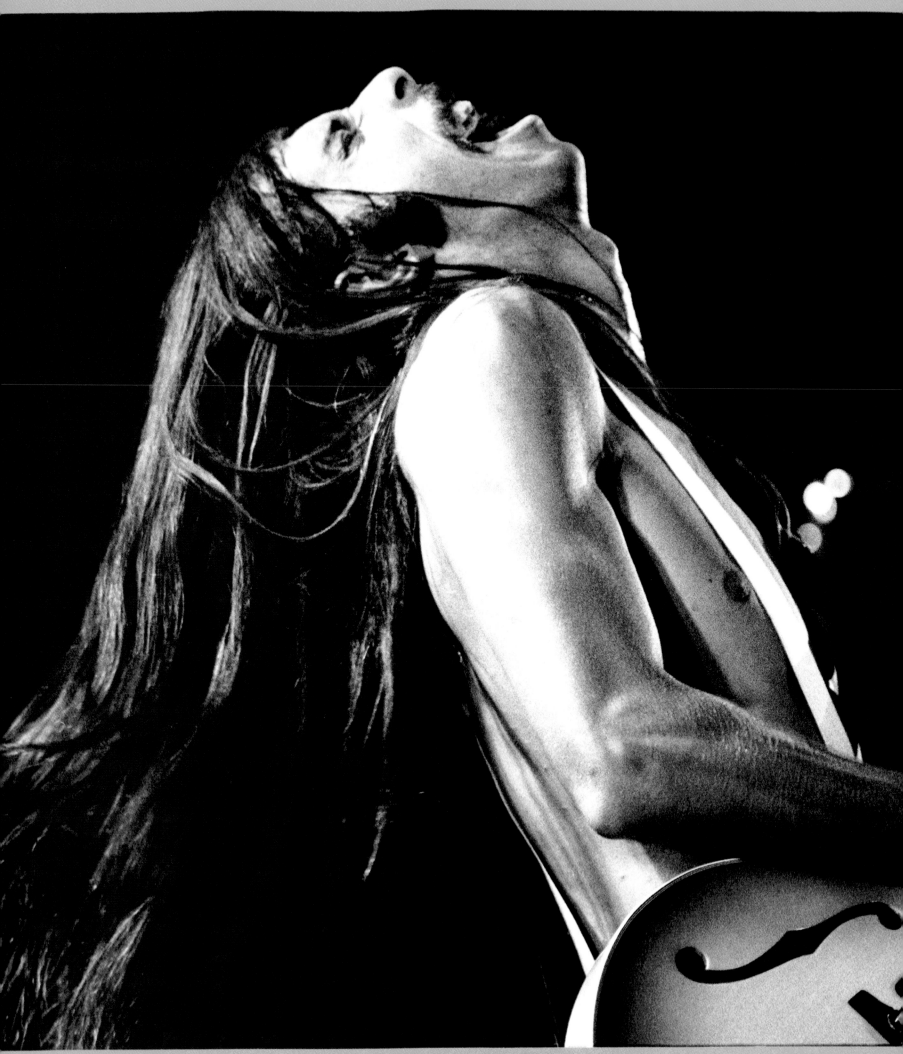

HARVEY JETT 1973 ©

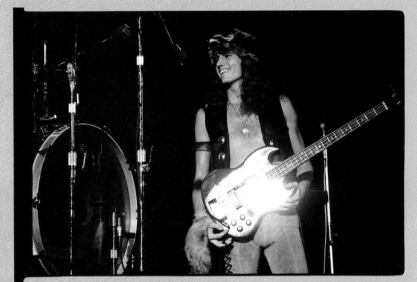

TOMMY DAUGHERTY 1973 ©

JAMES L MANGRUM (JIM DANDY) 1973 ©

TOMMY ALDRICH 1973 ©

Black Oak Arkansas was a southern rock band formed in 1965 and led by the charismatic Jim 'Dandy' Mangrum. Through a variety of influences and endless personnel changes the band has kept going for four decades and counting, although Mangrum remains the only constant. Originally called The Knowbody Else and working with stolen equipment they started as musical outlaws but eventually became a rock institution that still claims a loyal fan base.

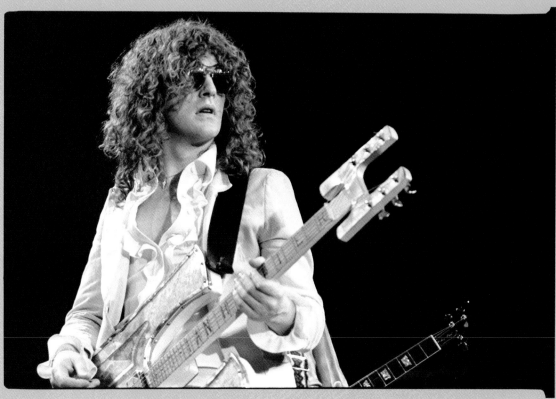

IAN HUNTER 1973 ©

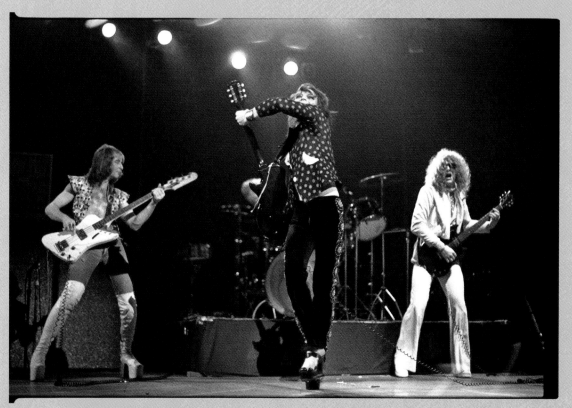

PETE OVEREND WATTS, MICK RALPHS & IAN HUNTER 1973 ©

After a stuttering career start in the late 1960s Mott The Hoople finally found fame in 1972 thanks to David Bowie who encouraged them to keep going, produced them and supplied them with a breakthrough hit song, 'All The Young Dudes'. A run of personnel changes (including the arrival of Mick Ronson) followed and so did a string of hits with 'All The Way To Memphis' scoring heavily. Ian Hunter, the band's Dylan-flavored lead singer, became central to Mott The Hoople's success and rumors of his impending defection led to an acrimonious breakup of the group in the mid 1970s.

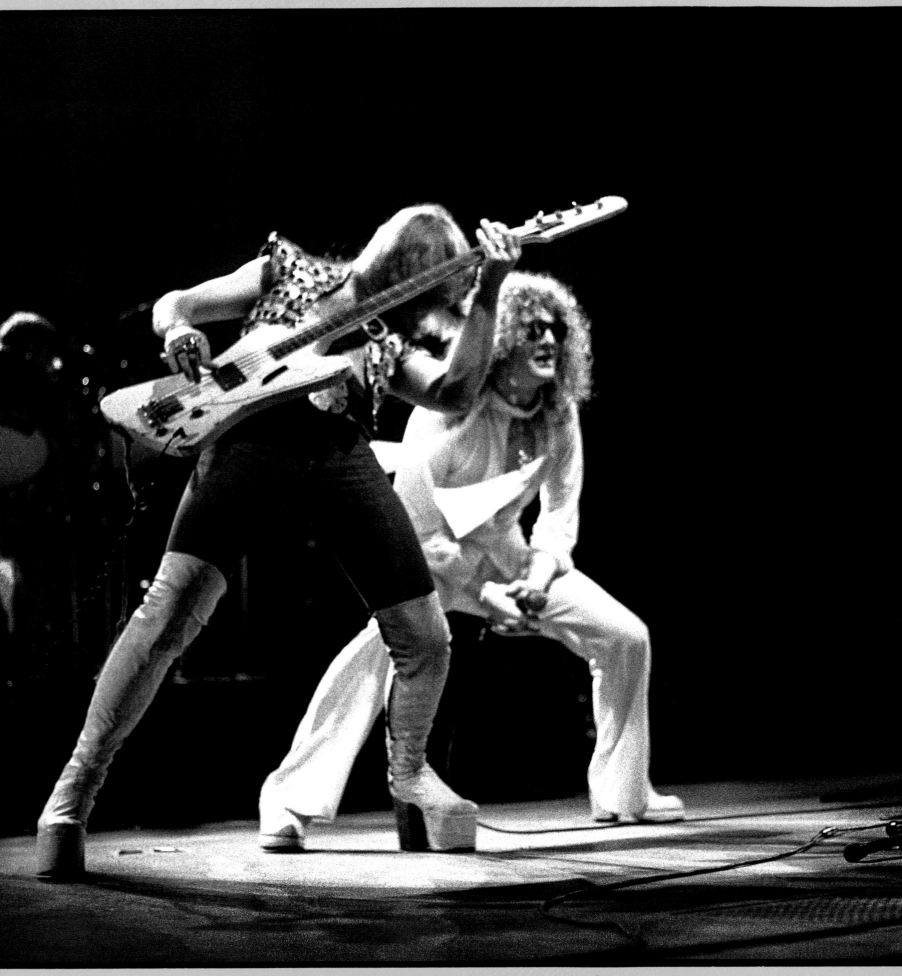

PETE OVEREND WATTS & IAN HUNTER 1973 Ⓒ

A cut-down version of the band pressed on under the name Mott. Despite a relatively short career, Mott The Hoople enjoyed a

big international reputation and 'All The Way To Memphis' featured throughout Martin Scorsese's *Alice Doesn't Live Here Anymore*.

Bob Dylan plays Madison Square Garden in
1974 as part of his return to touring after a
long break. Robbie Robertson and Garth Hudson
can also be seen onstage, part of The Band
who backed Dylan throughout this ambitious
coast-to-coast tour.

It was to prove a vintage year during which
Dylan also wrote the songs for one of his
greatest albums. *Blood On The Tracks* came
out in early 1975 and still stands as one of
Dylan's most painfully honest projects, a raw
response to the breakdown of his marriage to
Sara Lownds.

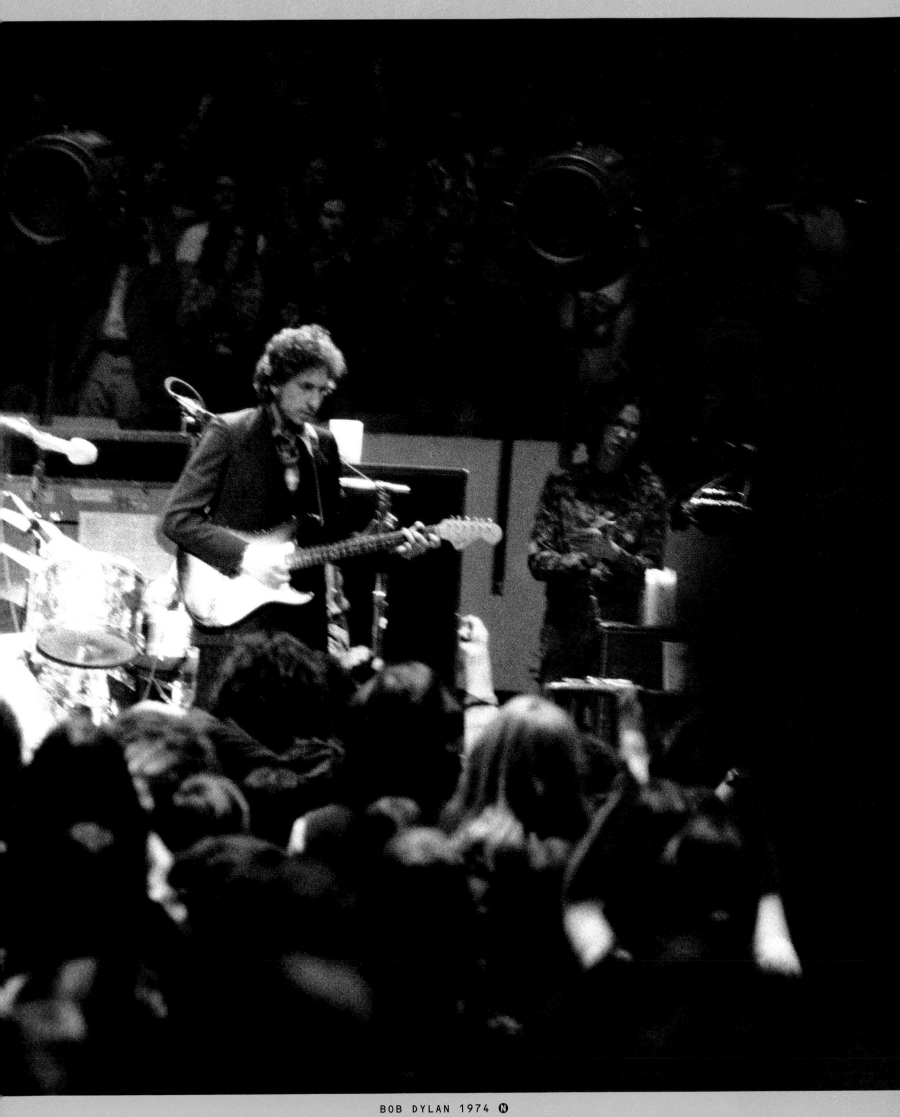

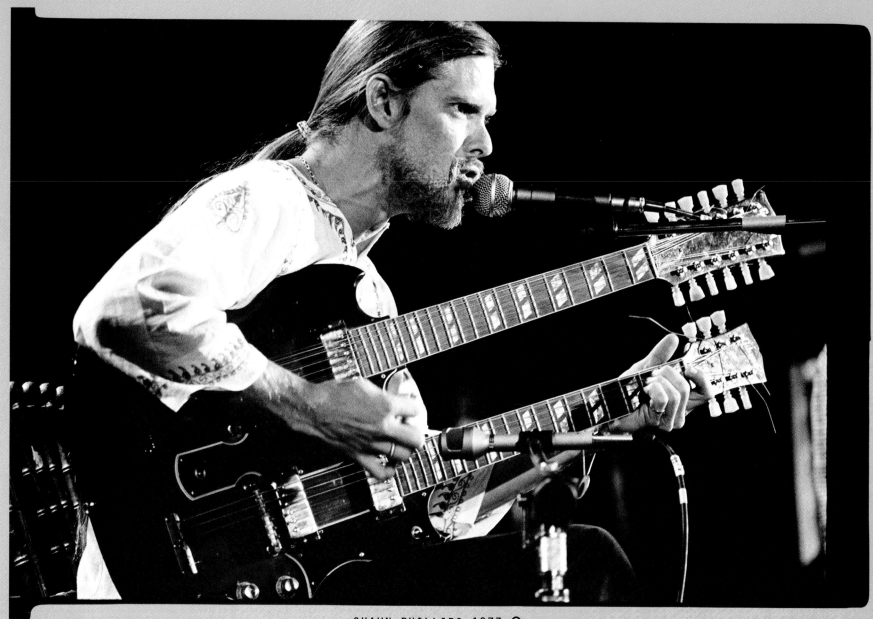

SHAWN PHILLIPS 1973 ©

Texas-born singer/songwriter Shawn Phillips was an active figure on the music scene in the 1960s, working in London, Los Angeles and New York's Greenwich Village. The impresario Bill Graham once called him 'the best-kept secret in rock', a status Phillips went some way towards maintaining by moving to Italy during the 1970s. Even so he produced some of his better-known albums during that Italian sojourn. He now lives in South Africa and still makes music.

JOSH WHITE JR 1979 Ⓑ

The career of Josh White Jr continued the work of his acclaimed singer/guitarist/actor/social activist father. Launched into the family business at the age of four, singing with his father at New York's Café Society (a progressive, integrated night club), he went on to act, record, perform and participate in numerous social programs as well as becoming a noted children's entertainer.

Their first hit came in 1961, but Gladys Knight & The Pips were still riding high in 1973 and enjoying the first in a series of country-flavored soul hits written by Jim Weatherly – 'Midnight Train To Georgia' – when they performed at Madison Square Garden.

After a long career together Gladys Knight finally parted company with The Pips in 1988 after contractual issues had prevented them from recording together for some time. They remain one of the most successful R&B acts ever.

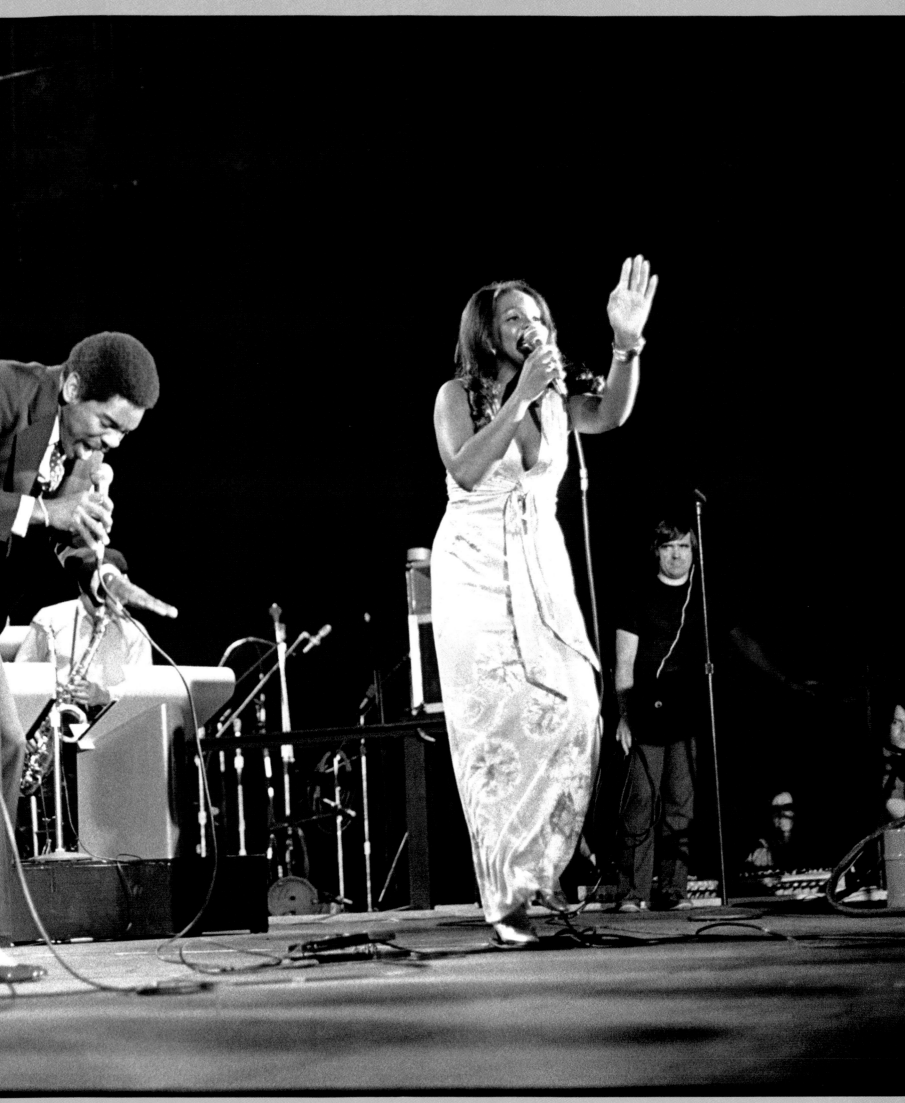

GLADYS KNIGHT & THE PIPS 1973 ©

JERRY FISHER 1973 ©

Herb Wise once set up an album cover photo shoot for Blood, Sweat &
Tears in a fine old house owned by 92-year old John Hinsdale in Raleigh,
North Carolina. He had come upon The Hinsdale House by chance
and selected it as a location because the band – who were on tour at the
time – did not want to be photographed in the countryside: they saw
themselves as an urban outfit. Herb persuaded John Hinsdale to let this
bunch of wild musicians into his precious home and move the furniture
around for the shoot.

A true southern gentleman, Hinsdale welcomed each band member
personally before letting them loose. Everyone behaved well, the shoot
was completed and the Hinsdale residence furniture was carefully replaced.
John Hinsdale pronounced it 'the happiest day of his life' and waived
compensation.

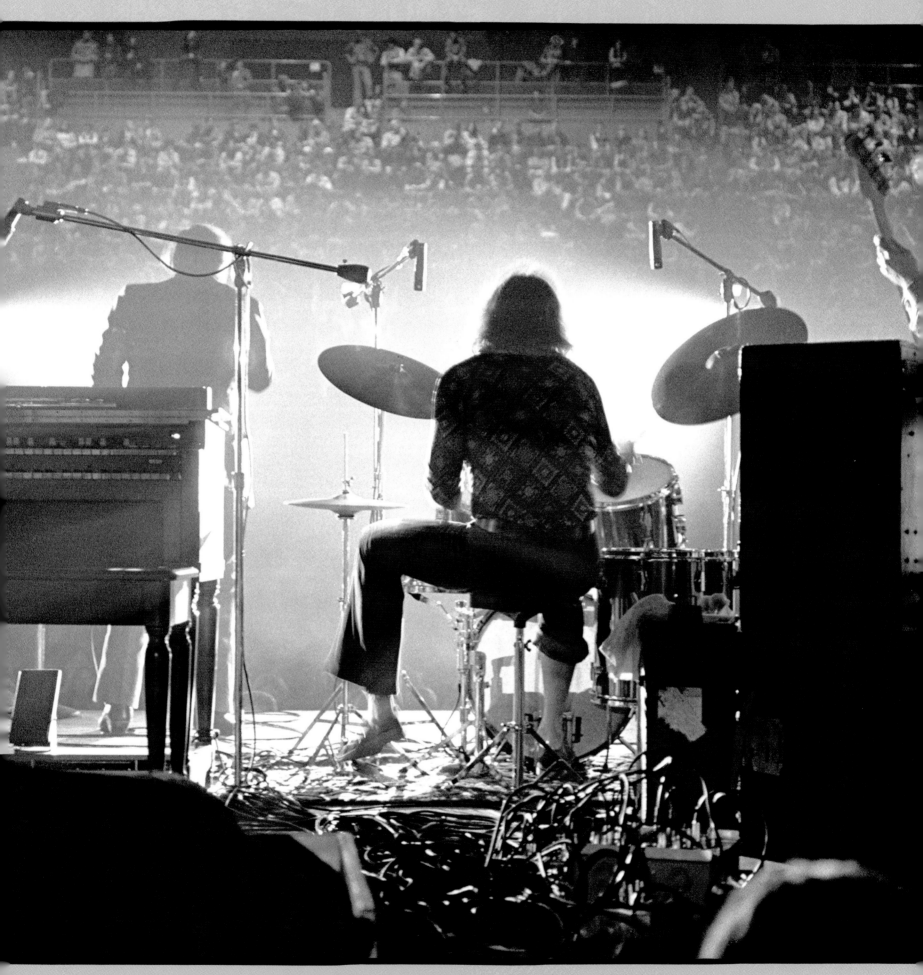

BLOOD, SWEAT & TEARS 1973 Ⓒ

STEVE FORBET 1970 ©

Doug Kershaw started out with his brother Rusty as a duo, but later forged a successful solo career based on his amazingly energetic singing/dancing/fiddle playing act. Writer of the seminal cajun song 'Louisiana Man', Doug Kershaw became one of genre's most famous names and still performs well into his seventies.

Like John Prine, Steve Forbert was one of a clutch of singers hailed as 'the new Dylan' in the late 1970s. He outgrew the label and had his biggest hit in 1980 with 'Romeo's Tune' which he dedicated to the ill-fated Florence Ballard who had been fired from the Supremes and descended into poverty and alcoholism before dying aged 32.

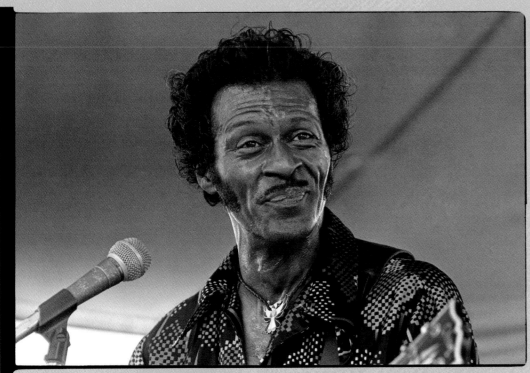

CHUCK BERRY 1981 🅞

Chuck Berry, rock'n'roll pioneer and practitioner of the famous duck walk, had an immense influence on the development of rock. A difficult man, imprisoned three times, he often refused to go on stage unless the cash was handed to him first. His live performances might be brilliant or sloppy but no one could ever doubt the importance of his witty songwriting, unique guitar-playing or his indelible impact on the popular music of the 20th century.

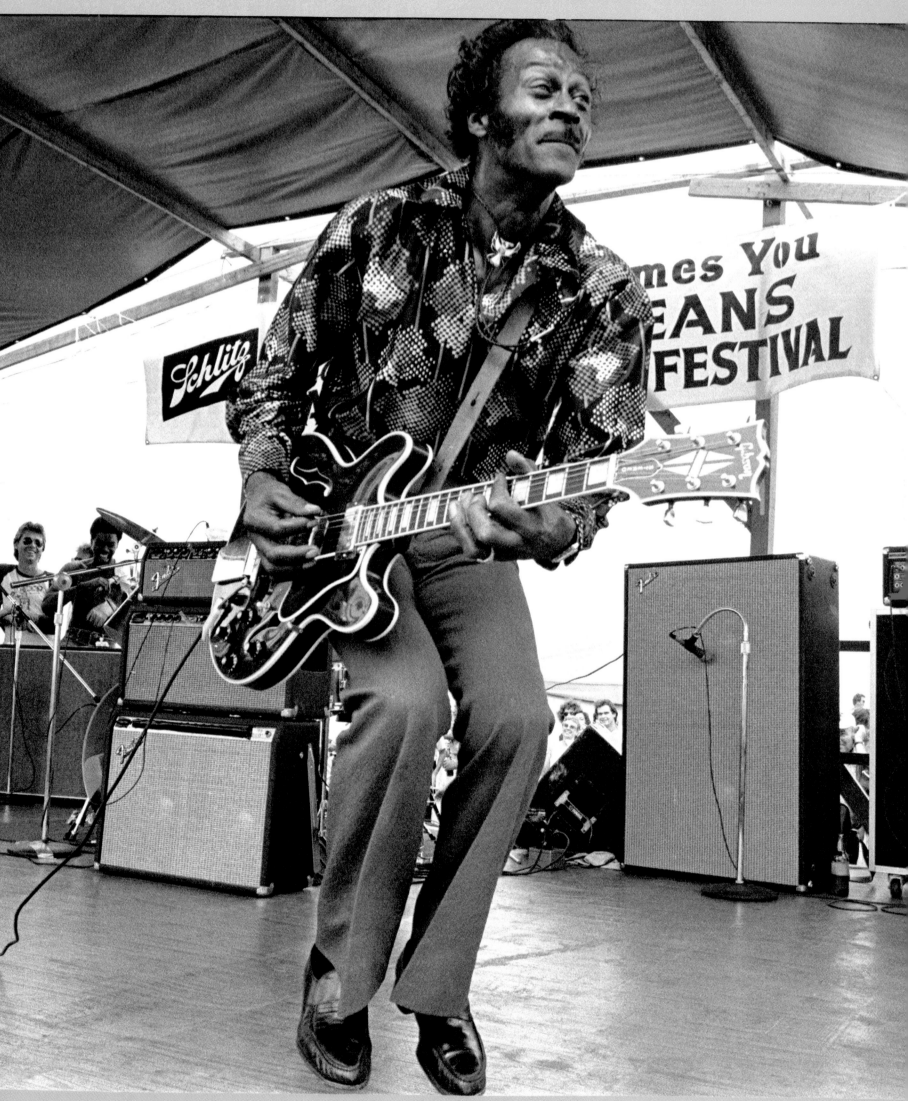

CHUCK BERRY 1981 ○

JACO PASTORIUS 1973 ©

Starting out as a drummer but switching to upright bass after sustaining a wrist injury, John Francis 'Jaco' Pastorius III later switched again, this time to the electric bass. In 1976 his first album, featuring Herbie Hancock and R&B singers Sam & Dave, raised the profile of jazz electric bass. Josef Zawinul soon took Jaco into Weather Report where he played on their now-classic album *Heavy Weather*. Leaving the band in 1981 Pastorius pursued many musical projects but, suffering from bi-polar disorder, he descended into alcoholism and died in 1987 after a confrontation with a club bouncer in Florida. He was 35.

Still active as he approaches 90, Dave Brubeck has long been a dazzling jazz pianist, composer and bandleader. Popularly best-known for the 5/4 time hit 'Take Five', Brubeck is a tireless musical experimenter, writing choral and orchestral works, playing in many latter-day variations of the famous quartet he led in the 1950s and 1960s, and receiving numerous awards.

DAVE BRUBECK 1972 Ⓜ

CANDID

The music festivals of the 1960s and 1970s presented certain opportunities
for the subtle photographer to capture off-the-cuff shots that were neither
intrusive nor prurient but simply revealing. Those temporary tent cities and
hastily-erected stages encouraged an air of informality far removed from
the closeted and regimented world of stadium rock, and the atmosphere was
usually one of good-natured collusion between audience and performer.

Taj Mahal, a thoughtful man and the son of well-known musician, built a
career out of exploring the Caribbean and African roots of blues. He progressed
from playing with Ry Cooder in the 1960s to becoming an internationally
respected solo artist with a preference for *al fresco* events.

'The music was designed for people to move' he has said. 'And it's a bit
difficult after a while to have people sitting like they're watching television.
That's why I like to play outdoor festivals – because people will just dance'.

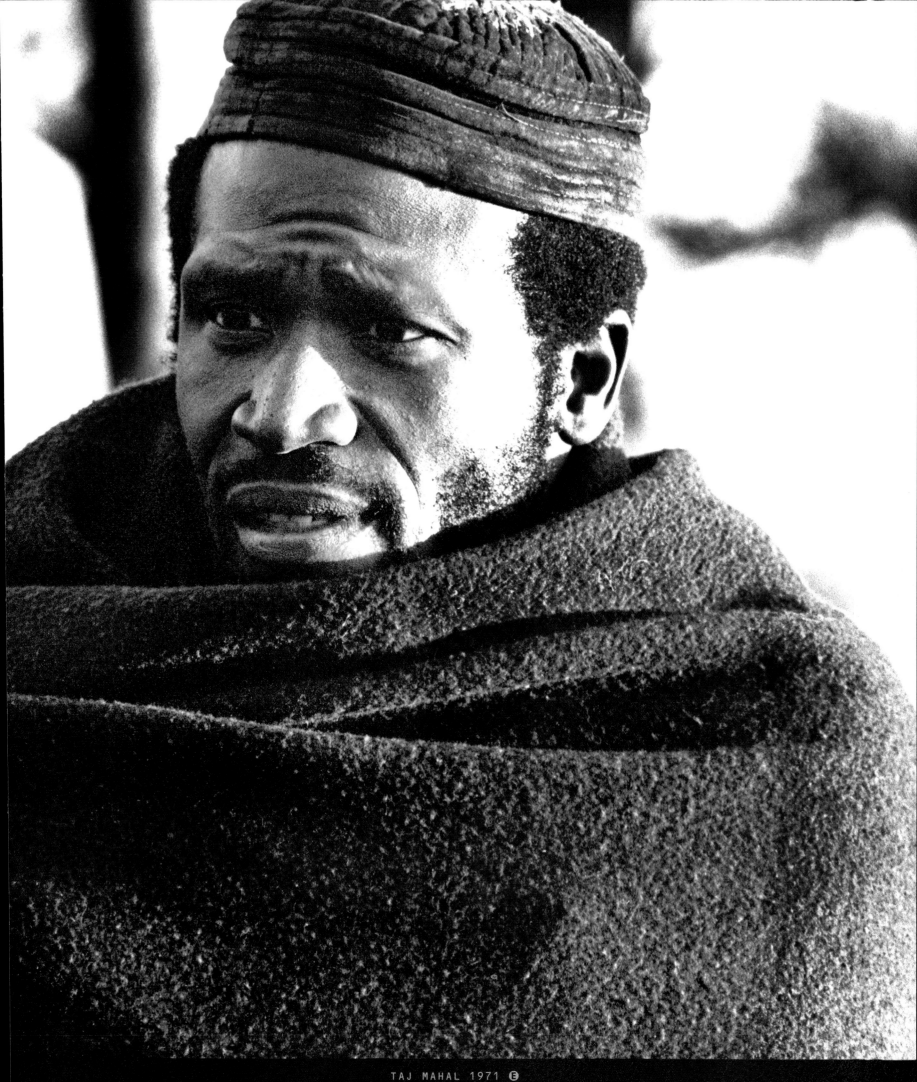

TAJ MAHAL 1971 Ⓔ

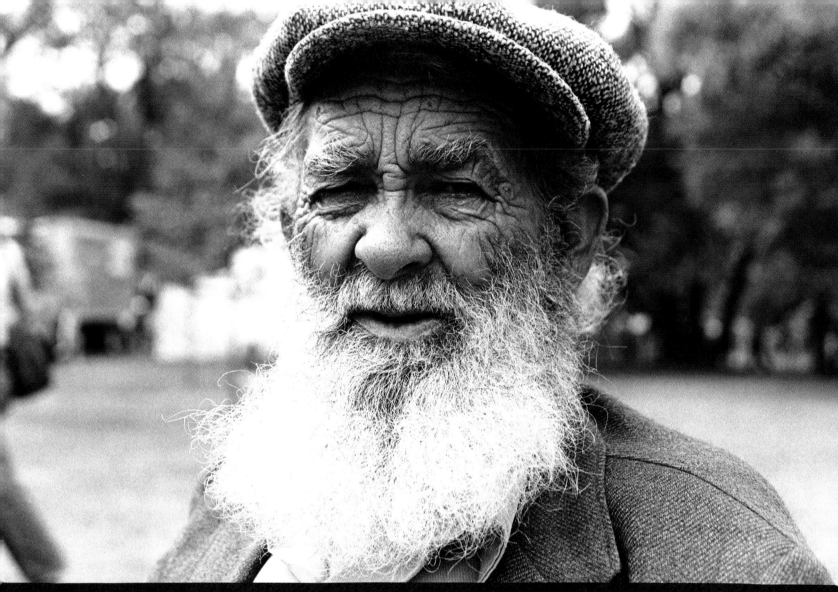

SAM CHATMON 1974 ℗

Born in Bolton, Mississippi in 1897, Delta blues guitarist and singer Sam Chatmon had his roots in the old South. He played in
the family band and later performed with two of his brothers as The Mississippi Sheiks. Like several others of his generation
he was rediscovered by folk and blues enthusiasts in the 1960s and subsequently played a number of festivals. On first meeting him
Herb Wise asked what his father did for a living. 'Ma father's born in slavery time' Chatmon replied pointedly. 'Slavery time'.
Chatmon died in 1983 and 15 years later a memorial headstone, paid for by Bonnie Raitt, was installed in the cemetery of the
Mississippi town of Hollandale that he had called home for much of his life.

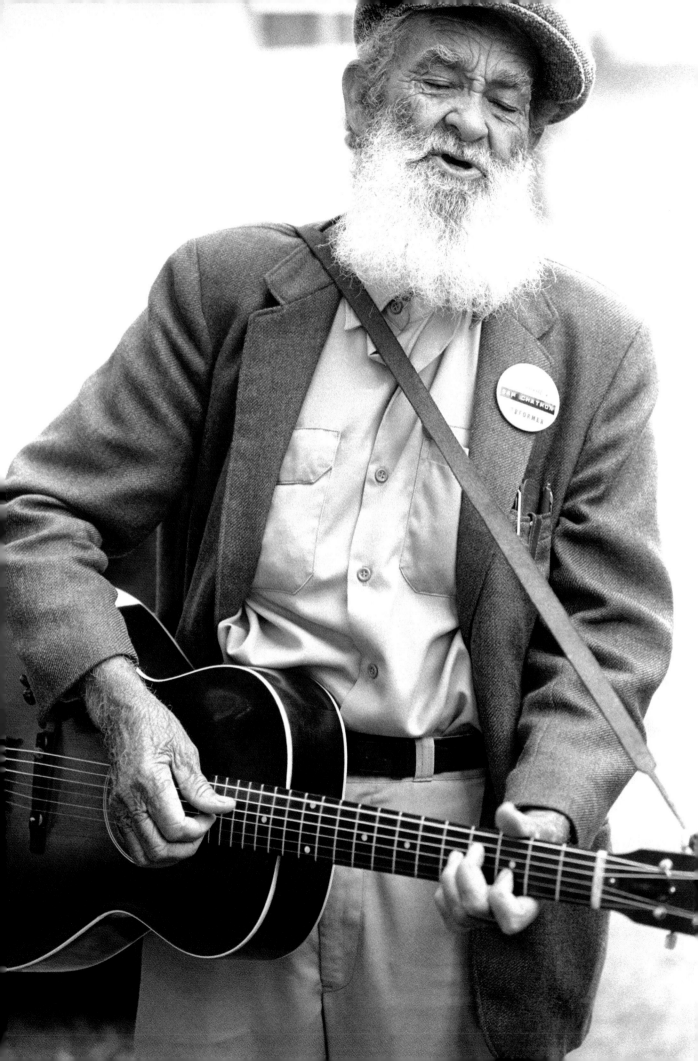

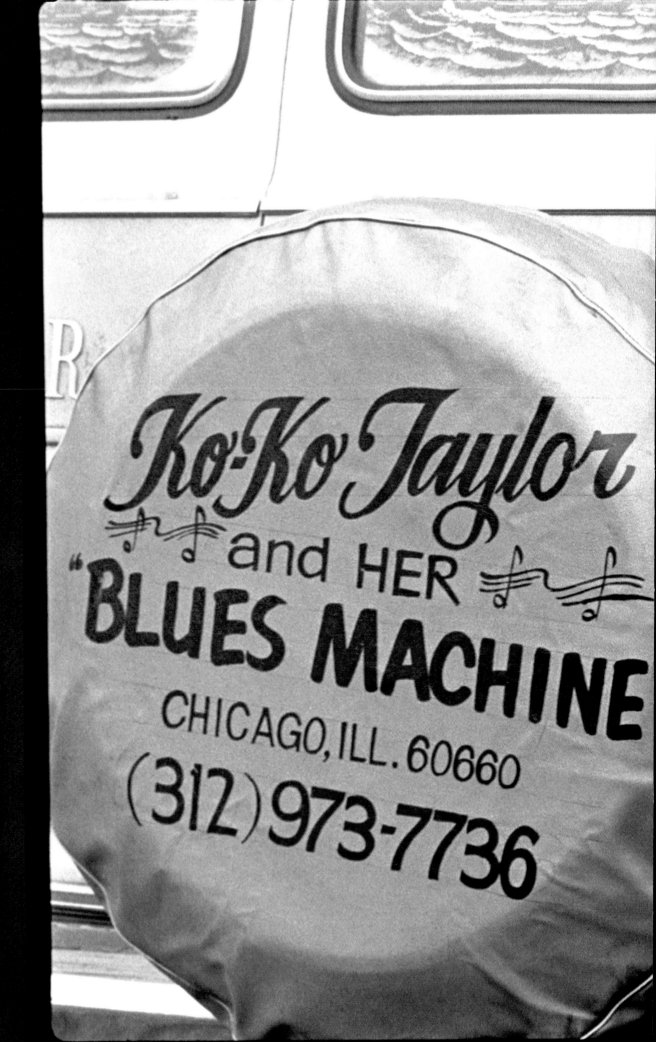

Herb Wise's famous shot of Ko-Ko Taylor provides a neat encapsulation of her personality and her act, not to mention her telephone number.

A great blues singer from Tennessee who relocated to Chicago at the age of 24, she developed her gritty vocal style in that city's blues clubs.

Discovered by Willie Dixon and eventually signed by Chess Records she promptly recorded an unforgettable hit, 'Wang Dang Doodle'. Howlin' Wolf had done it first but it was Taylor's hit version that prompted many cover versions over the years.

In her later years she appeared as herself in both John Landis' Blues Brothers and David Lynch's

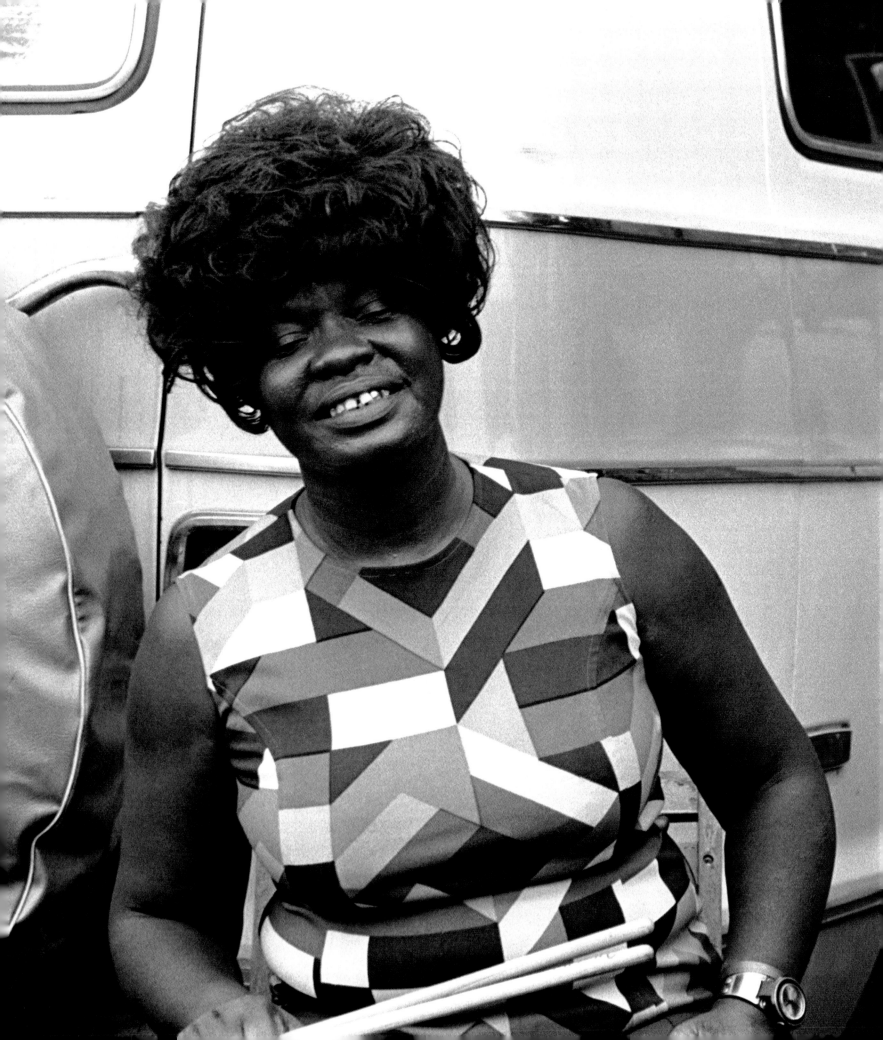

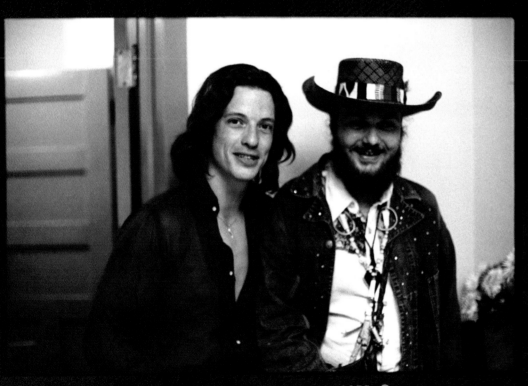

JOHN HAMMOND JR & DR JOHN 1973 ©

From the start of his career Malcolm John Rebennack Jr, aka Dr John, embodied a heady brew of New Orleans cultural and musical flavors. Regional R&B, boogie woogie, psychedelic rock and extravagant stage costumes with more than a hint of voodoo wer all underpinned by great vocals and piano work. By the 1970s, Dr John was an established session musician as well as a solo perform

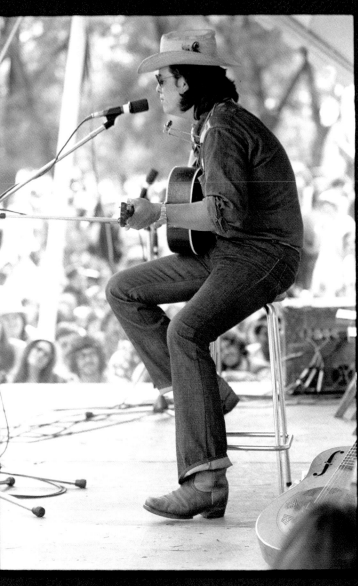

JOHN HAMMOND JR 1971 Ⓔ

n Hammond Jr, son of the legendary record producer, is

ues singer and guitarist who consistently attracted a positive

ical response in his heyday even though he has enjoyed

y moderate commercial success over the years. Sunny Schnier

the producer of Don Kirshner's New York-based *In Concert*

series broadcast on ABC throughout the 1970s.

show enjoyed a revival in the 1990s as *ABC In Concert*, but it

the 70s version (simulcast on FM radio due to TV's poor sound

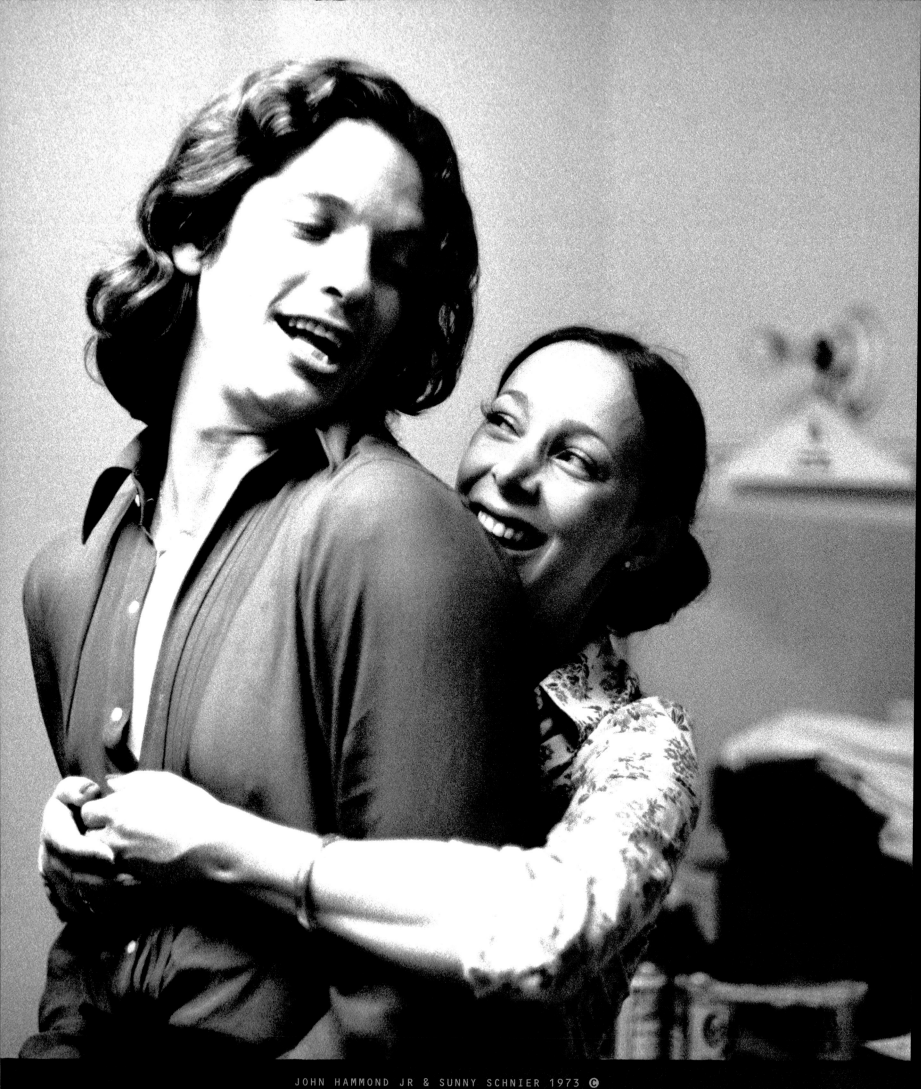

JOHN HAMMOND JR & SUNNY SCHNIER 1973 ©

Kenny Kosek was a city boy from The Bronx who
mastered traditional country fiddle styles with ease early
on in his career. Later he would go on to teach, become a
backing musician for everyone from Leonard Cohen to
Chaka Kahn, write for *National Lampoon* and extend his
playing range to encompass klezmer and a rich variety of

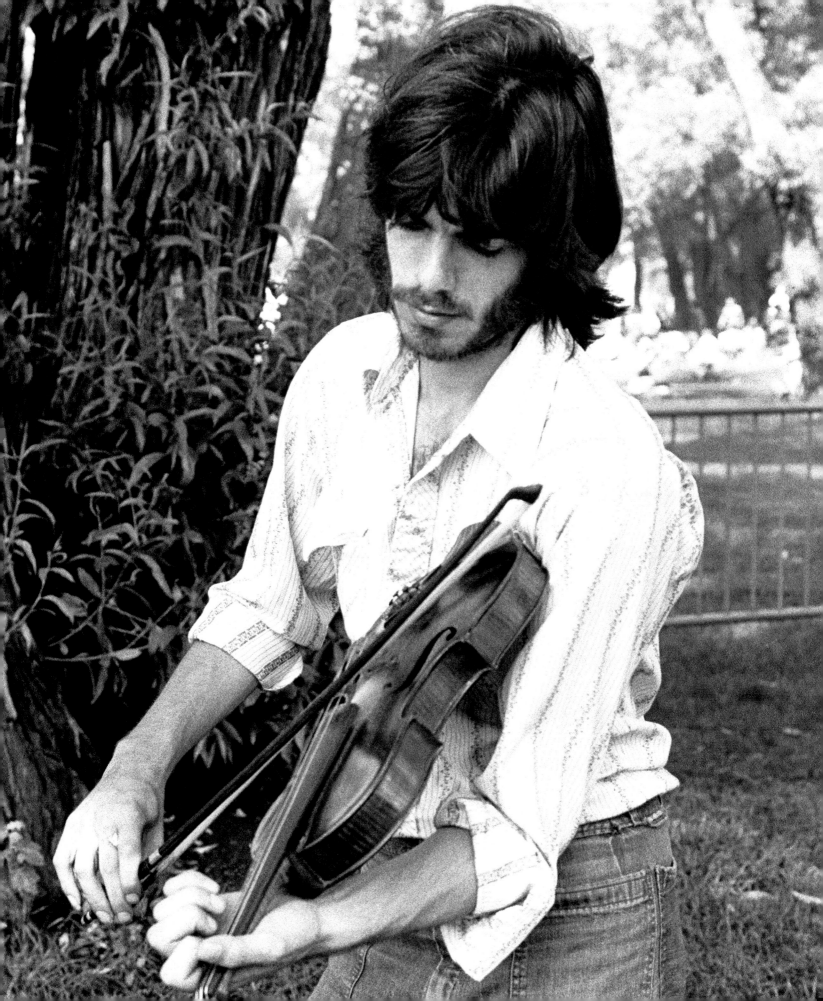

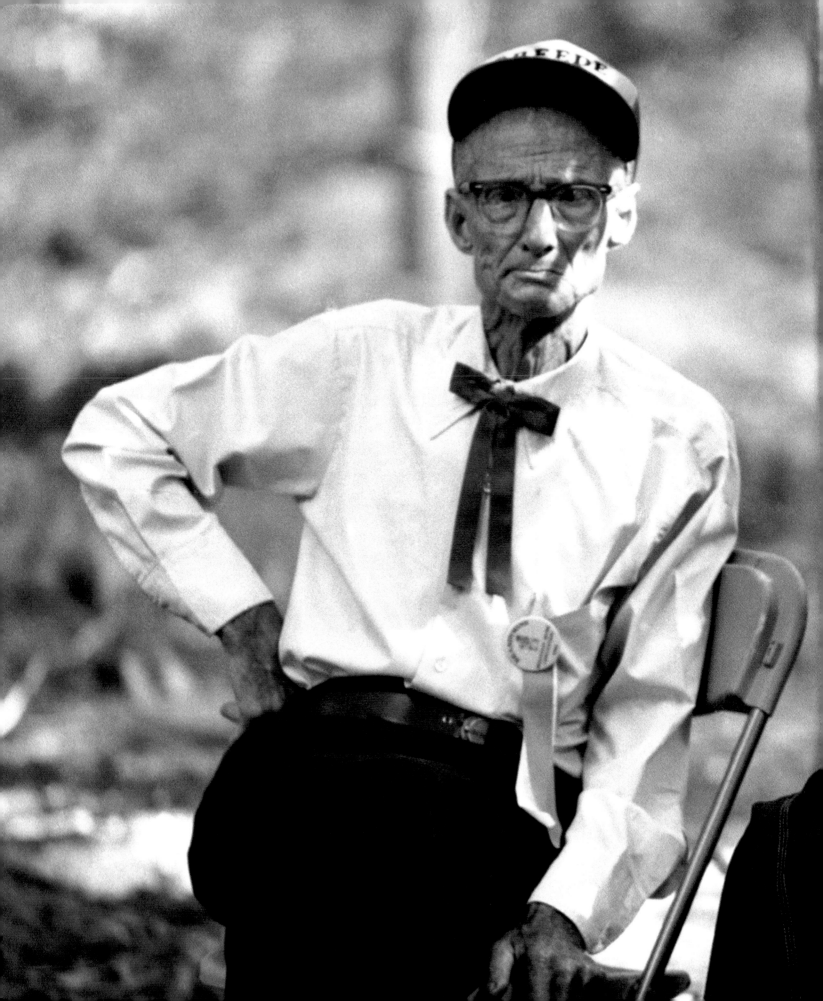

LEONARD EMANUEL 1975 Ⓢ

When folk and country periodically
go metropolitan, they stands no chance
of recruiting old school players and singers
like these. Leonard Emanuel, for example,
was champion Hollerer of North Carolina
in 1971 and a leading exponent of
what some believe to be the earliest form
of long-distance communication by
human beings.

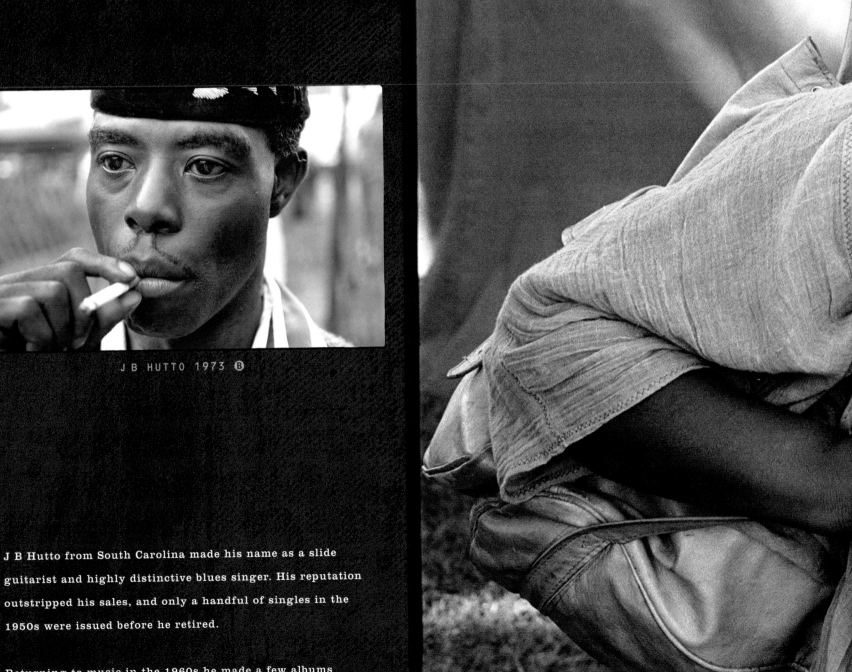

J B HUTTO 1973 Ⓑ

J B Hutto from South Carolina made his name as a slide
guitarist and highly distinctive blues singer. His reputation
outstripped his sales, and only a handful of singles in the
1950s were issued before he retired.

Returning to music in the 1960s he made a few albums

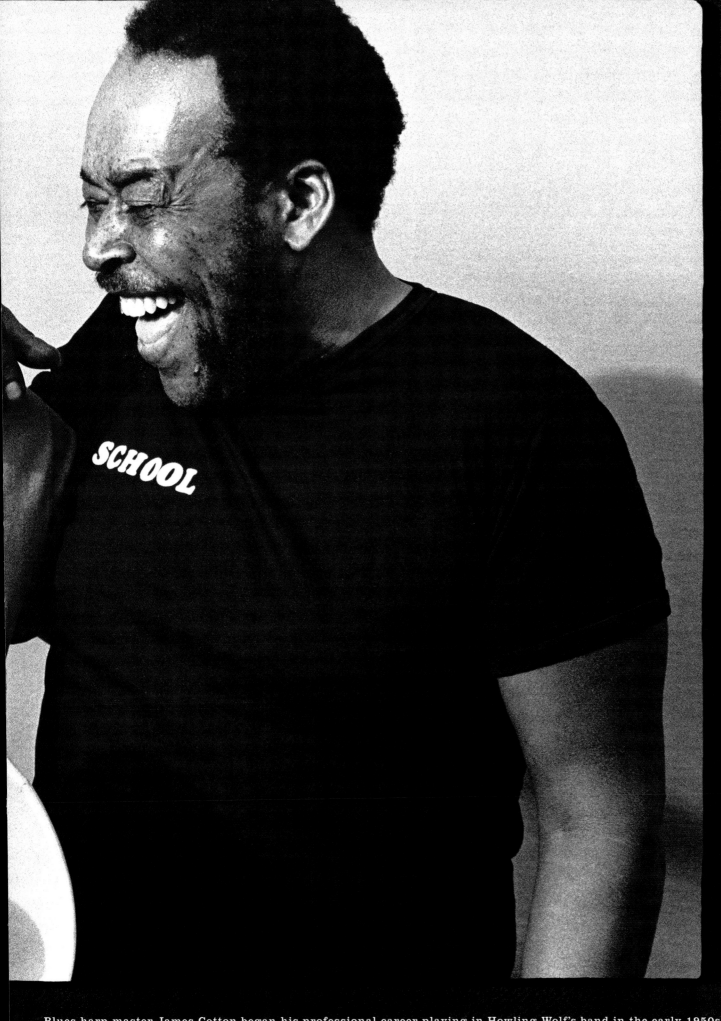

Blues harp master James Cotton began his professional career playing in Howling Wolf's band in the early 1950s.

He subsequently formed various blues bands, played with most of the great blues musicians, and finally received a Grammy for

Best Traditional Blues Album (*Deep in the Blues*) in 1996.

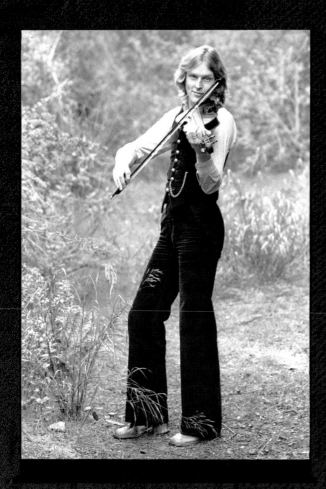

ROBIN WILLIAMSON 1975 Ⓡ

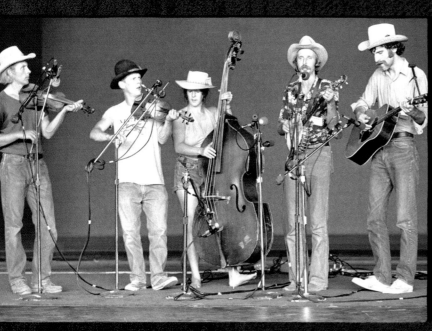

HILLSIDES STRING BAND 1978 Ⓑ

Scottish musician Robin Williamson was a founder member of The Incredible String Band, but left that influential group in

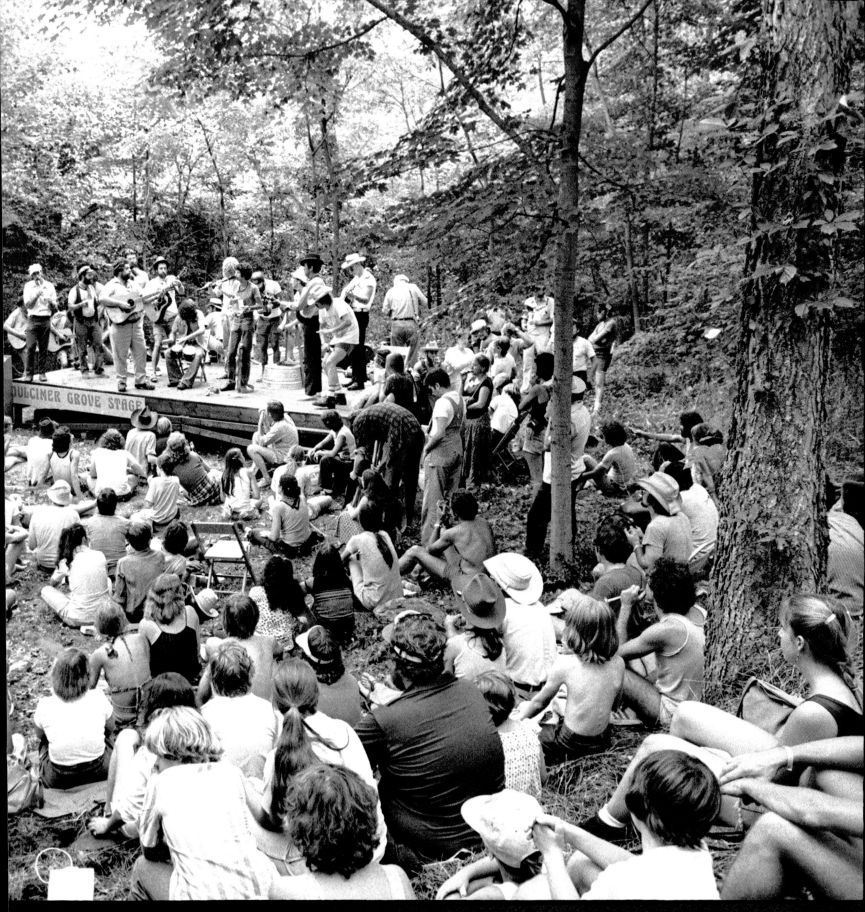

ROGER SPRUNG & HIS PROGRESSIVE BLUEGRASS BAND 1974 Ⓑ

Banjo star Roger Sprung (in the black hat) was a long-standing performer at the Philadelphia Folk Festival, appearing there

for 30 consecutive years while also pursuing a mainstream career playing with some of showbusiness's biggest stars, including

Willie Nelson and Dean Martin.

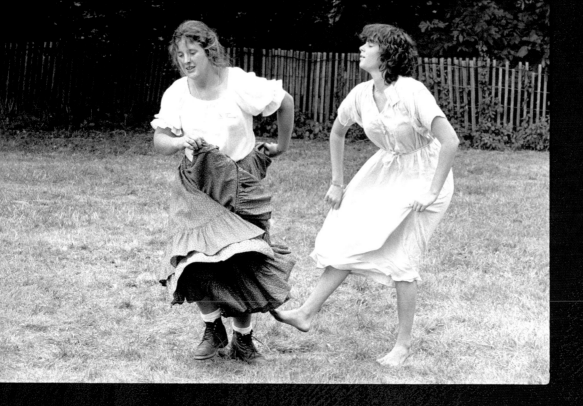

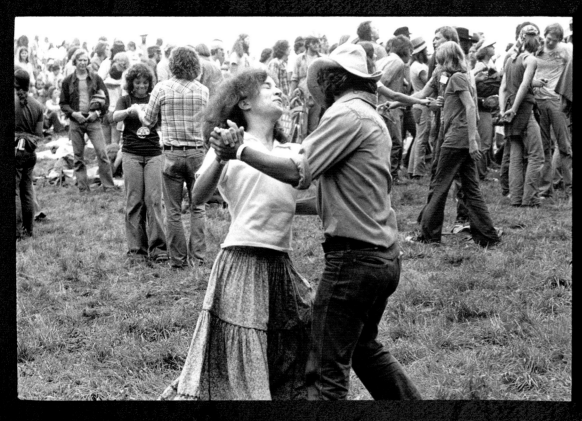

Dancers at the 1973 Philadelphia Folk Festival (above) and the 1974 Mariposa Festival (right) reflect the impromptu spirit of these classic outdoor events.

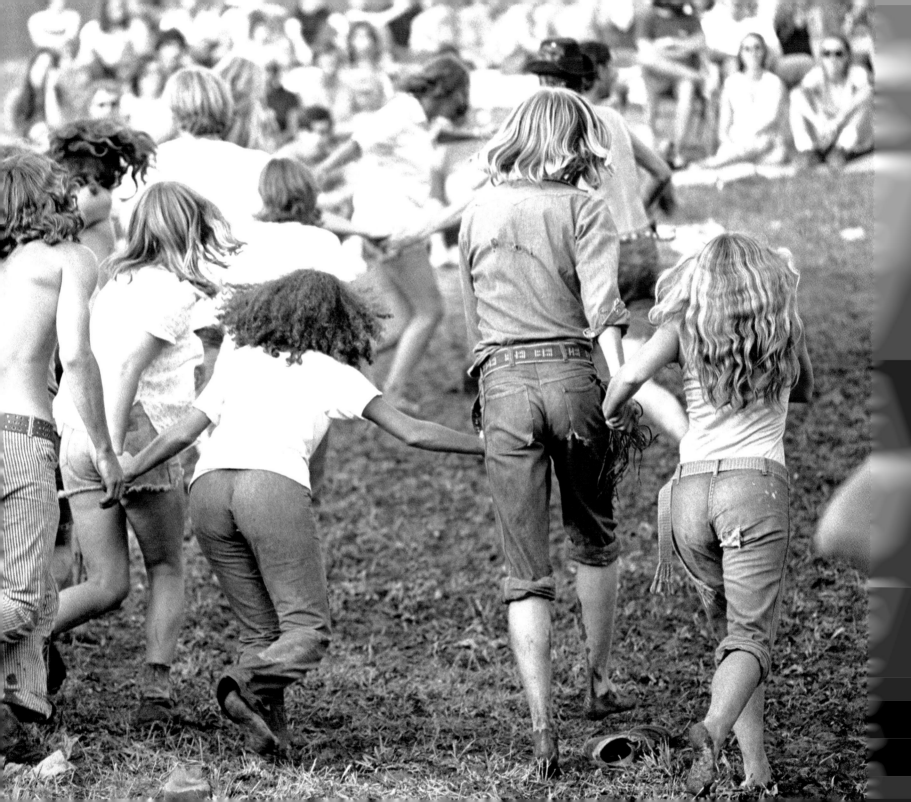

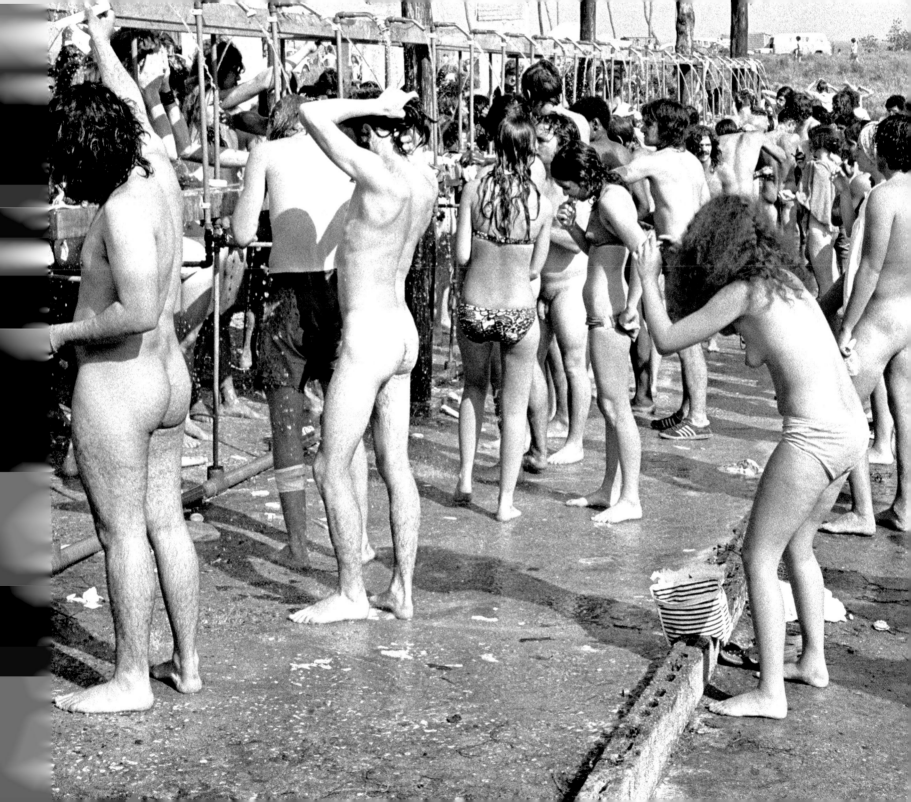

ROBBER BAND
BANDA DE RARAJO
NETZINGER
BROWNSVILLE STATION
MICHAEL OVERLY
GOOSE CREEK SYMPHONY
B.B. King

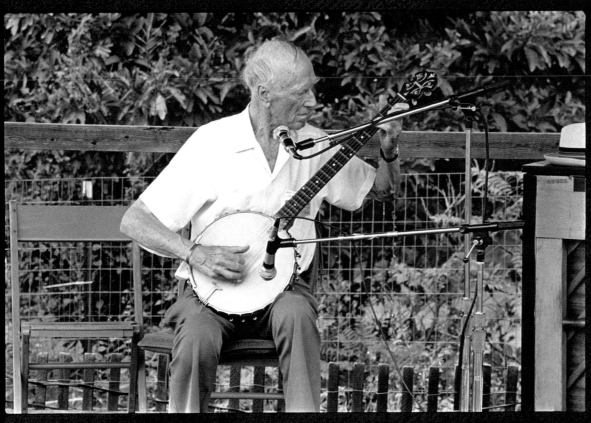

PAUL CADWELL 1979 Ⓑ

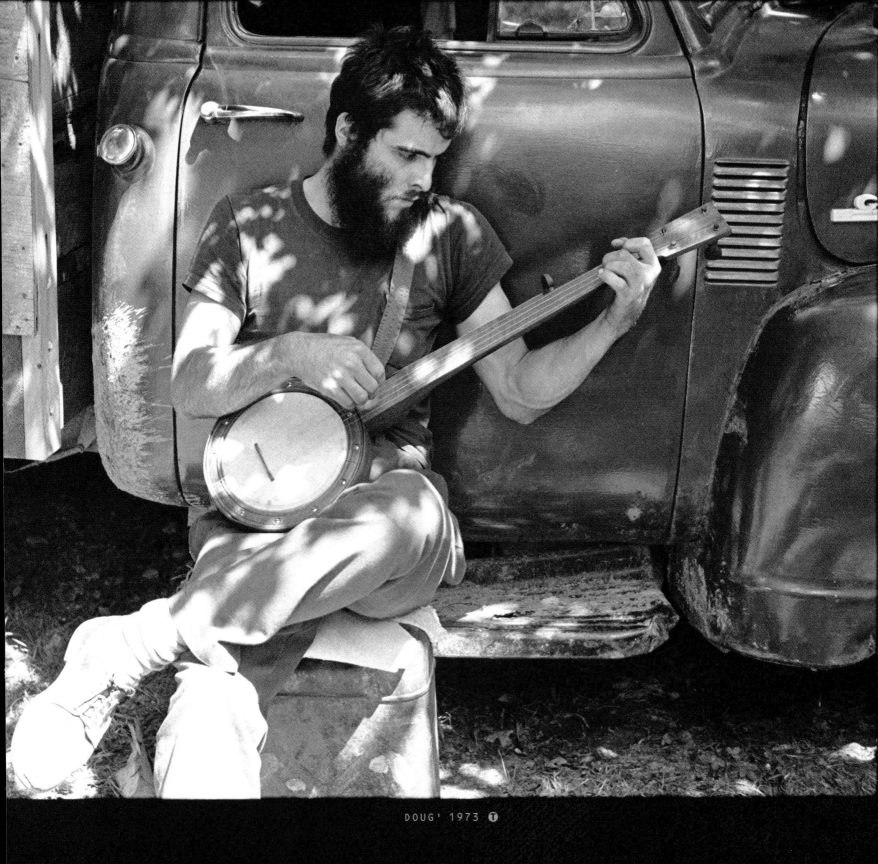

DOUG' 1973 **T**

'Doug' whose surname was either never used or has become lost in the mists of time, was also a familiar festival presence in the early 1970s. He made his own banjos and played them as well.

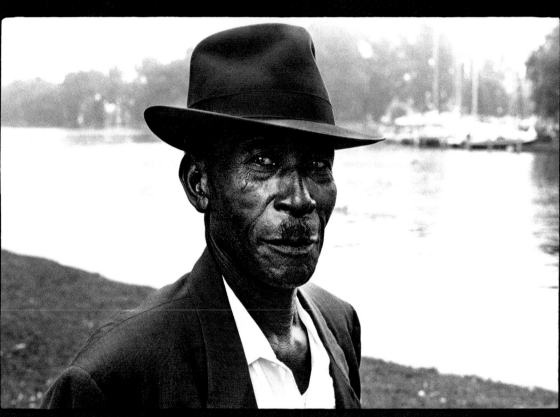

LONNIE JOHNSON 1970 Ⓐ

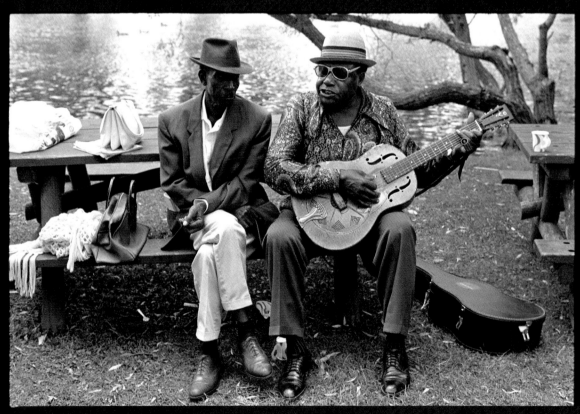

LONNIE JOHNSON & BOOKER WHITE 1972 Ⓐ

Alonzo 'Lonnie' Johnson, seen here both alone and with Booker White, was something of a reluctant bluesman, typecast by winning a blues competition in St Louis in 1925. The prize was a recording contract with Okeh. 'I guess I would have done anything to get recorded' Johnson said later. 'It just happened to be a blues contest, so I sang the blues'. He went on to pioneer an influential jazz guitar style, popularizing the single-string jazz solo.

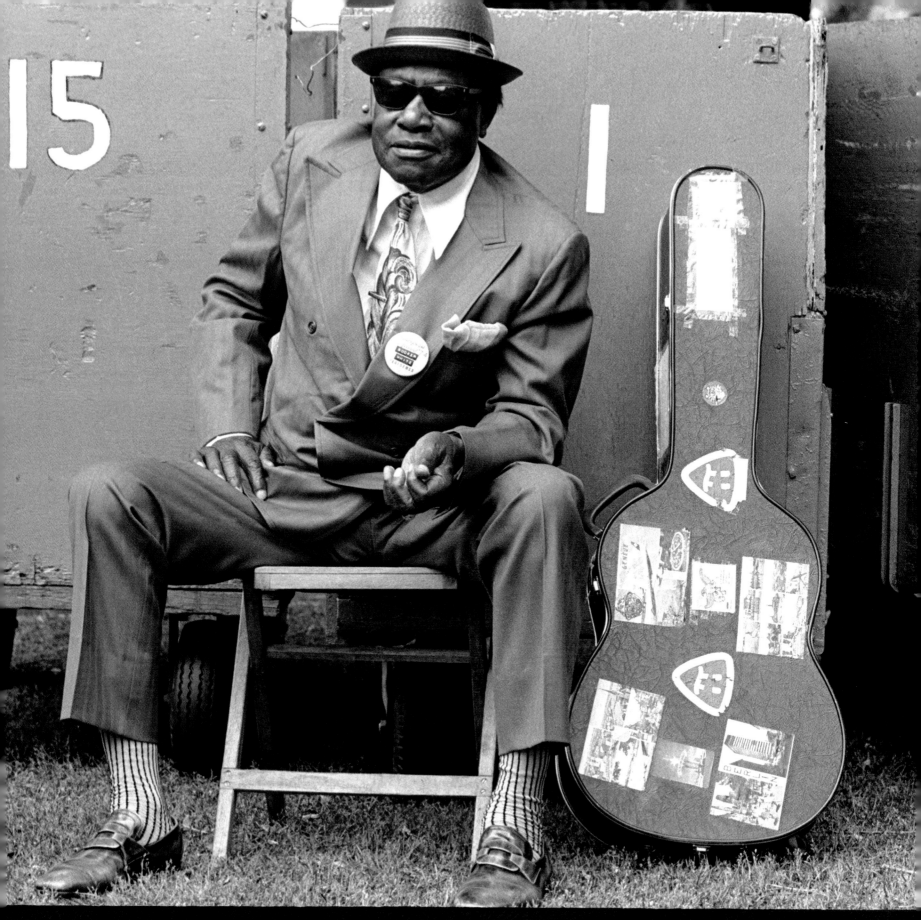

15

BOOKER WHITE 1974 Ⓐ

Booker T Washington White, was a delta blues guitarist and singer from Mississippi and a cousin of B B King. Born in 1906 he started
his career by playing the fiddle at square dances but later became identified with playing slide guitar, usually a resonator model

White's first name is occasionally misspelled 'Bukka', the lasting result of a clerical error by someone at a record label.

After a spell in Parchman Farm prison, he fell into obscurity during World War II. The rehabilitation of his career was triggered by a cover of his song 'Fixin' To Die Blues' on Bob Dylan's first Columbia album.

This in turn prompted interest from guitarist and music scholar John Fahey who tracked down White working in a tank factory in Memphis and re-recorded him for his co-owned Takoma label.

White subsequently became a familiar figure on the folk revival scene, stayed a lifelong friend of Fahey and was managed by Fahey's business partner Eugene Denson.

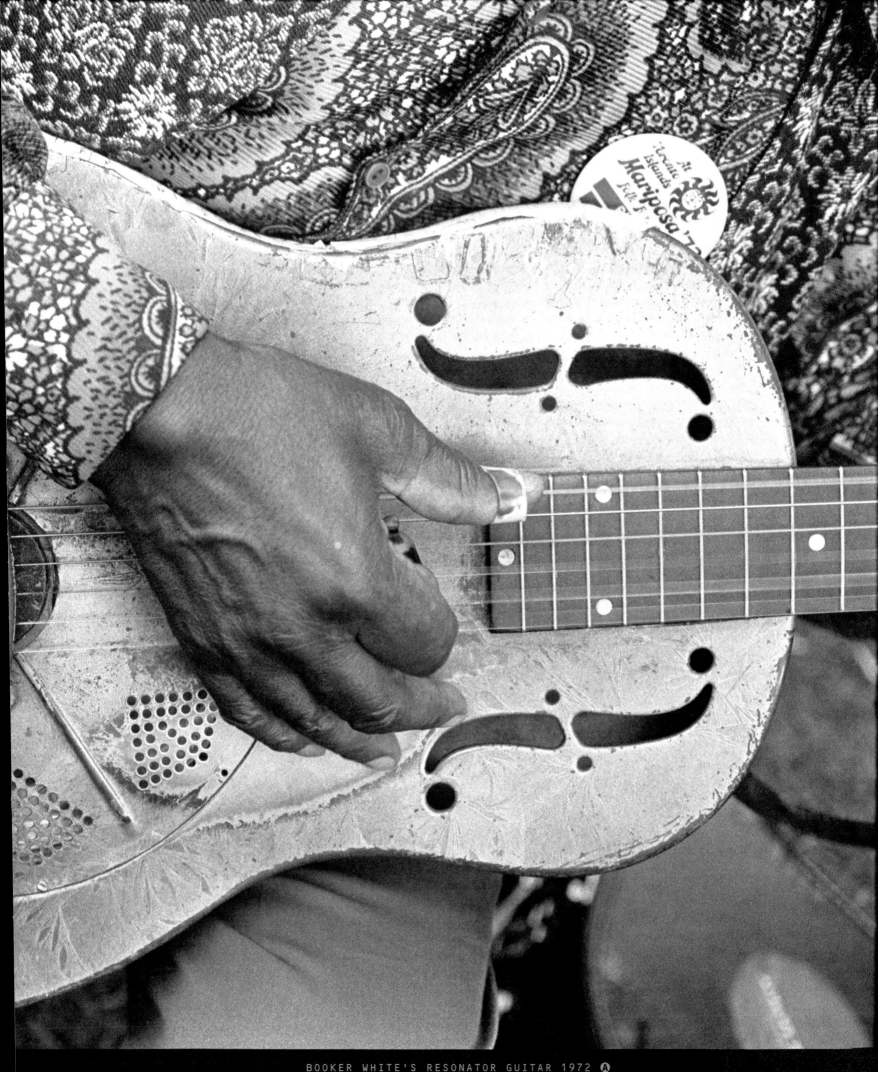

BOOKER WHITE'S RESONATOR GUITAR 1972 Ⓐ

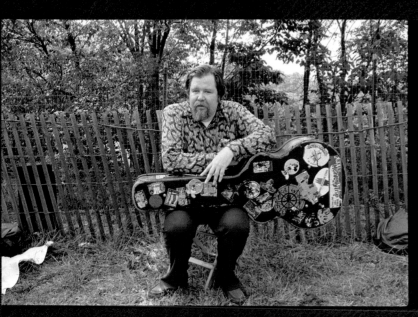

DAVE VAN RONK 1979 Ⓑ

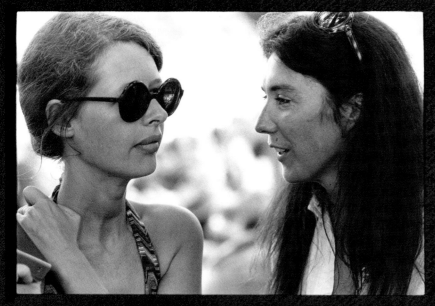

MARY MARTIN & KATE McGARRIGLE 1971 Ⓔ

Dave Van Ronk was one of the elder statesmen of the Greenwich Village folk scene and an early muse to Bob Dylan. A jazzman turned blues interpreter, he was noted for his precise absorption of traditional blues guitar styles – notably that of Mississippi John Hurt – and his larger-than-life personality. A cultured, often opinionated man, he was nicknamed The Mayor of MacDougal Street, the famous Greenwich Village thoroughfare that was his spiritual home.

Kate McGarrigle, seen here with music executive Mary Martin, was a major force in Canadian folk music, the ex-wife of Loudon Wainwright III and the mother of Rufus and Martha Wainwright. She first came to international notice in 1975 with her singing partner, sister Anna, four years after this photo was taken.

LEON REDBONE 1974 ®

Leon Redbone is a mysterious figure whose public image – Panama hat and sunglasses – masks a skilled musical magpie capable of creating authentic sounding pastiches of blues, vaudeville, jazz and pop. Redbone was a Cypriot who based himself in Canada, and has invented innumerable pasts and personas for himself.

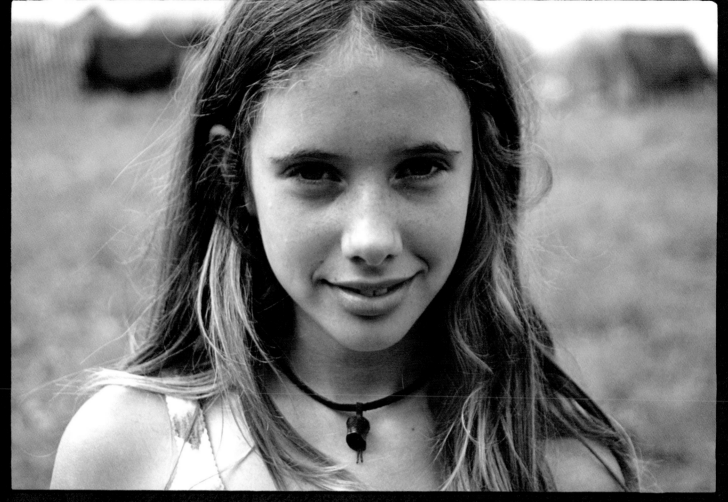

ROSANNA ARQUETTE 1973 Ⓑ

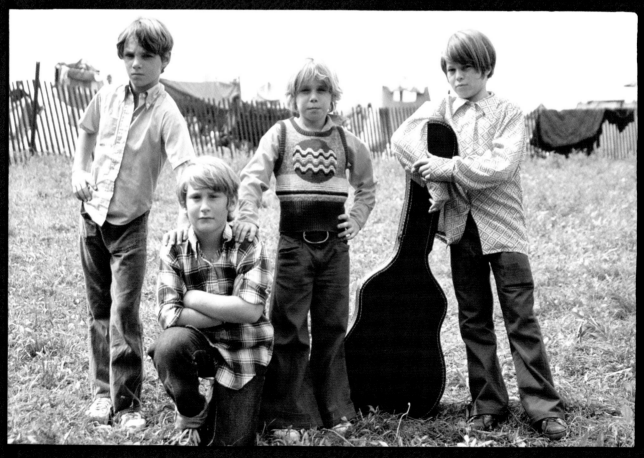

ARQUETTE FRIENDS 1973 Ⓑ

The colorful Arquette show business family spans several generations. The third generation of children – Rosanna, Richmond, Patricia, Alexis and David – were no strangers to music festivals when growing up. Rosanna and Patricia became movie stars, Richmond a television actor, Alexis a famous transsexual and David a movie actor and director who married Courteney Cox.

PATRICIA ARQUETTE 1973 Ⓑ

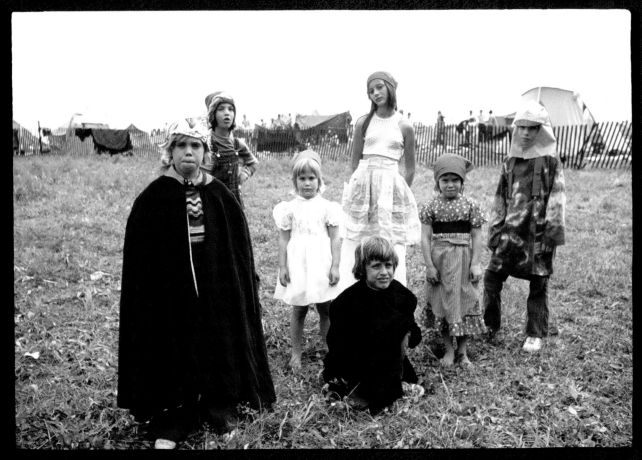

ARQUETTE FRIENDS 1973 Ⓑ

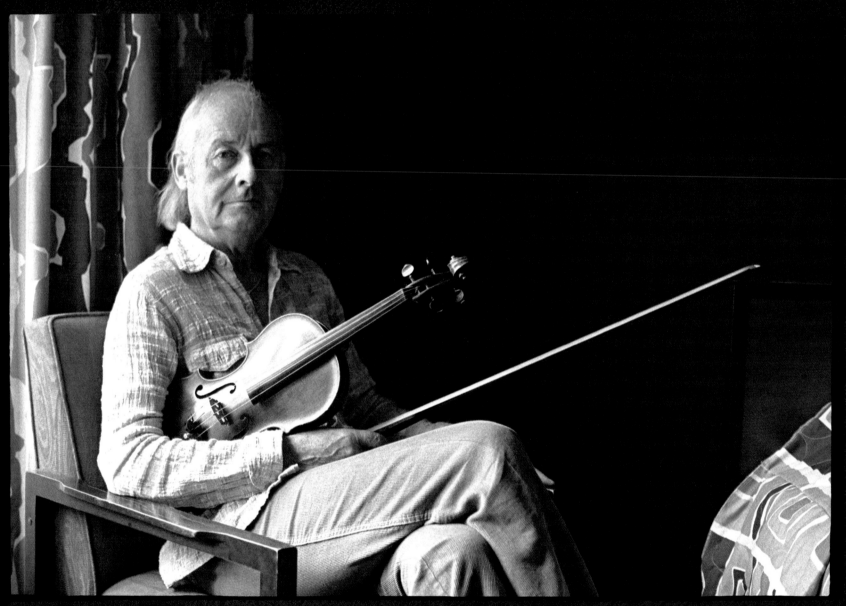

STÉPHANE GRAPPELLI 1976

Stéphane Grappelli's career echoed the history of jazz itself. Born in Paris in 1908 he was a member of the greatest European jazz band of them all – the pre-war Hot Club de France Quintet – playing violin alongside gypsy guitar legend Django Reinhardt. Later he played with everyone from Duke Ellington and Joe Venuti to George Shearing and Oscar Peterson.

STEFAN GROSSMAN 1972 Ⓥ

The Brooklyn-born guitarist and teacher Stefan Grossman is one of the great collectors and instructors of guitar styles. In the 1970s he made several albums in Europe, the most famous being *The Gramercy Park Sheik*. Herb Wise's picture shows the Sheik next to the park square in question.

PETE SEEGER 1978 Ⓑ

PETE SEEGER & UTAH PHILLIPS 1978 Ⓑ

UTAH PHILLIPS 1978 Ⓑ

Pete Seeger was a tireless folk performer and social activist from the 1940s well on into his 90s. He played for Eleanor Roosevelt, protested against the Vietnam War and co-founded Hudson River Sloop Clearwater, which works to call attention to pollution in the Hudson River and to clean it.

Utah Phillips was a spiritual accomplice to Pete Seeger – a folk singer and a fierce champion of the labor unions and the power of direct action.

MALVINA REYNOLDS 1971 Ⓔ

Malvina Reynolds was a folk singer and political activist who came to songwriting late in life but created several durable songs-with-a-message. Joan Baez recorded her 'What Have They Done To The Rain', a monitory piece about nuclear fallout, and The Seekers had a hit with her children's song 'Morningtown Ride'. Her most memorable success, however, was for Pete Seeger who had a hit with her 'Little Boxes', a scathing attack on suburban conformity. Ironically the song's greatest fame came in 2005 when it was used in multiple recorded versions over the opening credits of *Weeds*, a risqué cable TV series about a young widow who turns to drug dealing.

Jazzman Arnie Berle toured for years as a reed and flute player with many of the leading big bands in the United States. His subsequent career as an educator spanned saxophone, guitar, bass and a variety of musical styles.

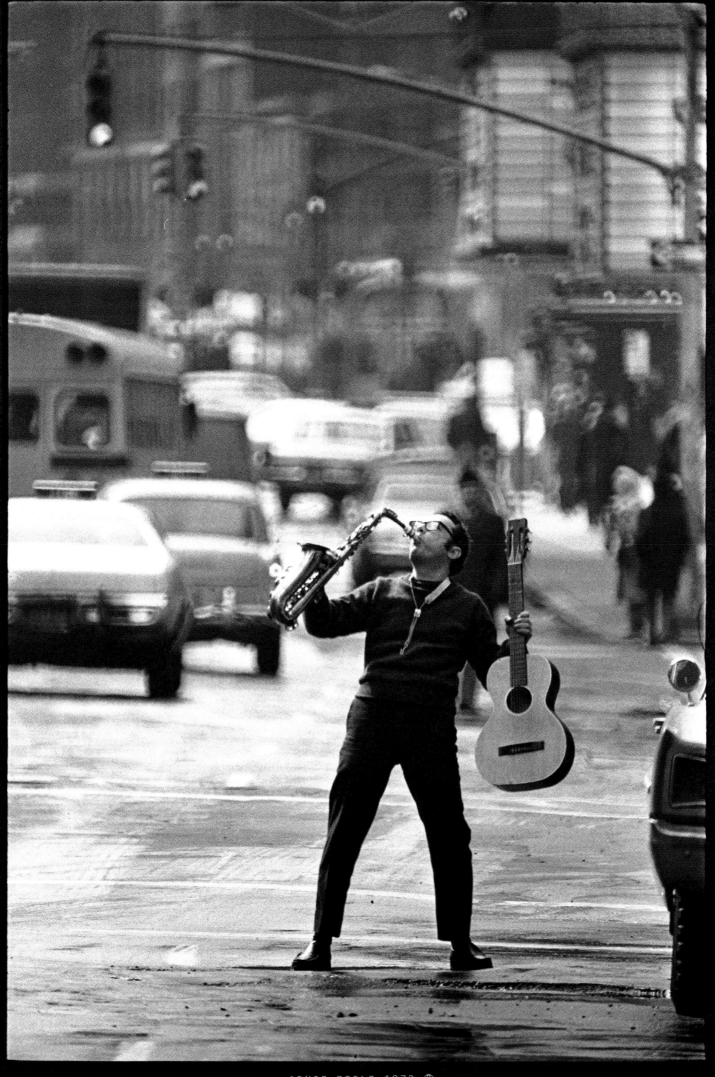

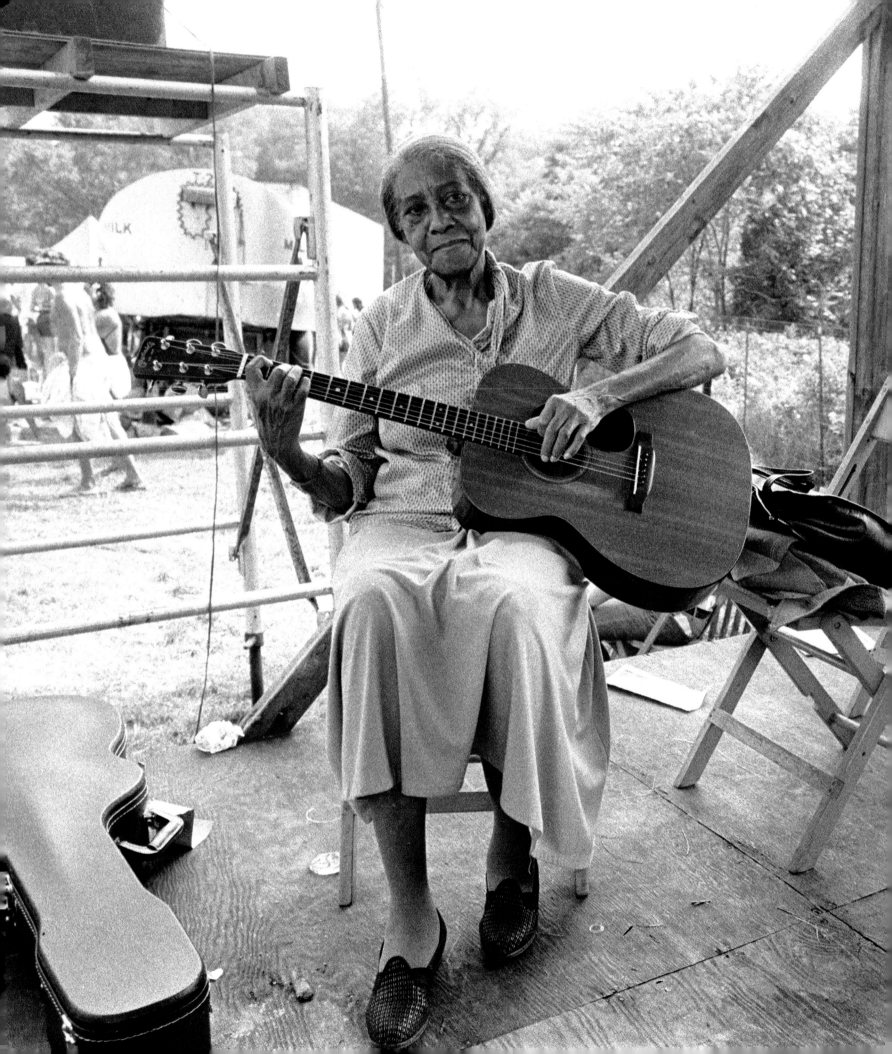

As a child Elizabeth 'Libba' Cotten learned to play banjo and developed a contorted left-handed guitar style by playing a conventionally tuned guitar upside down.

She subsequently forgot about music until she was in her sixties when a chance encounter led her into becoming a housekeeper for the Seeger family. Inspired to play music again she became a well-known and much celebrated link with old folk and blues songs.

Her youthful composition 'Freight Train' was much recorded, and both Rusty Draper and Chas McDevitt had a US hit with it in the mid-1950s.

PERCY RANDOLPH 1975 Ⓧ

NEW ORLEANS

New Orleans is the crucible of American music. The birthplace of Dixieland jazz, the home of unique musical funeral parades and marching bands, a focal point for cajun and zydeco music, the home of distinctive local brands of R&B and country, it also helped shape rock 'n' roll and proved an unlikely hothouse for heavy metal in the late 1980s. Music has been the lifeblood of New Orleans, an all-pervading fact of life that continues to define it in post-Katrina days just as it did in the early 1800s when slaves would congregate in Congo Square to play music and dance.

Percy Randolph was a New Orleans street musician who sang and played blues harp and, occasionally, washboard. He often accompanied the New Orleans folk blues performer Snooks Eaglin, sometimes on record, and for many years was a recognizable member of the informal cast of street performers that helped define the city's musical personality.

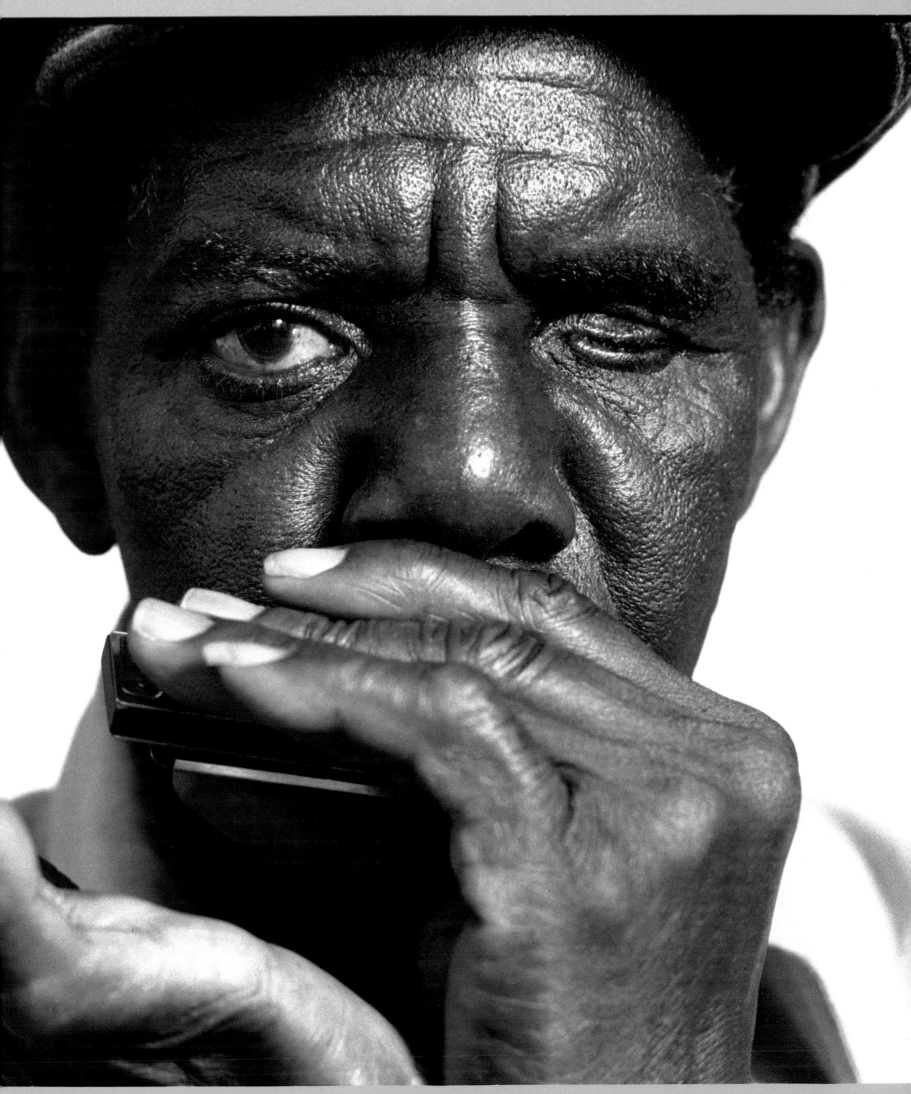

PERCY RANDOLPH 1975 Ⓧ

Starting out as a blues pianist under the name of Georgia Tom, Thomas Andrew Dorsey became the leading proponent of a form of gospel music that leaned heavily on blues and jazz.

Using his middle initial to distinguish himself from bandleader Tommy Dorsey, Thomas A Dorsey wrote a number of famous gospel songs including 'Peace In The Valley' and 'Take My Hand Precious Lord'.

He formed his own publishing company and founded a gospel choir, leaving behind numerous religious songs that have found their way into hymnals all over the world.

THOMAS A DORSEY 1973 Ⓢ

PROFESSOR LONGHAIR 1975 Ⓓ

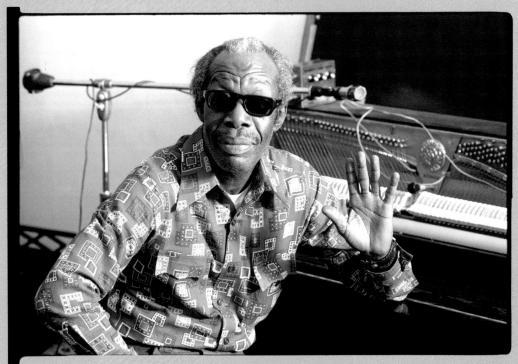

PROFESSOR LONGHAIR 1975 Ⓧ

Professor Longhair (real name Henry Roeland Byrd) was a New Orleans
institution. A bluesman and pianist born in 1918, he spanned early R&B and
the New Orleans jazz revival and never lost his rough edge, something
which made him less likely to have hits with his own songs than those who
covered them. His signature number, 'Tipitina', gave its name to a local club
where he played regularly, and his staccato vocal delivery combined with
his exotic rhumba-boogie stylings made him a uniquely eccentric performer.
He died in 1980.

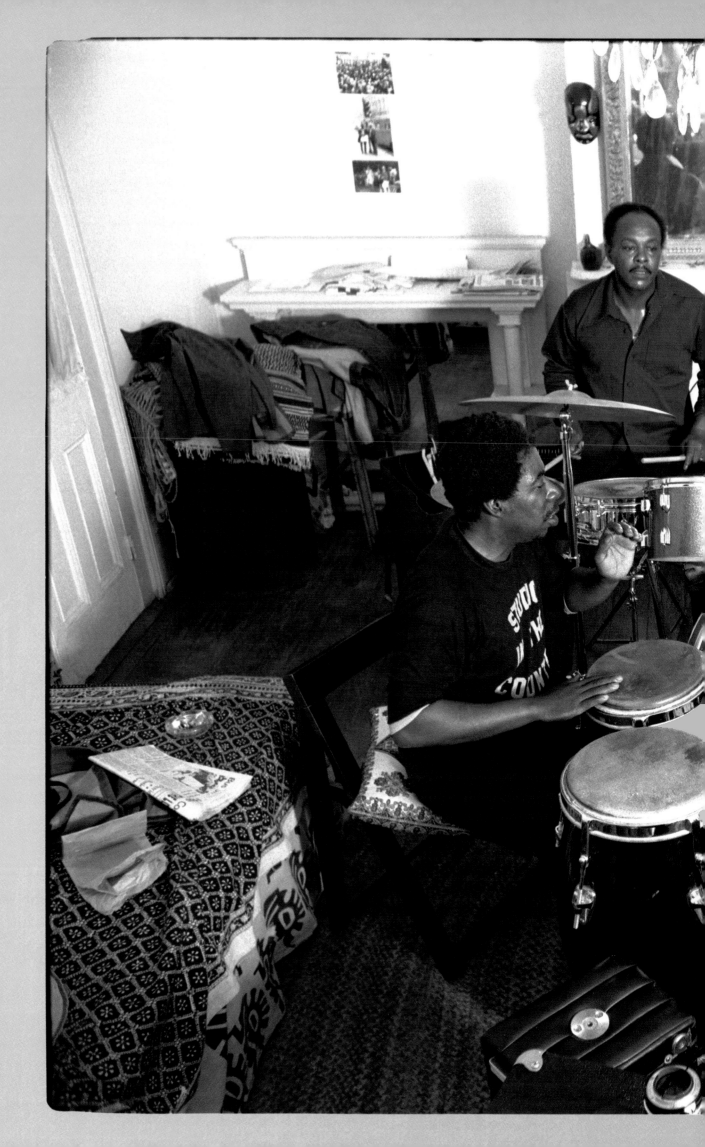

Professor Longhair
with musicians in his
home studio.

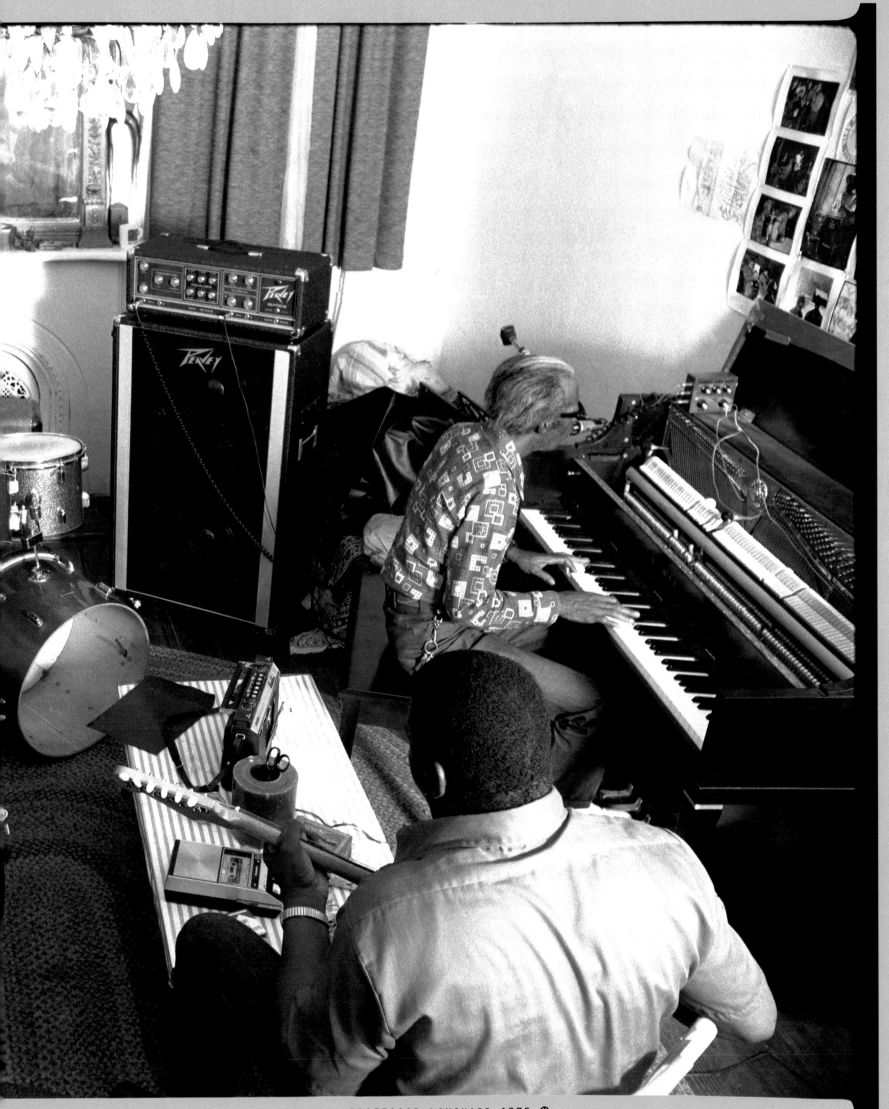

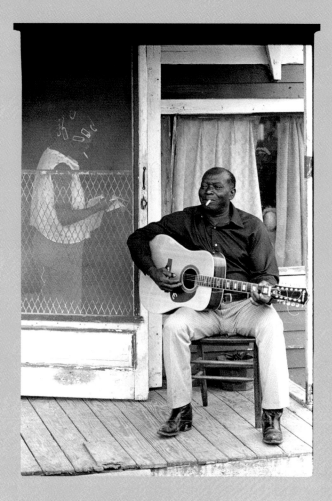

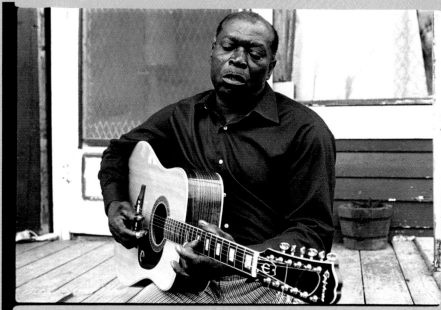

Robert Pete Williams was one of the New Orleans musicians Herb Wise photographed at their homes. In 1956 Williams had been convicted of manslaughter and sent to the notorious Angola prison. There he served two years before being discovered by ethnomusicologists Harry Oster and Richard Allen who recorded him and successfully got his sentence commuted to servitude parole, a status which still severely limited his musical ambitions.

Williams went into the scrap iron business and gradually resumed playing his unconventionally tuned guitar and singing, often about prison life. Captain Beefheart covered his song 'I've Grown So Ugly' and Williams became a celebrity at folk and blue festivals.

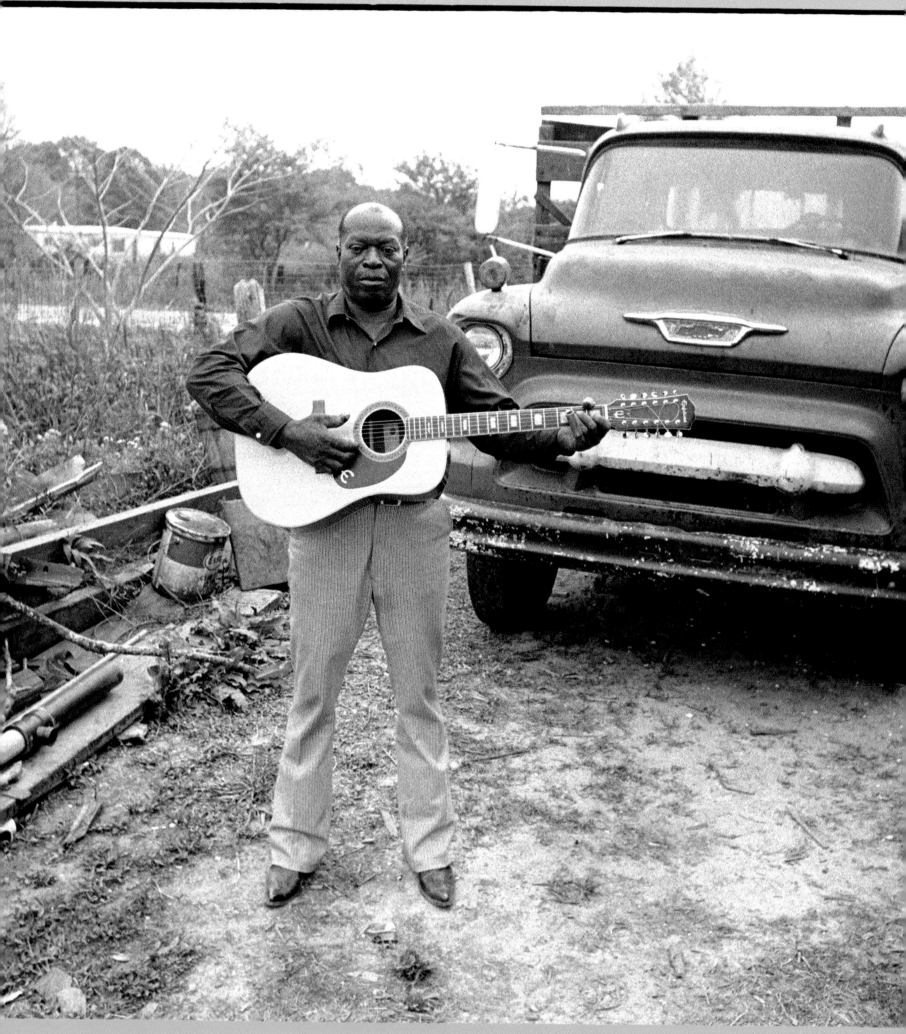

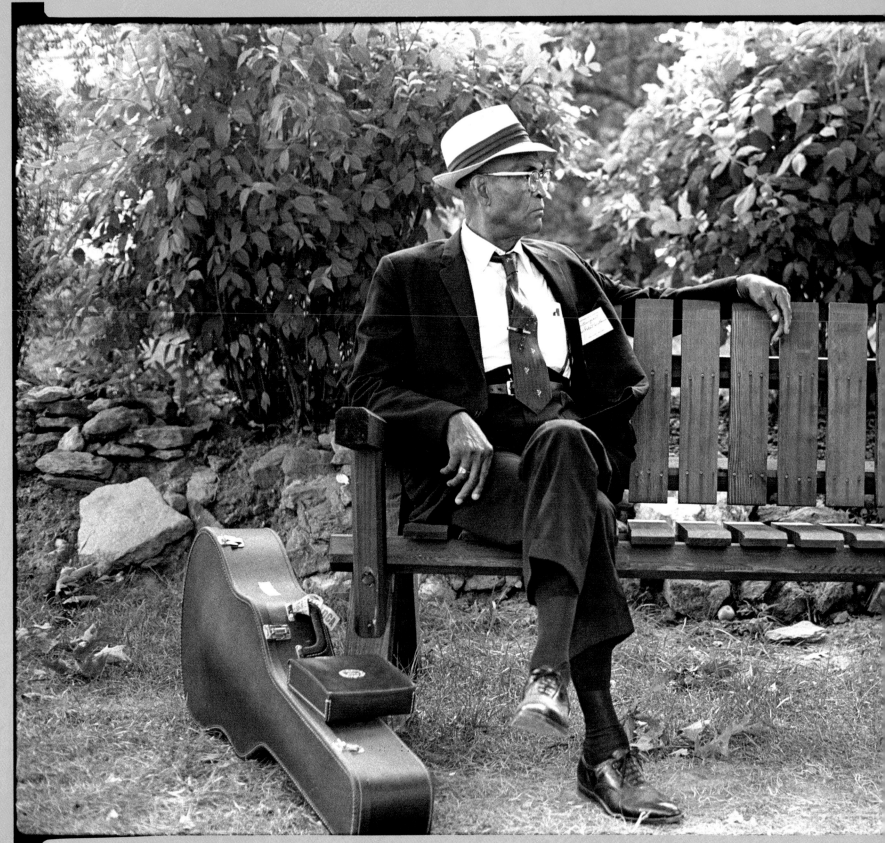

ROBERT WILKINS 1971 Ⓑ

Robert Wilkins, born in 1895 near Memphis, was a blues singer and guitarist with a long secular career. He turned to religion in the 1930s and re-titled his early composition 'That's No Way To Get Along' as 'Prodigal Son', under which title it was covered by The Rolling Stones, being the only non-self penned track on their 1968 *Beggar's Banquet* album. Now calling himself 'Reverend', Robert Wilkins was rediscovered in the age of the blues revival and began appearing at folk festivals and re-recording his gospel blues for a whole new generation of fans.

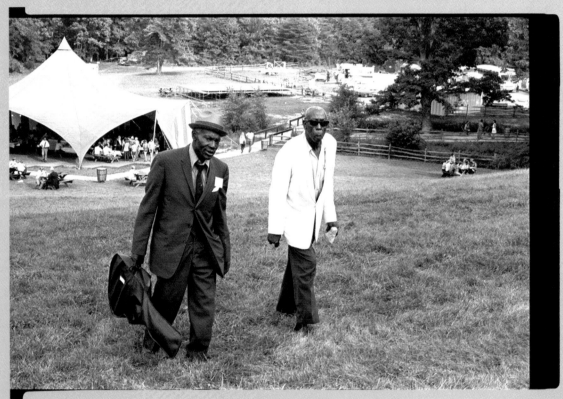

EARL BELL & MOSE VINSON 1971 Ⓢ

Earl Bell was born in the same small Mississippi town as Robert Wilkins but had to develop his musical skills covertly in his strictly
churchgoing family's household. He claimed to have co-written 'Terraplane Blues' with Robert Johnson with whom he travelled for a
while in the early 1930s. He is seen here with Mose Vinson, aka ('Boogie' Mose) a Mississippi piano player who learned to play sitting on
his mother's lap while she worked the pedals of the family organ.

This famous Herb Wise shot of Shaky Jake Woods's ring-laden fingers celebrates the occasion when Woods was invited to perform in Ann Arbor and liked it so much he never went back home to Saginaw.

Revered more as a local eccentric than a musician, he remained a much-loved part of Ann Arbor life for over 30 years.

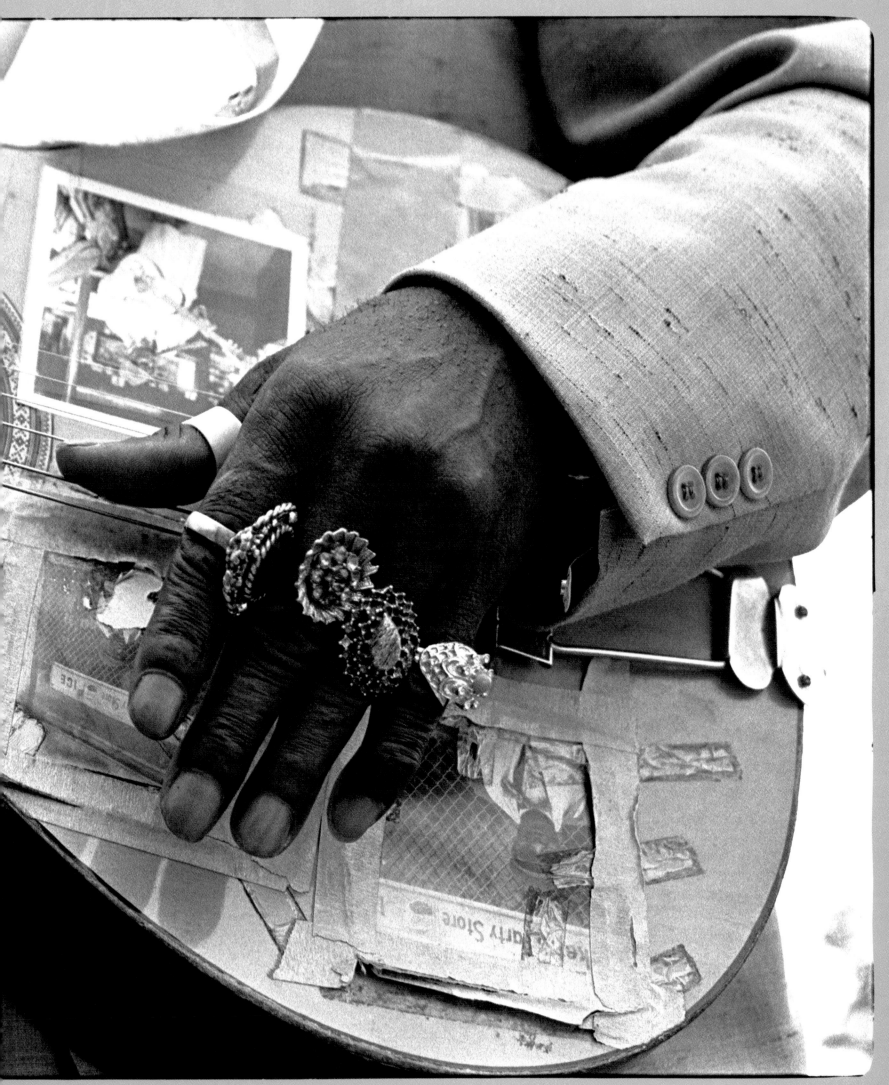

SHAKEY JAKE WOODS' GUITAR 1973 ●

ROOSEVELT SYKES 1981 ⓞ

Arkansas-born Roosevelt Sykes was a piano-pounding boogie pianist who played locally until he secured a recording deal with Okeh in New York in the 1920s. He later moved to Chicago where he recorded for Decca and Bluebird until the popularity of electric blues began to nudge him out of fashion. He relocated once more, this time to New Orleans where he spent the remainder of his days, occasionally making records that provided a permanent record of his old-style, thumping barrelhouse boogie.

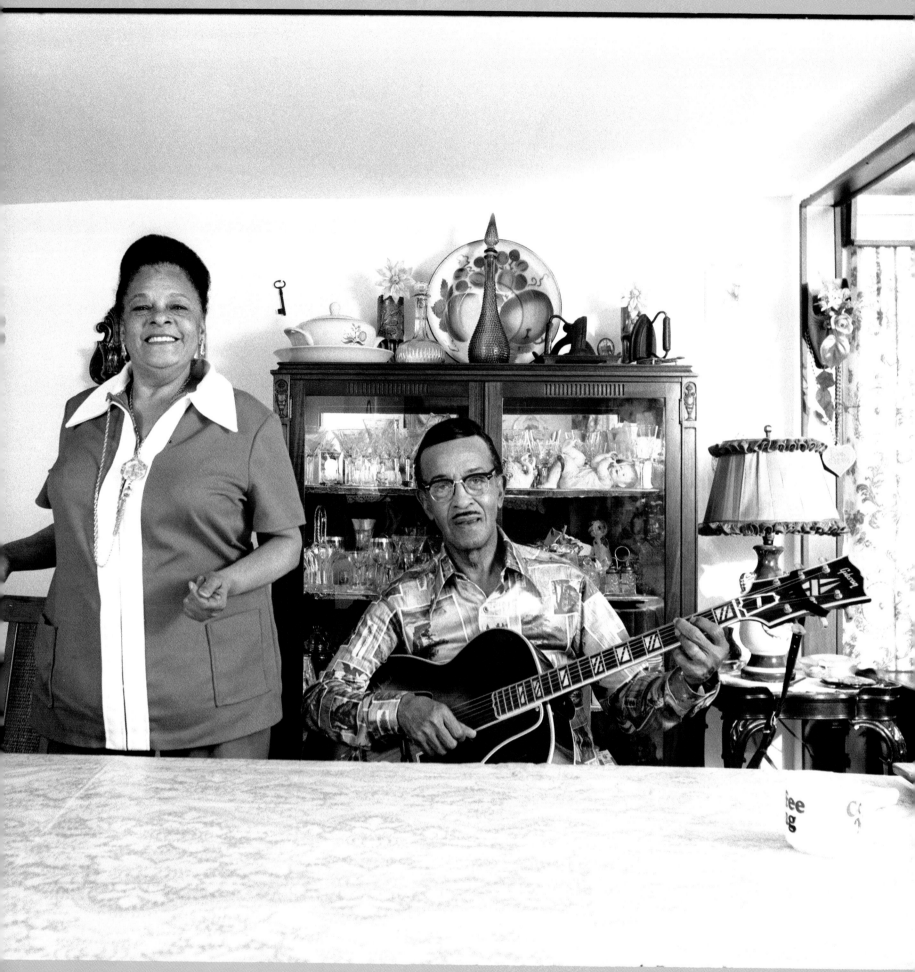

BLUE LU & DANNY BARKER 1976 Ⓧ

Blue Lu & Danny Barker were dyed-in-the-wool New Orleans musicians. From the late 1930s to the late 1940s Blue Lu recorded many jazz-flavored numbers, usually with small combos led by her husband, guitarist (and occasional banjo player) Danny Barker. Her final recording was a live performance at the 1998 at the New Orleans Jazz and Heritage Festival, although a video of her wake was actually included in a TV documentary about New Orleans jazz funerals.

BYRON HOLMES & JAMES BLACK 1975 Ⓧ

Byron Holmes was an electric blues guitarist with more than a little of the Jimi Hendrix about him. He eventually relocated to France where he can still be seen in clubs occasionally playing guitar with his teeth on the odd Hendrix number.

James Black was little known outside of New Orleans and never recorded an album under his own name, but he was a versatile drummer, working in various genres.

He accompanied Fats Domino and Ellis Marsalis and later went on to play with Yusef Lateef and Lionel Hampton.

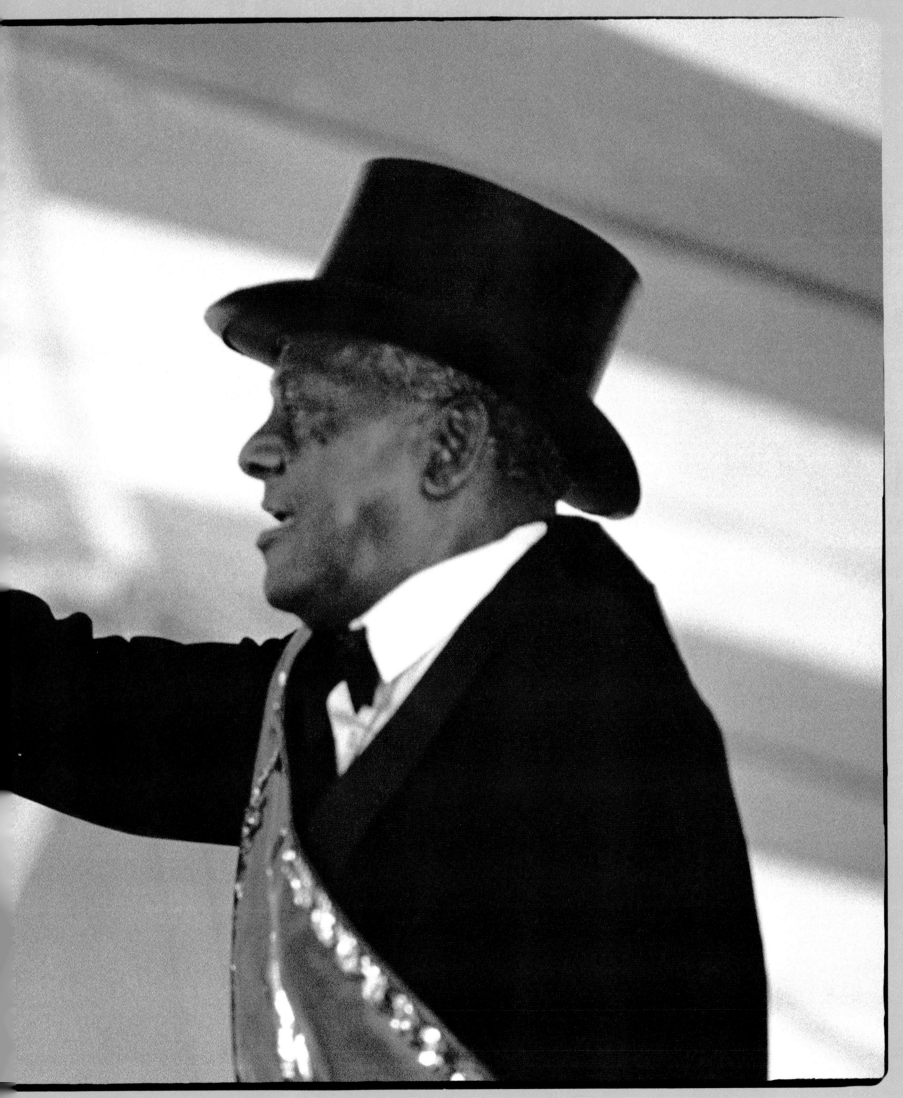

CAPTAIN OF THE ONWARD BRASS BAND 1975 ⊠

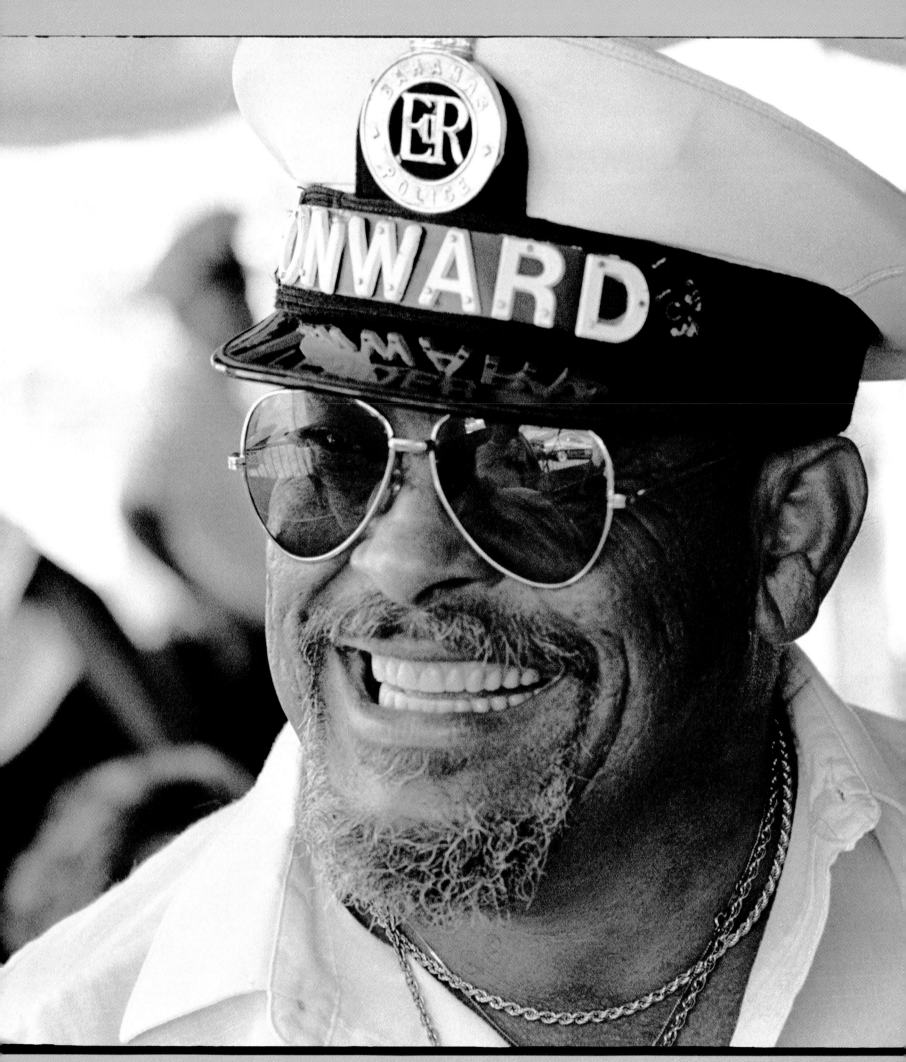

THE ONWARD BRASS BAND 1975

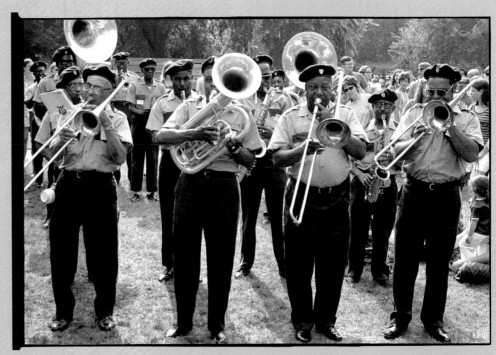

MARCHING BAND 1975 X

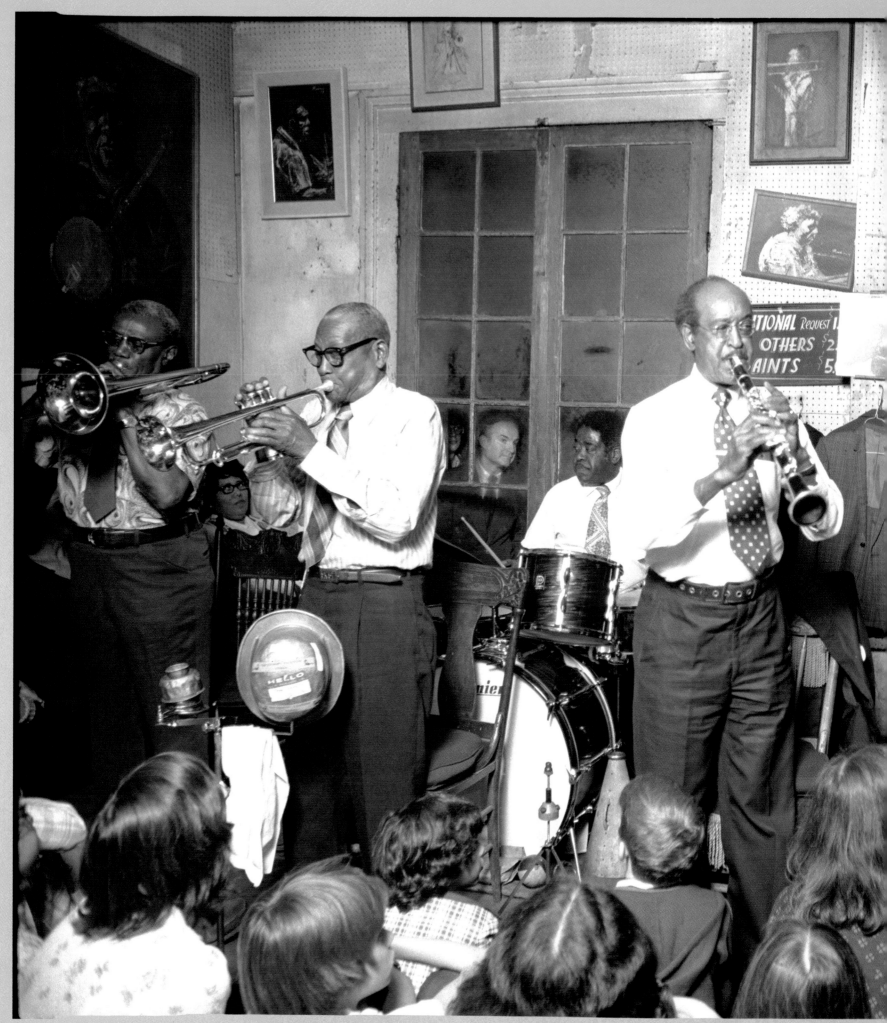

PRESERVATION HALL JAZZ BAND 1975 ✕

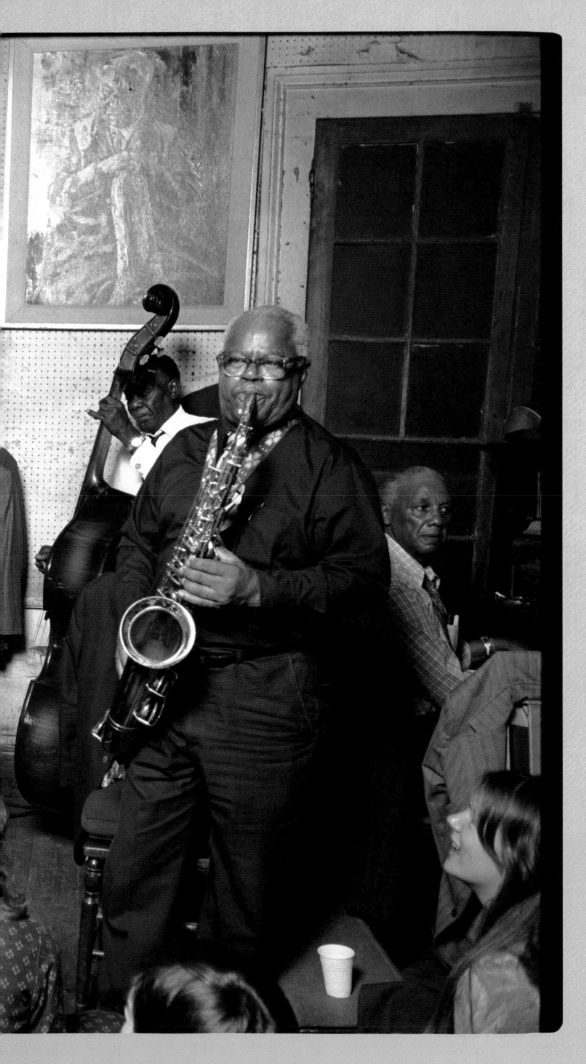

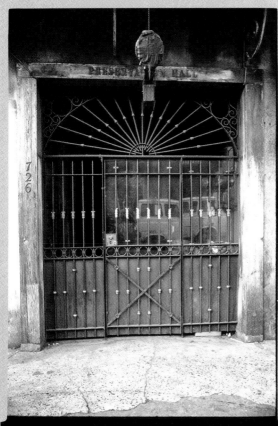

PRESERVATION HALL 1975 ⓧ

The Preservation Hall Jazz Band is
indivisible from its headquarters,
Preservation Hall, a venerable music venue
located in the heart of New Orleans' French
Quarter. Founded in the early 1960s the
band operated as a travelling ambassador
for New Orleans Jazz and for some
years there were several outfits travelling
internationally under the name.

Many of its personnel had played with
the great names of the past, among them
Jelly Roll Morton, Louis Armstrong, and
Bunk Johnson.

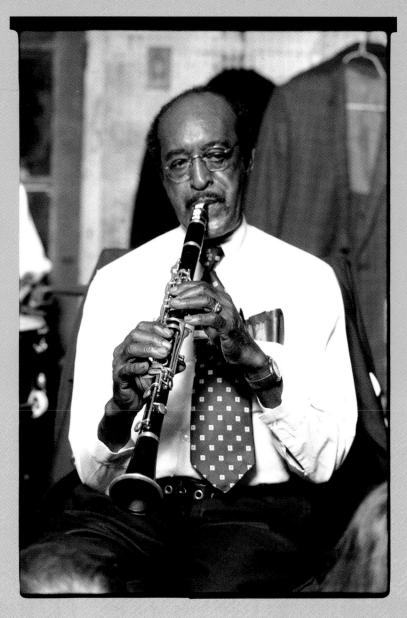

PRESERVATION HALL
JAZZ BAND MUSICIANS
1975 Ⓧ

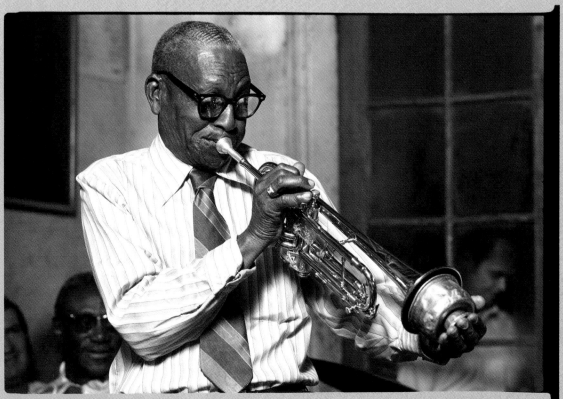

One of The Preservation Hall Jazz Band's many bandleaders was 'The Bell Gal', Sweet Emma Barrett, who, along with several other New Orleans musicians, can be seen performing in Norman Jewison's 1965 movie 'The Cincinnati Kid'.

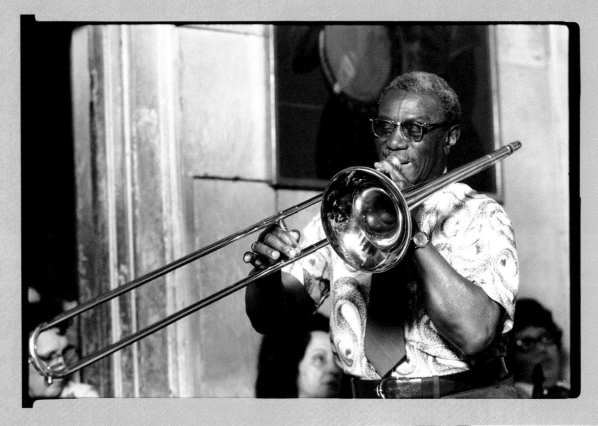

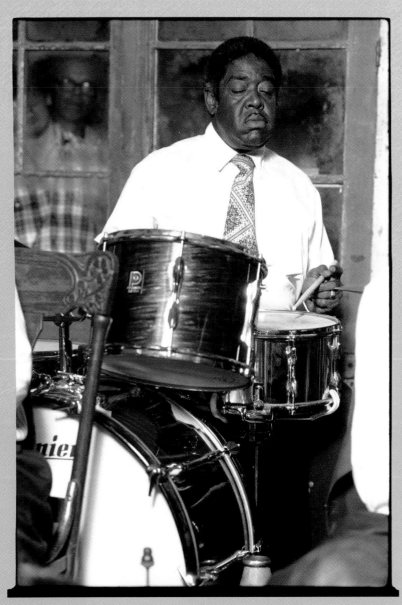

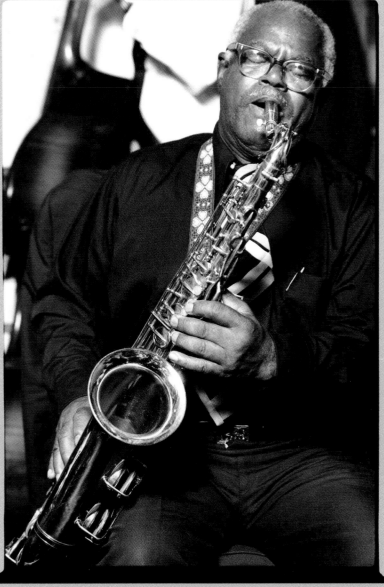

The Preservation Hall endures at its original location on 726 St Peter Street, a shrine to what aficionados see as New Orleans' purest form of jazz, the pre-Dixieland style.

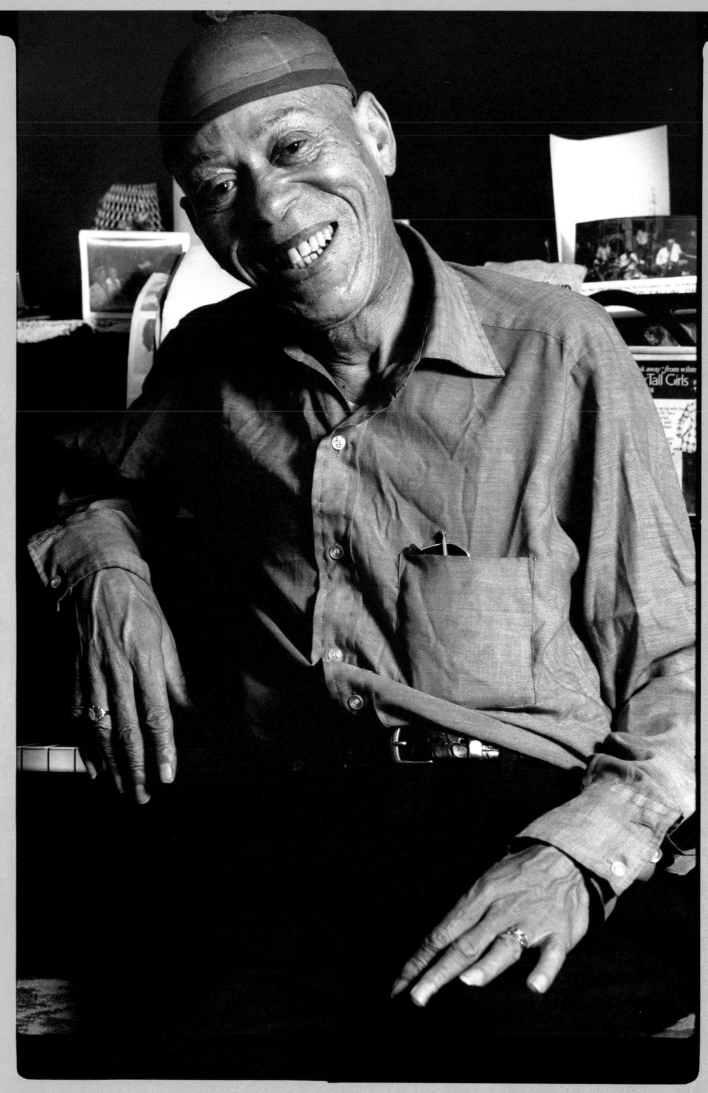

TUTS WASHINGTON 1975 ✗

'Tuts' Washington was one of the defining exponents of New Orleans R&B style piano. Born in the city he studied with jazz pianist 'Red' Cayou and subsequently played in numerous local dance and Dixieland bands. After a spell during the 1950s playing in Smiley Lewis's band he moved to St Louis for a while but returned to New Orleans in the 1960s. There he became a regular artist at the city's restaurants and clubs as well as the New Orleans Jazz & Heritage Festival. For years he also had a residency at a piano bar in the Pontchartrain Hotel.